the art and craft of
collage

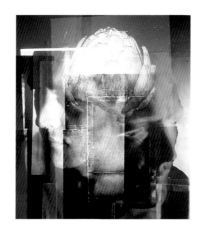

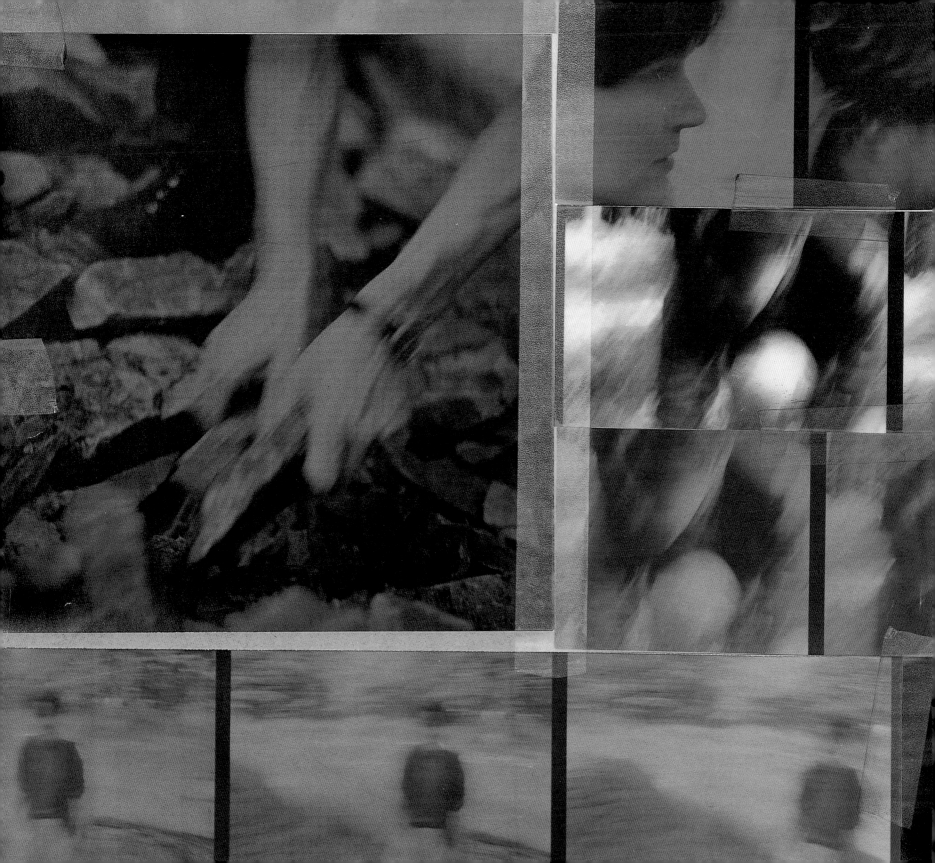

the art and craft of
collage

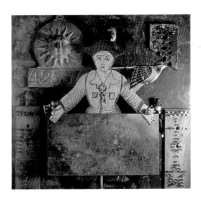

simon larbalestier

CHRONICLE BOOKS

SAN FRANCISCO

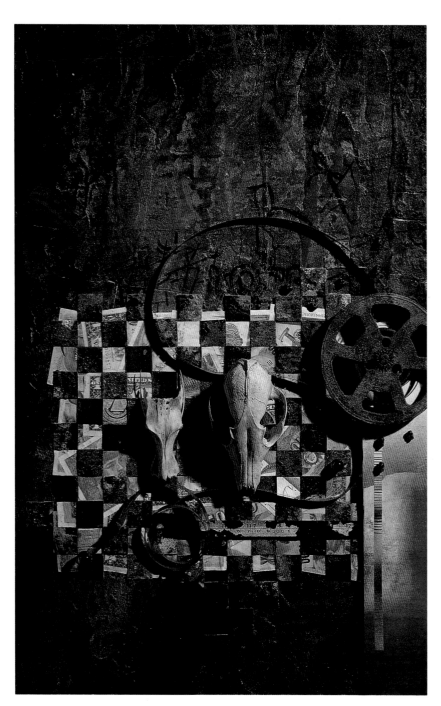

Printed in Hong Kong.

First published in the United States in 1995 by Chronicle Books.

Book interior edited and designed by Mitchell Beazley Publishers.
part of Reed International Books Ltd.
Michelin House. 81 Fulham Road
London SW3 6RB

Cover Design **Leeb & Sons, Carrie Leeb**
Senior Art Editor **Larraine Lacey**
Editor **Catherine Ward**
Production **Sarah Schuman**
Art Director **Jacqui Small**

Library of Congress Cataloging-in-Publication Data
Larbalestier. Simon.
The art and craft of collage/Simon Larbalestier.
p. cm.
Includes index.
ISBN 0-8118-0806-8
1. Collage. I. Title.
TT910.L37 1995
702'.8'12–dc20 94-22236
 CIP

Distributed in Canada by Raincoast Books.
8680 Cambie Street, Vancouver. B.C. V6P 6M9

10 9 8 7 6 5 4 3 2 1

Chronicle Books
275 Fifth Street
San Francisco. CA 94103

Contents

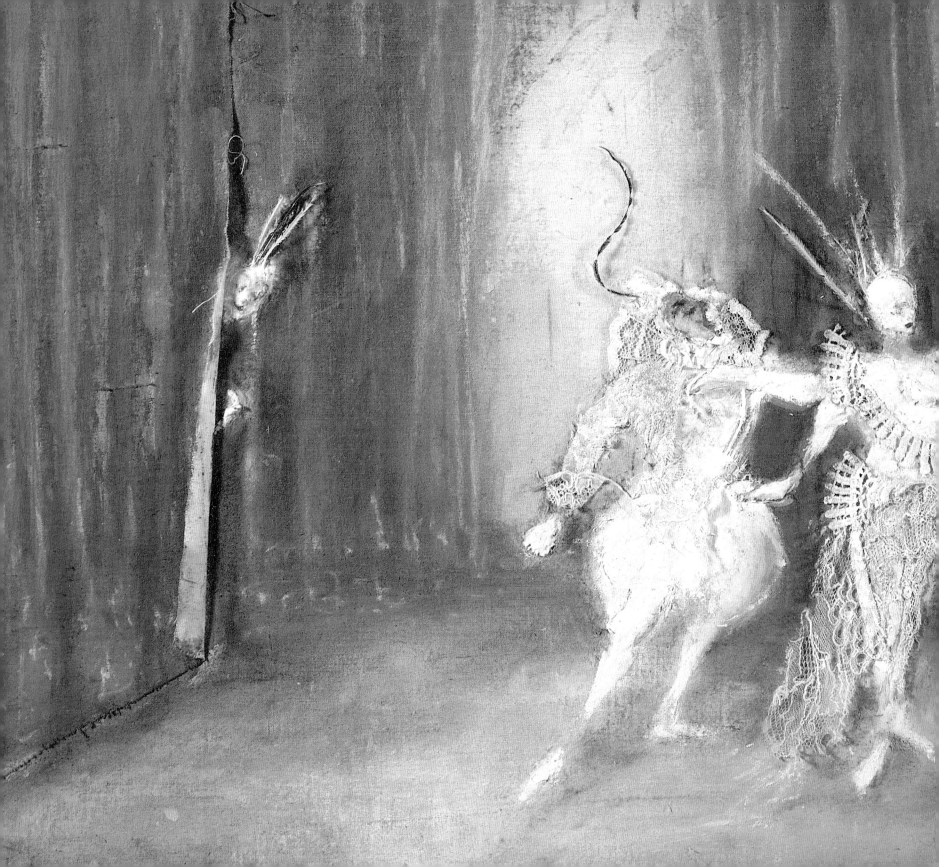

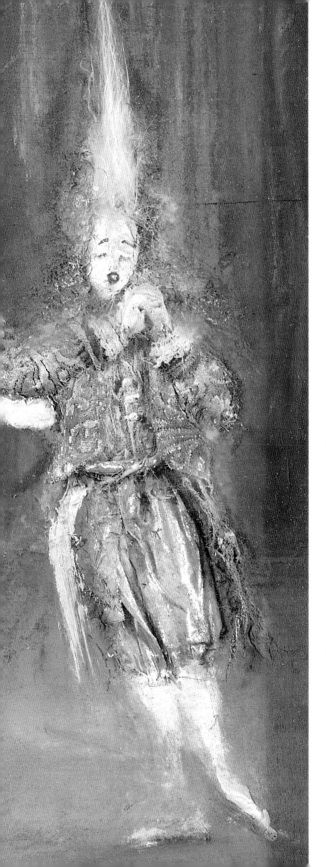

Foreword

\mathscr{T}he words "collage","montage," and "assemblage" all describe an image that has been created from a combination of sources – be it found images, printed ephemera, three-dimensional objects, or painted media. The results can look very different, as the images in this book show. Some disguise their origins and appear as a single surface, while others draw attention to the inherent qualities of their chosen materials and are more sculptural. Before examining the components that make up these images, it is worth looking at the French origins of the words "collage," "montage," and "assemblage." Collage comes from *coller* (to stick), while montage derives from *monter* (to mount) and assemblage from *assembler* (to bring together). It is easy to see that the boundaries between these words can become blurred since an image can embody all of these criteria.

I have divided montage, the art of combining collected and processed images, into two basic categories: Paper, and Mechanical Reproduction. The main difference between the two is that the materials that make up a "paper" collage have *not* been altered by mechanical means. For example, an image (such as an encyclopedia photograph) will be mounted in its original form, without having been photocopied or re-photographed to change its size and shape or alter its quality. By contrast, Mechanical Reproduction is the process of using reprographic tools – such as photocopiers and cameras – to modify or manipulate an image and take it through a series of transformations.

This book should not be seen as an A-Z of collage techniques, nor does it profess to cover every method in the fascinating world of blending disparate images – you can't! More importantly, it doesn't advocate the theory that the more equipment you have access to, the better and more resolved your image will become, since without a strong concept in the first place all you will achieve is a beautiful surface, empty of content, emotion, and provocative thought

Left: Collage, montage, and assemblage offer many opportunities for creative expression. By combining these techniques with different media, you can produce complex images like this piece, entitled Les Indes Galantes, *which has been produced using lace, canvas, and plaster. (Danusia Schejbal)*

Perspectives

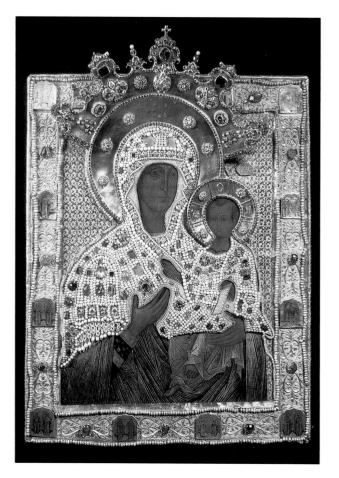

If you think of collage, montage, and assemblage, in their simplest form, as being a combination of different materials arranged together either on a flat surface or in some sort of three-dimensional structure, examples can be found in many primitive cultures around the world. In these societies, magical powers or mystical properties are often bestowed on what appear to be, to the uninitiated, apparently unrelated objects. To believers, the result is a totem – an energy-focusing device that embodies powers to ward off evil or bring victory over one's enemies. Such notions are centuries old and still play an important role in many cultures of the world today.

In India, the belief and rituals associated with the Hindu god Siva provide a good example of this cultural tradition. From the very earliest times, one of Siva's worshiping forms has been a ceremonial red cloth representing feminine energy, or *Sakti*. This is adorned with sandalwood paste and various fruits and flowers placed there by believers in preparation for ritual worship.

Cultural traditions

The art of combining cut-out shapes and papers can be dated as far back as a thousand years ago, when Japanese poets and calligraphers were making collage poems depicting landscape scenes embellished with delicate cut-out shapes of animals and birds. Work by the 10th-century poet Ise provides clear evidence of the antiquity of these collage techniques, and today in Japan the tradition lives on in the shape of New Year cards utilizing this same ancient art form.

From the 13th century there is evidence of a Persian collage tradition in the form of cut-outs incorporated in the leather bindings of books, and in the 16th century Turkish artists were producing beautiful illuminated texts combining elements of collage techniques. At about the same time in Western Europe illustrations of heraldic coats of arms were being produced using cut-out elements

pasted onto painted backgrounds. A century later, aristocratic ladies indulged in the gentle art of collage, using such items as beetles, coffee beans, fruit stones, feathers, lace, and other types of cloth. A popular collage material in 18th-century Europe – before ideas of nature conservation gained currency – was butterflies' wings which were used primarily in representations of Christian religious imagery.

The importance of the Church as one of the primary patrons of artistic endeavor in Europe can be seen in the tradition of Russian icon painting and decoration. And from about the middle of the 15th century, collage began to play an increasingly important role in this particular field, with the religious characters depicted on painted wooden panels often decorated with precious metals and stones, gold leaf, ivory, mother-of-pearl, fine lace, and beautifully embroidered materials. It is sometimes possible to find these icons famed in metal arabesques, a tradition that was much imitated and later became a stylistic device used by artists for framing their collage images.

In the 17th and 18th centuries, paper collages depicting saints became extremely popular, and these were often used as page-markers for prayer books. Intricate paper lace patterns adorned the painted heads of the figures, which were made for sale at churches and religious shrines. The mass production and popularity of this religious ephemera provoked imitative designs in the decoration of greeting cards. An excellent example of this transition can be seen in the St. Valentine's Day card, which, once stripped of its religious connotations, became enormously popular in Britain during the early part of the 18th century and was equally well-received in the United States from about the mid-19th century. These early valentines were commonly adorned with paper lace fringes and cut-out images of hearts, flowers, and other similar romantic symbols.

The Industrial Revolution of the 18th and 19th centuries provided a massive stimulus for the popularity and expansion of collage imagery. The "machine age" was to produce huge changes in social structures, culminating in mass migrations of populations away from the countryside and into the cities. Manufactured goods became increasingly common and varied, and paper and printed products, cloth, beads, glass, and other similar items started to be combined in new ways in the form of motifs to decorate the products that were being manufactured night and day in the factories.

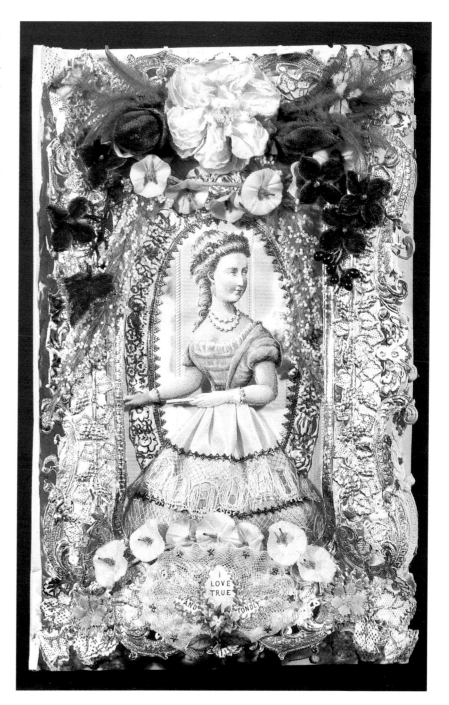

Left: Ikon of the Virgin, from the Smolenskaja Monastery in Russia, demonstrates the diversity *of material used in icon imagery. Here, painted media are combined with jewels and other objects.* *Right: An intricate Victorian valentine with the message "I Love True and Fondly."*

The flood of new products that came on the market during the 19th century was fueled by a host of technological advances as well as the introduction of totally new technologies. Two that were to play a crucial role in the development of both collage and montage as art forms were the invention of the photographic negative and the introduction of the photocopier.

The development of photography

In 1839 the Frenchman Louis Jacques Mandé Daguerre was credited with achieving the world's first genuine photograph – a permanent image produced by the direct action of light that did not fade when re-exposed to light for viewing. The image was produced on the surface of a silvered copper plate coated with iodine vapor and developed by exposing it to heated mercury. To make the image permanent, the plate was washed in a solution of ordinary cooking salt and distilled water. Each Daguerreotype, as the images were called, was unique and could not be reproduced.

However, it was an Englishman, William Henry Fox Talbot, who invented the photographic negative, the basis of all modern photography. In fact, Talbot's successful experiments to achieve a permanent image predate Daguerre's triumph of 1839. By 1833 Talbot had produced permanent photographic paper negatives, but it was not until 1840 that he found a practical way of making positive prints on sensitized paper from those original negative images. His process was patented first as the Calotype and later as the Talbotype. The earliest recorded negative image, a view of the library window of Talbot's home at Lacock Abbey in Wiltshire, England, was taken by Talbot in August 1835.

Today, much the same process as Talbot invented is used to make contact (proof) prints. Strips of negatives (made on polyester film, not paper) are sandwiched between photographic paper and a heavy glass contact-printing frame and exposed to light, usually from a photographic enlarger.

The development of the photocopier

The precise date of the invention of the photocopier, or "automatic copier," is difficult to determine historically, for several machines capable of reproducing originals were marketed during the 19th century. One, the Mimeograph, was invented by Thomas Alva Edison during the 1880s and marketed by a company called A.B. Dick in 1887. It used stencils cut from the master original. Another, although a slightly later introduction than Edison's machine, came from the French company Photostat in 1909. This machine used photographic paper to produce copies. However, in the context of the photocopier that we are all familiar with today – that is, a machine that can produce dry-paper copies using ordinary paper in a matter of seconds – the credit must go to the American patent attorney Chester F. Carlson.

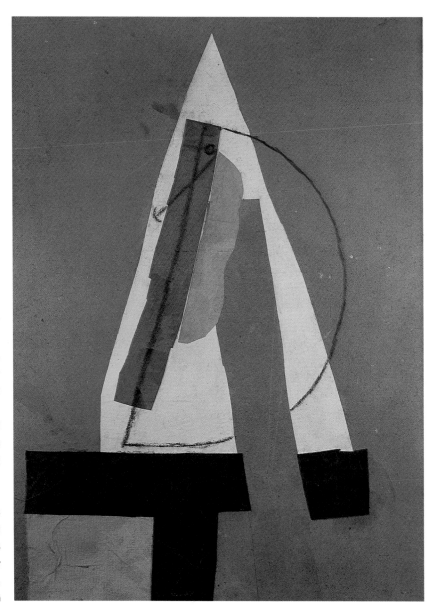

Above: The artist Pablo Picasso (1881-1973) explored the use of collage in his cubist imagery. This image, entitled **Head (collage),** *is made using a combination of paper and hand-drawn marks.*

Carlson's process, invented in 1938, involved the use of special metal plates that became photosensitive when they were given an electrostatic charge. An image was first exposed onto the photosensitive surface of the plate. Light areas of the original (where most light shone through) displaced the electrostatic charge on the metal, so that when powdered carbon toner was dusted onto the surface it adhered only to those areas that were still holding an electrostatic charge (representing the dark areas of the original). Ordinary dry paper, which had been given an opposite electrostatic charge, was next placed in direct contact with the pattern of toner adhering to the plate, and the toner was transferred onto the paper's surface. In the final stage, the toner was fixed to the paper's surface by subjecting it to heat, in a process known as fusing.

Carlson named his electro-photographic process "xerography," taken from the Greek words *xeros,* meaning "dry," and *grafein,* meaning "writing." This process was taken up by the American company Haloid, which later became the Haloid-Xerox Company. The first Haloid-xerographic copier, of the basic type we know today, was introduced in 1949. This was an enormous machine with a camera, a bellows and lens, and it required a complicated series of procedures to achieve the reproduction of an original image. Its size made it totally unsuitable for use in small offices. It was not until 1960 that Haloid-Xerox introduced the revolutionary model 914 that enabled the same original to be repeated on any number of plain sheets of paper. This placed it within the reach of small business offices, and it became widely used as a fast and cost-effective means of duplicating documents.

The first color photocopier was introduced by the 3M Company in 1968, with a machine called Color-in-Color. The Xerox 6500 followed several years later, using patented Xerox processes and colored toners. These toners were cyan, magenta, and yellow – the standard process colors that are used in color photographic and photomechanical printing.

During the 1980s, Canon introduced a revolutionary series of color copiers, including the C.L.C. 1 (unveiled in 1987), the world's first digital color copier using the three process colors and black.

Artistic applications

The importance and visual awareness of imagery became integrally linked with the rapid developments in printing and photographic technologies, particularly when these were linked with the vastly improved transportation and communications systems, which provided a much-enhanced consumer market for newspapers, posters, illustrated books, magazines, packaging, and product advertising. The availability and variety of printed material, especially in the form of photographs and graphic images, were to provide an infinite source of collage and montage material, a resource that was exploited by many of the art movements that are known for their "ready-made" imagery. These movements included the Cubists, Futurists, Dadaists, Surrealists, and, later, the Pop Artists and Post Modernists.

Cubism

Two major artists in the 1900s were to lend significant weight to collage as a serious art form: Pablo Picasso (1881-1973) and Georges Braque (1882-1963). In their paintings, Picasso and Braque used geometric space and structure rather than the application of heavy pigment to depict visual space, and their technique can be said to have heralded the beginnings of modern collage.

Braque's preoccupation with trying to define the visual space objects occupied by using geometric, three-dimensional shapes, rather than the painterly techniques of perspective and light and shade, led him to experiment with paper cut-outs, sand, newspaper, and cloth. Besides representing part of a landscape or object within a painting, the materials Braque employed had their own identity and exhibited their own physical and tactile qualities. These features extended the pictorial depth of his work.

Picasso used many real objects and materials in his paintings. He often mixed sand and other substances into his pigments to extend their range of colors and to enhance the physical properties bestowed on them when placed alongside other elements in his compositions. Pasted papers, overpainted with chalks and oils, were added, and he also incorporated patterned wallpapers and letter forms. Picasso also used junk or discarded objects in his collages. A good example of this technique is his *Glass of Absinthe,* made in 1914, which is a three-dimensional bronze assemblage cast from an original relief made of wax depicting a sugar lump balanced on a goblet.

Futurism

The visual power of collage and montage was widely adopted by the Futurists in their quest to undermine the social structure and status quo of the machine age, which had been brought about by the Industrial Revolution. Futurism was the first artistic movement to recognize the potential offered by the mass-communication technologies of photography, film, newspapers, magazines, and advances in telecommunications. Futurism provided a fresh source of inspiration, allowing artists to express their feelings in an art form that was related to and embraced this new world.

A principal Futurist who applied the medium of collage to his sculptures was Umberto Boccioni (1882-1916). Boccioni advocated the use of materials associated with everyday life, instead of the bronze and marble traditionally used for sculptures. His sculpture entitled *Head + House + Light* (1912) combined an

old iron gate with a plaster head. Boccioni also incorporated paper and newsprint in his paintings and drawings. Another Futurist, Gino Severini (1883-1966) was interested in the relief qualities produced when objects were glued to pictures. His picture entitled *Portrait of Marinetti* (1913) included half a false mustache and pieces of felt. In other images, Severini also used broken texts spread across the canvas.

The Russian experiments

The Russian Revolution of 1917 was a catalyst for radical change in Russian industrialized society, and montage was quickly adopted as a means of political propaganda. Photography was the perfect medium, and photomontage was a very real and powerful means of expressing ideas. This Agit-Prop art form was controlled by the Rosta – the Russian wire service – and many artists were given the opportunity to work on public collage art. As a result, many Russian towns and cities were plastered with enormous photomontages bearing slogans and propaganda in support of the Revolution.

In the 1920s, photomontage became an accessible medium in the field of Russian graphic arts, especially in association with books and magazines. Two artists in particular were to exploit photography and montage in very influential ways; these were El Lissitzky (1890-1941) and Alexander Rodchenko (1891-1956). Both experimented with various photographic techniques, Lissitzky exploring the possibilities afforded by distorting lenses, multiple exposures, and altered perspectives coupled with the deliberate blurring of images, while Rodchenko experimented with typographic elements and photocollage, particularly for book and magazine illustration.

Dadaism

The Dada movement had a profound effect on the expansion of collage as a vehicle for expressing opposition to the accepted attitudes of society. Collage provided an ideal medium for challenging pictorial conventions. The artist Marcel Duchamp (1887-1968) incorporated found objects, including junk, into his work. The most famous of these were his "ready-mades" (see p.14). Junk – discarded consumer trash or rubbish – now had a new identity as an art form under the umbrella of Dadaism. This notion of challenging established social values and aesthetics was not a new one, but Dadaism was to give collage a more powerful public voice in the form of posters, publications, and leaflets.

The Berlin Dadaists used photomontage as a tool of political propaganda – newspaper images became the perfect raw material for ridiculing political and social attitudes. John Heartfield (1891-1968) was a master exponent of this technique (see p.13). His technical skills in cutting and retouching fragments of photographs allowed him to create powerful illustrations which satirized Hitler and Nazism. The German magazine *Arbiter-Seating* published more than 200 of Heartfield's montages.

In Paris during the 1920s, Man Ray (1890-1977) was experimenting with photography to create his own imagery, rather than relying on clippings of existing photographs from printed sources. He discovered way of making random, chance occurrences in the spontaneous Dadaist tradition by creating "Rayographs" – images of unconnected objects such as pieces of pipe, eyeglasses, pieces of film, flowers, and other "light-sculpting" articles. These photographs, which later became known as photograms, were made simply by placing objects in direct contact with light-sensitive photographic paper and exposing them to a light source. Light would pass through transparent or translucent objects to varying degrees, or be blocked completely by anything opaque to leave a curious silhouette shape around it (see p.114).

Kurt Schwitters (1887-1948) is renowned for his use of collage and assemblage in his work. His collages became known as "Merz" constructions and were made from discarded materials, bric-a-brac, and junk. The word "Merz" was taken from a fragment of a newspaper clipping that he incorporated into one of his early collages. This discovered material was absorbed into Schwitters' collages and constructions as he explored new ways to express the power of the human spirit. In 1923 he began constructing his masterwork – *Kathedrale des Erotischen Elends* ("Cathedral of Erotic Misery") – which took ten years to finish but was tragically destroyed during World War II.

Surrealism

The advent of Surrealism was a most significant development for montage techniques. Montage, with its chance combinations of disparate elements, both physical and on a two-dimensional plane, provided a rich source for the exploration of Fantasy Art – the visual interpretation of dreams and hallucinations. Individual images with no apparent connection could be made to relate through subconscious connotations under the flag of Surrealism.

Joseph Cornell (1903-1972) created box constructions containing a vast array of everyday objects. These "poetic works" stemmed from Cornell's fascination with science and mysticism – a constant source of reference to try to clarify his own daily experiences – and provided the basis for his object collages. Objects were combined to provide impetus for fresh associations gleaned from Cornell's obsessional interests in reading, poetry, dance, and music, and he set them in boxes for future contemplation and, often, change.

Photography played an important part in the Surrealist movement. A photograph is supposed to be a true representation of what it records – that of light falling on three-dimensional forms. It sees as we do. Or does it? It is a fact

Right: Kurt Schwitters, who was renowned for his extensive use of collage, utilized discarded materials and assorted printed ephemera for his "Merz" constructions. This piece, entitled Collage M2 439, *was produced in 1922.*

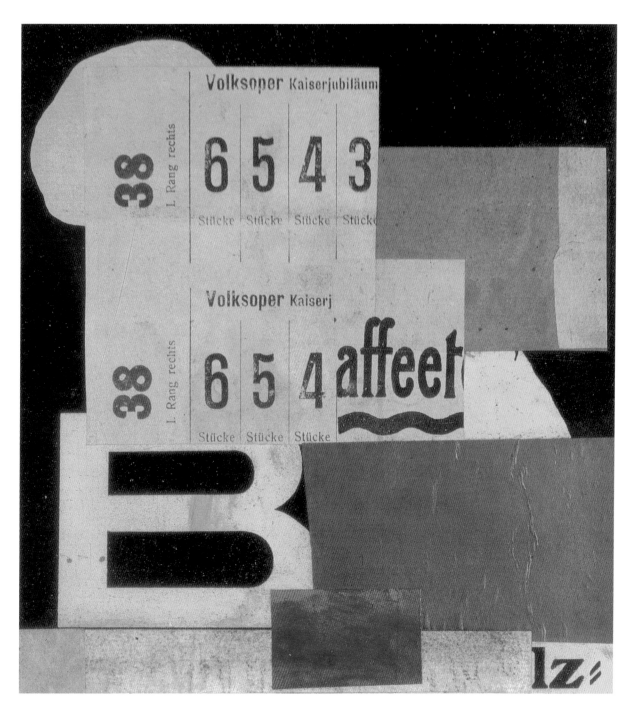

that photographs can be manipulated in such a way that they convincingly distort the truth; indeed they can even be made to appear to create and fabricate truth. In this, it is possible to see the aptness of montage for Surrealist art. Through the medium of photography, Surrealists were able to allow images to exist simultaneously in situations that could not exist in real time and space, recreating the magical, mysterious world of the subconscious. The medium of photography had the scope to produce images that could fabricate situations and document them in such a way as though they were, and always had been, in existence, with the photograph itself being a recognized form of historical proof.

The Surrealists were to investigate fully the avenues of photography as an expressive medium: photograms (cameraless images pioneered by Man Ray's

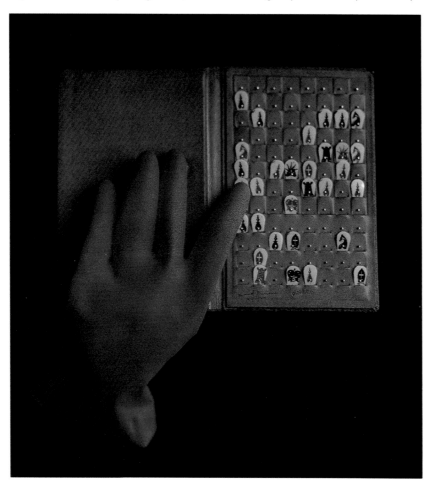

Rayograms), solarizations (briefly exposing a print to light partway through its development to create a curious negative/positive effect in some parts of the image), negative printing, double exposures, multiple combination printing (in which negatives are sandwiched together and printed as one onto a single piece of paper), images made by distorting the surface of photographic film by subjecting it to heat, and photocollage. However, the physical cut and paste of photocollage often destroyed the "seamless" effect that the darkroom processes produced with such credibility, thus preserving "photographic truth."

Abstract Expressionism

After the Second World War, collage as an art medium was liberated by the artists of the Abstract Expressionism movement. The use of involuntary action was the nucleus of their art, and "action painting" was seen as a revolt against the earlier pictorial compositions of the Surrealists. Extraneous "outsider" materials were not regarded as an alternative to paint, but rather combined and fused with it. An example of this art concept can be seen in the work of the contemporary Spanish artist Antonio Tàpies (born 1923) and his mixed-media paintings. In one such image, *Fons-forma*, created in 1985, the artist's own slippers are found on the canvas combined with cloth and thick paint.

The German artist Anslem Kieffer (born 1945) often combines objects (lead fragments and clay and other natural forms) and his manipulated photographs of geographical views and structures (cloud formations, rocks, water, cityscapes) with paint media.

Pop Art

Beginning in the mid-1950s and blossoming in the 1960s, the Pop Art movement also exploited the collage medium, particularly in its use of kitsch and trivia images derived from such "found material" as photographs and grocery packaging. The consumer-oriented world, with its popular mass-media cultures of cinema, television, newspapers, fashion, and advertising, provided a plethora of material to be assembled and reconstituted as powerful visual art forms. In Britain, such artists as Eduardo Paolozzi, Richard Hamilton, and Peter Blake were active participants from the early days of the movement.

The work of Eduardo Paolozzi (born 1924) embraced many art processes, and, as with many artists, he cannot easily be classified as belonging to any one specific art movement. Along with printmaking and sculpture, collage and assemblage play central roles in his creations. In a series of collages from 1946, Paolozzi integrated machine parts with museum prints and sculpture friezes, producing strange half-man/half-animal machine hybrids. In another series, Paolozzi made a series of magazine collage portraits. These composites were made from issues of *Time*, incorporating portraits and other found images.

In the United States in the mid-1960s, such prominent artists as Andy Warhol (1931-1987) were also exploring the imagery to be found on popular consumer packaging and that connected with pop stardom and cult personalities. Robert Rauschenberg (born 1925) is one of America's most prolific living artists. Rauschenberg has always felt a fascination for – and his work is rooted in – the found object in combination with the gestural power of paint media. This can be seen in his early paintings, which explore the themes of colors and textures in association with dense collages made up of a variety of materials.

Post Modernism

The use of found and existing imagery achieved new expression in the U.S. in the late 1970s with the rise of Post Modernism – a concept that is still being explored by artists today. As with the Pop Artists, the inspiration for much Post-Modernist work is the media, including product advertising, window displays and packaging, television, films, and books. The use of existing imagery is not a new concept, but unlike artists such as John Heartfield, who made collages of photographic imagery to make satirical or propaganda points, Post-Modernists such as Sherrie Levine and Richard Prince choose other avenues to explore.

For Sherrie Levine (born 1947), it is the very nature of the reproduction of a photograph that provides her with subject matter. The limited edition print and modern techniques of reproducing existing images, such as posters and images in books, distance the artist from the reprinted form. The reproduction is similar, but not the same as, the original. This is the case with many of her images. Levine photographs the reproduced photograph and represents it in a slightly different form by using different devices such as scale, color, surface texture, or the resolution, or sharpness, of the image. Her signature deliberately questions the authorship and originality of the image, providing a clear example of an appropriated image represented in a new context.

In conclusion

Photography, the plain paper photocopier, and the flood of printed material from magazines, books, posters, product packaging, leaflets, and brochures have produced a wealth of material that has immeasurably extended the techniques of montage and collage. The technical processes that produce this imagery have had a major influence on contemporary design and packaging. A brief visit to a bookstore will reveal a wide range of jacket designs that have been created using collage techniques, many as a result of the development and accessibility of color photocopiers. The ability to describe several aspects of a book on its front cover produces visual power and content information as a single unity. The effect is synergistic, with the combined effect of the design being far more arresting than that of the individual elements that go to make it up.

Left: Although made in 1943, after the Dada movement, this collage by Marcel Duchamp, entitled Pocket Chess Set with Rubber Glove, *embodies much of the Data aesthetic.*

Below: Artist Raoul Hausmann's paper collage, which he entitled The Art Critic, *is an early example of Dadaist photomontage. It was made in 1919.*

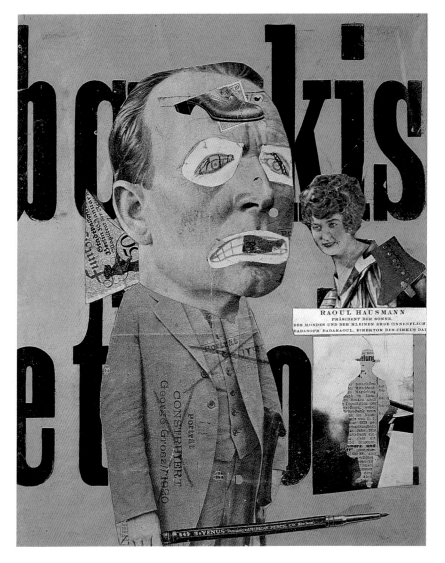

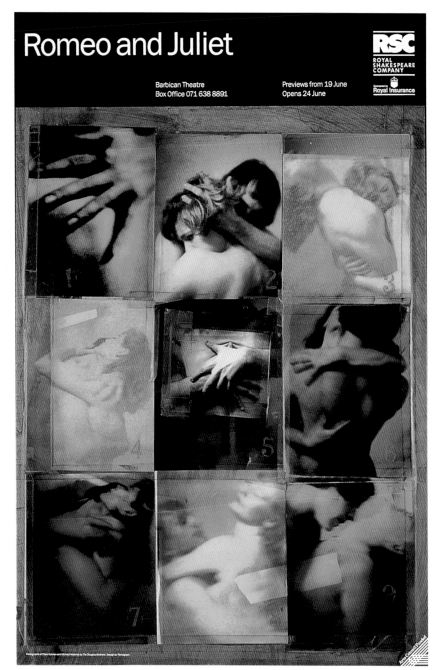

Far left: Photographic manipulations were used to distort these images and suggest the theme of passion in the play. (Douglas Brothers)

Left: A variety of different objects were combined to produce this assemblage for the cover of a book. The artist, Russell Mills, produced it in collaboration with the designer Vaughan Oliver and the photographer David Buckland. (Russell Mills)

Right: Black and white photocopies taken from 60-year-old tools and equipment manuals were manipulated using photographic technology to create a mechanical appearance. (Dan Fern)

VLADIMIR ASHKENAZY

DECCA

DIGITAL

ROYAL PHILHARMONIC ORCHESTRA

SYMPHONIES 1 & 6

1

6

SHOSTAKOVICH

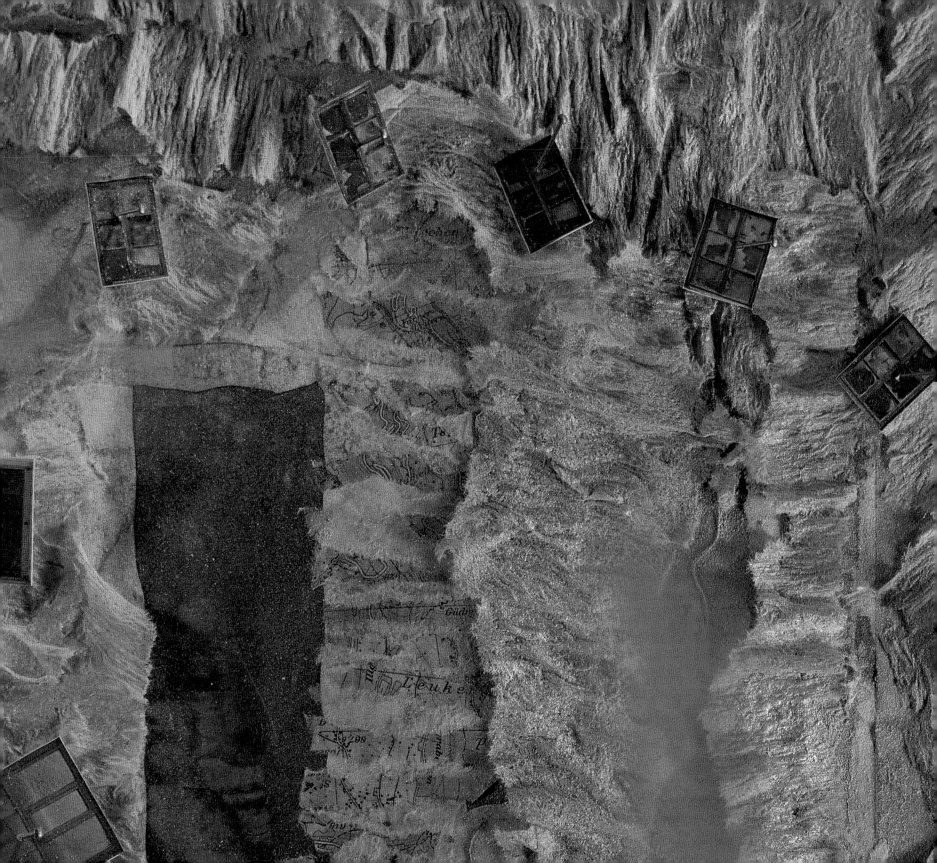

Paper

Paper montages are made from collected source materials. These usually consist of different types of paper and printed material like banknotes, tickets and labels, used in their original form (they have not been duplicated or manipulated by photocopiers or cameras). Because of this, the images have a particular clarity and strength. This is in part due to the fact that the artist takes a creative risk when gluing each element into the montage since if a mistake is made that item becomes irretrievable. Unlike mechanical montages, where an important part of the artistic impetus lies in the manipulation of the original, in paper montage found material, and the artist's response to it, is at the heart of the creative process.

The paper section examines the methods you can use to assemble a collage or montage – from the joining of two different types of paper to the intriguing construction of three-dimensional artworks. It also covers the application of a whole range of manufactured and natural materials which lend themselves perfectly to collage-making. Many of these are readily available and range from bus tickets and envelopes to rice paper, newspapers and leaves.

The beauty of working with paper by-products stems from their age and their sentimental value. Sometime there is no logical reason why you are drawn to such things – they simply have a special aura that makes them compelling. In the same way, the creation of a collage is also fascinating since the placing of one element against another creates unexpected nuances that are otherwise unobtainable. The advantage of working in this medium is that if you are dissatisfied with the results, you can simply remove an element and replace it with another. For me, this was the primary attraction of working with collage. I wanted to create images in a way that allowed for flexibility; collage gave me the freedom to change my mind at any point in the long process of picture-making.

Design

Approach

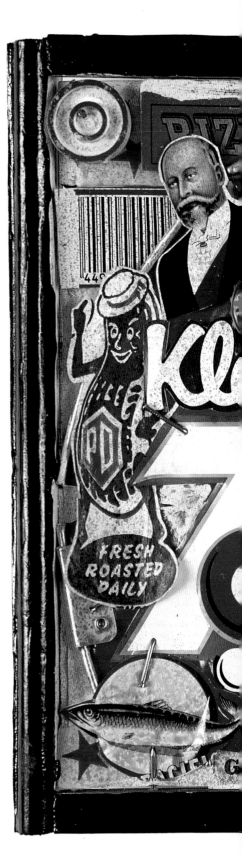

Previous page: Repetition Scattered Like Mountains. (Steve Wallace)

Below: This paper collage, part of the Akantchen series, was created from assorted travel ephemera, including Czechoslovakian alphabet letters, café receipts from Holland, and collected travel documents. (Dan Fern)

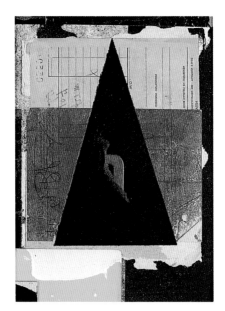

Right: The eclectic Brand Names *was originally commissioned to illustrate a feature article.* (Archer/Quinnell)

You should find the process of collecting the "raw" materials for collage very enjoyable, as it enables you to indulge in your interests and obsessions. For example, Dan Fern is fascinated by graphic forms – numbers, diagrams, typography, and geometry – and these form the basis of all his images. His early interest in stamp-collecting has led to an enthusiasm for the whole process of the worldwide postal system – franking marks, envelopes, different packaging papers, and hand-written marks – which has become a rich source of inspiration for his work: "Things which arrived through the mail were linked with a world which was unknown and fascinating." Fern finds that collecting printed matter offers infinite choice and the opportunity for the chance discovery of rich new imagery. Even the very nature of storing raw materials – which he packs into flat files – allows for a random pre-arrangement of elements that may inspire a new composition. "There is a very obvious link . . . between what you collect and how you keep and store it . . . in that in one plan chest [flat file] . . . the top two drawers are full of wooden type and then the third drawer down is full of a collection of envelopes from India and Afghanistan." Fern also finds that the structure of collage allows him to produce a sequence of images that follow the same theme. Such a series, which can be created over a number of years, sometimes totals more than 20 images. This method of working can prevent individual pictures from becoming too crowded and overworked because a series of images can provide visual "breathing spaces" in the same way that punctuation marks allow the reader to make sense of individual words.

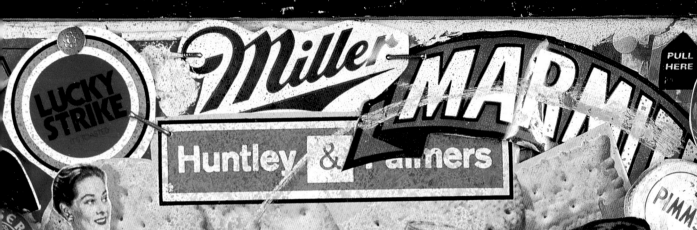

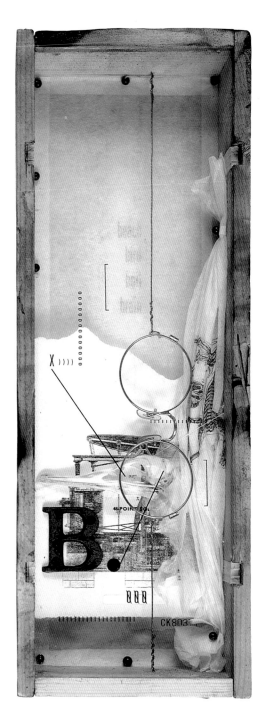

The creation of montages can grow out of an artist's collection of objects. Magda Archer and Peter Quinnell have accumulated a vast selection, many of which have a nostalgic or Pop Art aspect and include the bright graphics found on packaging – from matchboxes to wrappings. For Archer/Quinnell, the objects themselves are the primary source of interest. Often they prefer to incorporate in a montage items that have been discarded by someone else, instead of those that they have bought from a market, since, in the former case, "the pieces have already been selected by someone else for you to choose." And once the objects are fixed within one of their collages, they are "passed on" for someone else to buy.

Artists generally create a montage by deciding on a starting point – this may be shape, color, form, or a particular theme or experience such as travel. Christopher Corr draws his inspiration from "the human quality of paper," and in his search for materials and ideas he takes long trips to India and China, where he collects unusual paper of all kinds. For example, in Rajasthan he found a paper made from cotton rags that had the quality of cloth. Curiosity prevails n his quest for new materials – papers, labels, posters, tickets, and cards fill sketchbook after sketchbook. Invaluable reference material, they are personal diaries of a particular time, journey, or event, preserved through collage.

Travel not only provides a source of pure inspiration for artists, it can also play a major role in the approach to visual ideas. For example, commonplace objects often have a different sense of importance placed upon them in an unfamiliar society – their function and value may differ. Everyday objects and activities are imbued with a fresh excitement and curiosity. It is for these reasons that travel interests the artist David Blamey. What becomes immediately noticeable to Blamey are all the things that we take for granted in our own society. In the same way that you might isolate a familiar object and combine it with unexpected elements or place it in unfamiliar surroundings in order to change its interpretation, so the mind of the traveler is affected when he or she is transported into an alien culture. If an object, when considered *in situ*, holds an aura or power, that particular item is immediately identified and collected by Blamey: "I won't pick things up ad-hoc and then try and invest relevance in them later on, I will only use them if I identify a relevance as they are in use, in life."

Another design approach focuses on the process of constructing the collage itself. For example, Andrew Hirniak's work incorporates found images and textures, but his principle interest in montage is the way in which he assembles the image as a three-dimensional piece, carefully considering each element for its spatial qualities. Hirniak constructs his montages from old medical and scientific equipment, choosing articles that have "either gone through some

Left: A pair of spectacles, a bird skull, metal type, dry transfers, a fluorescent tube, and a combination of different papers, pieces of wood, plastic, and glass were collected and housed in a three-dimensional box collage construction. While the discovery of the spectacles provided the starting point for the structure, the bird's skull is the main point of focus, and the other elements were selected to enhance it.

The long diagrammatic arrows are designed to provide a visual reference point for the eye to follow. They appear to intersect the different surfaces of the selected objects and highlight the spacing and opacity of the articles they pass over, under, and through.
(Andrew Hirniak)

Below: Lemon Doctor *is a mixed-media construction incorporating plastic lemons, a printed label, nails, a wooden frame, and protective glass.* (Archer/Quinnell)

Right: A mixed-media construction that includes a metal sign, buttons, pins, a plastic skeleton, a chilli, painted wood, and glass, entitled Voodoo Chilli. (Archer/Quinnell)

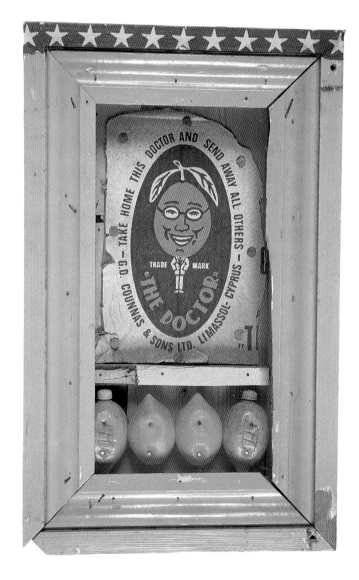

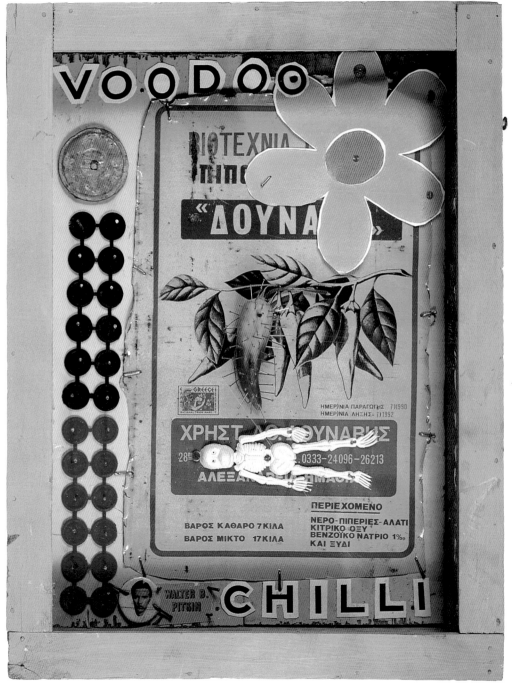

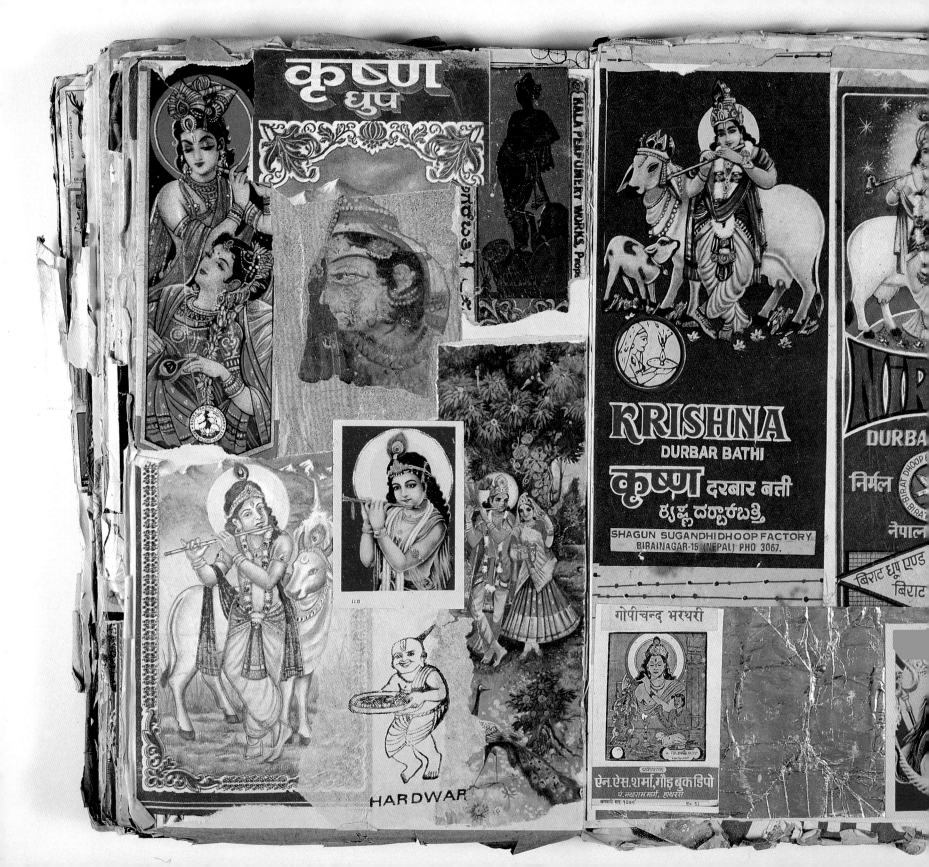

Left: Pages from India Scrap Book, *made during a journey through Northern India in 1986. The collection forms an invaluable reference book and a personal diary of the artist's travels.*
This spread is entitled Lord Krishna *and is made from a variety of found matter, including religious imagery, incense packaging, holy pictures, and gold paper.*
(Christopher Corr)

Right: A page from a Bookwork mixed-media project, entitled Day in, Day in, *started in 1989 and still in progress.*

Images come together from a variety of sources – such as snippets of news, a death in the family, or even the circumference of an ice-cream scoop – and these provide a starting point for each of the artist's drawings.

Every page follows in sequence, and many individual drawings function only when they are seen in context.

This epic work now fills hundreds of pages and represents "one person's tiny presence in a particular period of time."
(David Blamey)

of Paper

Below: This detail from
H, Z, E represents
two of the artist's most
personal obsessions:
stamp collecting and his
love for his children
(the letters are the initials
of their names). He also
incorporated some rare
pre-perforation "Indian
Feudal States" stamps.
(Dan Fern)

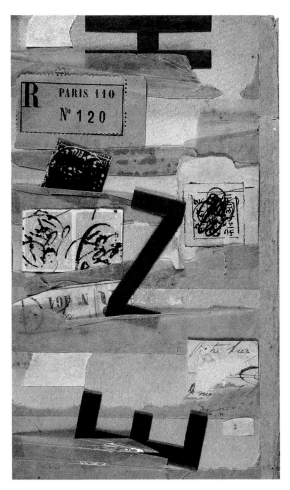

Paper is usually made up of a thin tissue of vegetable fibers called cellulose which contains insoluble coloring substances that have to be chemically bleached out to produce the "white" material that we recognize. The invention of paper is historically credited to a Chinese minister, T'sai Lun, in A.D. 105. Prior to this, the Ancient Egyptians made sheets of writing material by gluing together strips of papyrus, then flattening them out with stones to produce a smooth surface.

Paper is one of the most versatile collage materials because of its physical properties. However, its very nature is paradoxical: it appears to be fragile yet it can also be quite strong; it surrenders to fire and water but at the same time it can be adapted to withstand them; it can be manipulated to resemble many forms by molding and painting; and, in the form of documents, it can preserve history over many centuries. Paper can be discarded without a second thought or it can be protected in a museum-controlled environment for years to come. The surface of a single sheet can be radically altered in a variety of ways: by crunching it and flattening it out again, by folding it to create multiple planes, by cutting or tearing it, by fixing it to another surface, by pasting materials onto it, or by decorating it with paints. In fact, whatever you do to paper will alter its very nature; this flexibility is its greatest asset and the reason why paper is the central component in collage-making.

Very thin paper is usually semi-transparent and can therefore be laid over opaque types to create interesting effects, since the paper underneath will "bleed" through. A paper's age can suggest emotive or nostalgic connotations as paper

Right: Two from a series of more than 50 postcards that were made from a variety of found images and printed ephemera and glued onto wood.

The two artists work as a pair, and fun and comedy are a central part of their imagery.

The use of typography is a crucial element in the work of these two artists, sometimes providing the starting point for an image or the title theme for a whole series of illustrations. Letters are incorporated for their shape as well as for their language.
(Archer/Quinnell)

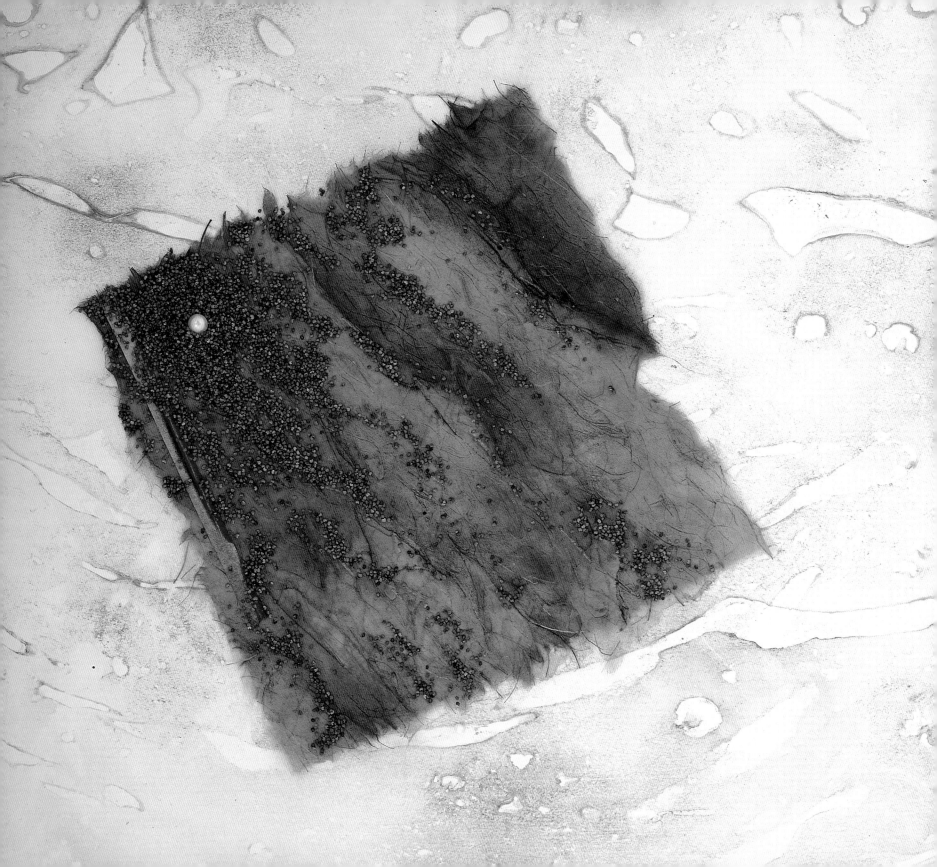

retains its own particular history and can give the artwork a very particular mood. You can find aged paper in the end pages of old books. (A word of caution: old paper can be brittle and may not tear or cut as smoothly as new would.) Newsprint, which yellows rapidly when exposed to bright sunlight, is an inexpensive alternative if you need large quantities of "old" paper.

Tissue papers have a unique translucency that makes them ideal for collage. They are available in different grades – from the basic bathroom kind to expensive Japanese tissue. Japanese tissue and Indian papers often have grains, flowers, plant strands, and other natural forms encapsulated into their surfaces, and these can give an image extra dimensions. When tissue paper is pasted to another surface its translucence allows the surface below to "seep" through in a muted version of the original. Often tissue glues so well to another surface that it becomes invisible, while the surface below is transformed into a new texture with a gossamer-like sheen to it. Tissue comes in a spectrum of different shades which can be blended together by layering different colors. And its transparency can be exploited to selectively obscure particular elements within the collage, thus creating additional surfaces, textures, and nuances. Some colors are more lightfast than others, and faded colors offer further potential. You can strengthen and protect tissue by covering its surface with acrylic medium or paper varnish. Tissue wrinkles easily when it is wet, and the colors are occasionally prone to running into each other. Both qualities offer unexpected results: new surfaces, color blending and fresh associations which can add to the excitement of collage-making. Available in many sizes, weights, surfaces, and colors, pre-printed papers offer just as much potential as tissue. The choice of such papers is enormous and ultimately depends upon your own personal preference. Some practicalities, such as lightfastness and price, are worth considering.

Paper also has other associations, particularly when it is used as a form of mass communication. Newspapers and magazines are filled with potential collage material – from photographs and letter forms to diagrams and drawings. Consumer packaging offers further collage pickings. These ready-made, pre-printed images hold multifarious connotations and provide new associations when they are combined in a collage. Without any need for alteration, they offer a huge choice of color and subject matter which is otherwise available only if you have extensive resources to photograph and to reproduce. However, the copyright of these original images rests with the photographer, artist, writer, magazine, or publisher that produced them, so select such imagery carefully. Direct plagiarism is illegal, and although the very nature of collage often relies on your choosing such imagery, many artists often distort the meaning of these images by altering them physically until they are given a new identity.

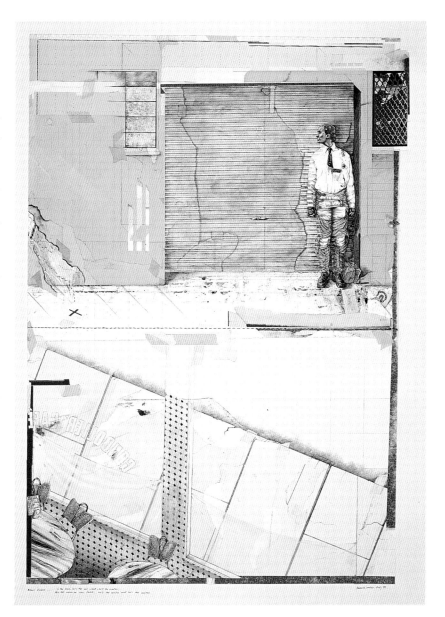

Left: Album cover artwork for The Pearl *by Brian Eno and Harold Budd. Japanese rag paper, poppy seeds, and a pearl were combined on a melamine board to make this collage. (Russell Mills)*

Above: Blank Frank *forms part of the artist's* More Dark than Shark *series. (Russell Mills)*

Manipulating paper

*B*efore you incorporate your collected source material into your collage, you will usually want to manipulate its size and shape. Unless you decide to use your collage element as a whole piece, there are three methods of manually altering its shape and size: cutting, tearing, or folding. Each method will produce a different finish, and your choice will depend both on the effect you want to achieve and on the materials you are working with. Cutting produces a sharp, crisp edge which can be effectively juxtaposed with a softer torn edge in your collage design. The main advantage of this method is that it allows you to "edit" an image by removing any unwanted areas – for example, you can accurately cut out a detail from your image using a craft knife and incorporate this portion into your design. Tearing produces a rough, white torn edge (depending on the color of the underside of the material) as the paper's inner layers become visible. You can either tear paper by hand to create an abstract shape or use a ruler as a guideline to produce a more "controlled" tear. Another method of manipulating paper is to fold it to order to produce a relief appearance.

The equipment that you will need for working with paper is readily available and, in most cases, very simple to use. Obtain sharp scissors and craft knife blades for cutting papers. A short, thick blade is more suitable for cutting heavy papers, where firm pressure has to be applied without fear of breaking the blade, whereas a narrow, finer blade is excellent for cutting out or around small details and trimming of unwanted areas once the collage begins to take shape. Craft knives are available with a wide choice of blades from art stores. However, the blades do tend to blunt quickly and therefore need to be replaced frequently. Always exercise extreme care when using them, as the razor-sharp blades are brittle and the finer ones have a habit of snapping when too much pressure is applied. Scissors are just as useful as blades for cutting out shapes, and they are much safer to use. However, they are not the best tool for carrying out very delicate cuts. Another useful piece of equipment is a safety ruler, which has a protective edge to prevent your blade from skidding across the ruler's edge. While tearing is often best done by hand, you could use a ruler to achieve a very clean, straight tear (plastic rulers give more accurate positioning than wooden types).

Cutting mats, which are non-cut self-sealing rubber surfaces, provide stability and a cushion for the fine point of the blade as it passes through the paper, thus prolonging the life of the blade. The main advantage of a cutting mat is that it always gives a very clean cut, as it prevents the blade from dragging across the surface – any previous cut marks are absorbed by the mat and reseal themselves to provide a smooth cutting surface. (If you use a piece of cardboard as a cutting board, any cut marks in its surface will snare the blade when it passes over the surface, thus blunting the blade and affecting the quality of the result.)

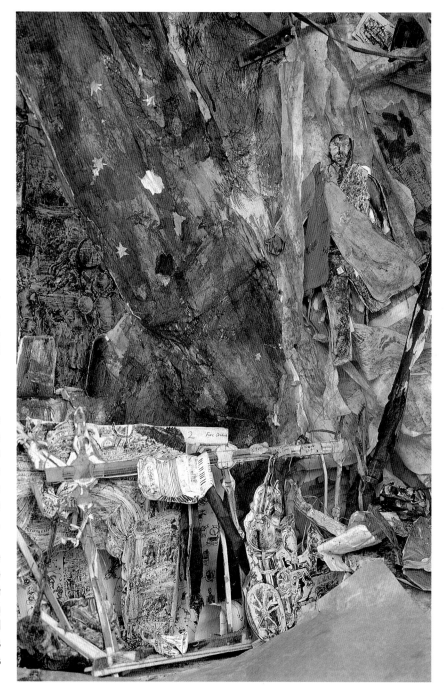

David Loftus "edits" the printed matter for his collages by cutting and tearing small details from existing images (see far right and right). Using a sharp knife or his fingernails, he cuts or tears tiny fragments from banknotes, maps, and postage stamps and collages the resulting elements together. This "editorial" process can produce diverse results. While a craft knife will create a precise razor-sharp outline, a fingernail tear will result in an uneven, jagged edge. When he assembles the elements together, Loftus offsets the torn elements against the rigidity of the cut elements – the detail of the ships (far right) is made entirely from knife-cut elements. Loftus works to a very tiny scale – his images are sometimes no bigger than 2½ inches square. The image on the far right measures 7 x 3½ inches.

Jon Boatfield works in an entirely different way from that of David Loftus. His images are produced on an immense scale – he began "Chaos and Old Night" (see left and right) in 1986, but continued to develop it into the 1990s. It currently measures 18 feet wide by 12 feet high, although its size can be changed as new elements are added. Boatfield produces his "environments" principally from ordinary packaging – anything "that comes into the house by natural means" – for example, butcher's paper, cereal boxes, and food containers. He folds or glues the pieces in place (see left) or suspends them from another piece (see right). The nature of the paper he selects is crucial to his design – for example, its natural tendency to curl gives weight and presence to his "environment."

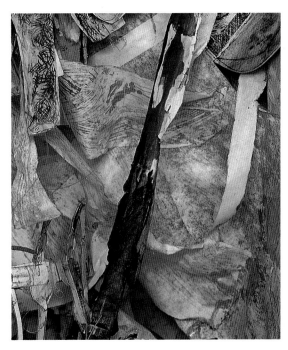

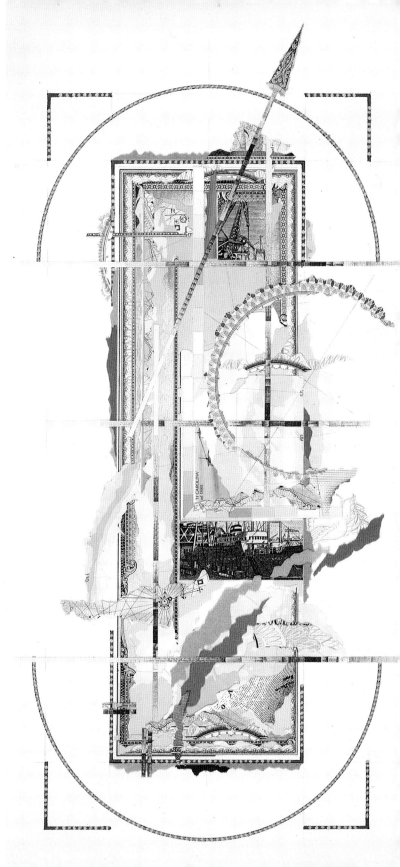

Glues and *Adhesives*

*Previous page: Taken from the **Fratres** series, this detail was inspired by a piece of music by the Estonian composer Avor Pärt. The image was bound in strips of tape and mounted onto the reverse of a cloth-backed map. (Dan Fern)*

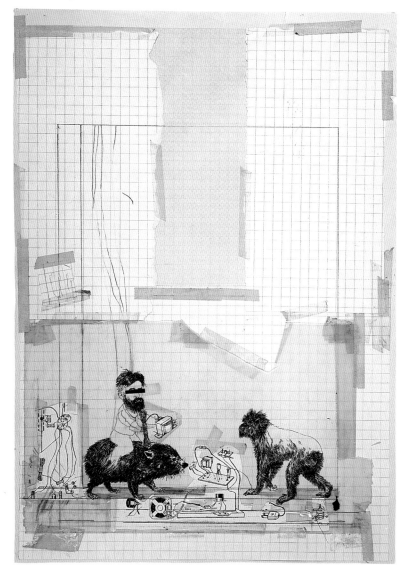

*Y*ou may find the range of proprietary glues and adhesives on the market bewildering at first. However, careful examination of their individual uses soon pinpoints those that are most suitable for working with paper. Your choice of glue will depend on the type of paper or material that you are working with and the matboard or illustration board on which your collage is assembled. For example, if you are using a thin matboard – the type of board used to make a window mat for framing a picture – as a backing for your collage, a heavily water-based adhesive, such as wallpaper paste, would be unsuitable. This is because the paste will saturate the board, which will begin to warp as the collage dries.

Spray adhesives are designed for use with boards of various kinds. However, aerosol products are highly flammable, so you should always exercise extreme care when using them. There are also indications that inhaling such products can lead to health problems, and therefore aerosol glues are banned in some countries. If you can buy aerosol products you should take stringent safety precautions – never use them near a naked flame; always use a "spraybooth" (which ensures ventilation and removes any harmful solvents), or work near an open window with lots of newspaper as a base for spraying on; clear the nozzle regularly by holding the can upside down and spraying; and always apply a firm pressure when sticking down the individual collage pieces. Spray adhesives provide a very fast and convenient method of gluing and are also "repositionable" (if you are unhappy with the position of your piece you can reposition it elsewhere).

However, if you reposition your piece too many times the adhesive is likely to dry out, becoming unusable or at least non-permanent. In hot environments spray glues tend to dry out very quickly, so it is important that you work fast and that you apply a firm pressure in order to obtain good results. A small roller is an ideal tool for pressing the pieces firmly in place, but make sure that you keep it clean to avoid spreading excess glue over other parts of the collage. A special cleaning fluid designed to remove this type of glue is available, but if you can't find this product, lighter fuel or mineral spirits will serve the purpose equally well.

Glue sticks are also suitable for attaching small pieces to thin boards and the glue is washable and non-toxic. White glue is another non-toxic glue; it can be removed easily by rubbing it when it is dry. However, this glue dries invisibly and is therefore difficult to notice when you are cleaning up your finished collage. If you don't remove it at this stage, unsightly yellow marks are likely to appear where the excess glue has been exposed to the air and light. White glue must be used sparingly on thin boards, as it can cause warping.

Provided that you use a suitably sturdy board, wallpaper pastes are very useful (and inexpensive) when working with large sheets of paper and color or black and white photocopies, as they always give a very smooth surface. Plywood or multi-density fiberboard (M.D.F.) are the most appropriate backing boards for use with wallpaper paste; they are available in a variety of thicknesses to suit your needs. Avoid using thin hardboard (the kind used to back framed pictures), which is apt to warp if it becomes oversoaked with glue. Water-soluble glues, such as wallpaper paste, are ideal for use with photocopies, whereas spray adhesives are apt to remove the surface of thermal-bonded papers. Keep the surface of your collage clean at all times, and remove excess glue with a clean cloth.

Rubber cement is particularly suitable for fixing fragile papers such as tissue paper, as it provides a transparent join and will not cause the dyes in the tissue to run, which can happen with water-based glues. Make sure that you rub off any excess cement when it is drying as it is prone to yellowing. Latex decorating paint, gel media, and pastes are also useful compounds for working with collage. Gel medium allows granular substances such as sand to adhere invisibly to collage surfaces, while latex paint can be painted over the whole collage surface to provide an invisible film that seals the image and provides a degree of protection.

Tapes provide another alternative to glues, offering different advantages: they can be incorporated naturally into your design so that the joins become part of the collage. Masking, or drafting, tape and invisible tape are two good examples, while double-coated tape and garden tape are also potential "fixers." Each type has its own surface quality, so it is important that you consider the overall look of your collage before you make your choice.

Left: **Animal Experiments** *reveals the effect that age can have on your work – this image was made more than 20 years ago. The transparent and masking or* drafting tape that holds the elements of the collage in place has started to deteriorate, giving the piece a sense of mystery. *(Terry Dowling)*

Below: 20 years of exposure to light has caused the glue that seals **Two Chairs and a Car/The Wearing of Smart Suits** *to turn yellow. (Terry Dowling)*

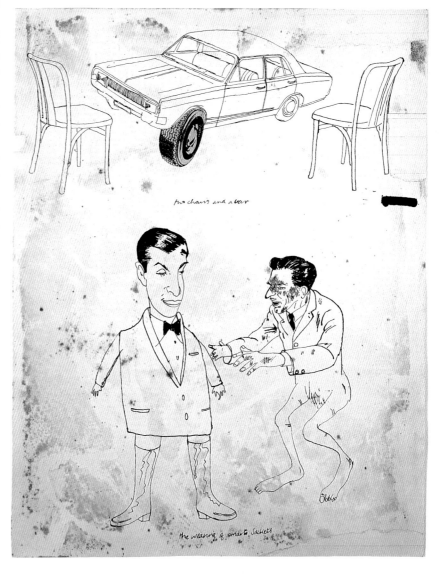

two chairs and a car

the wearing of smart Jackets

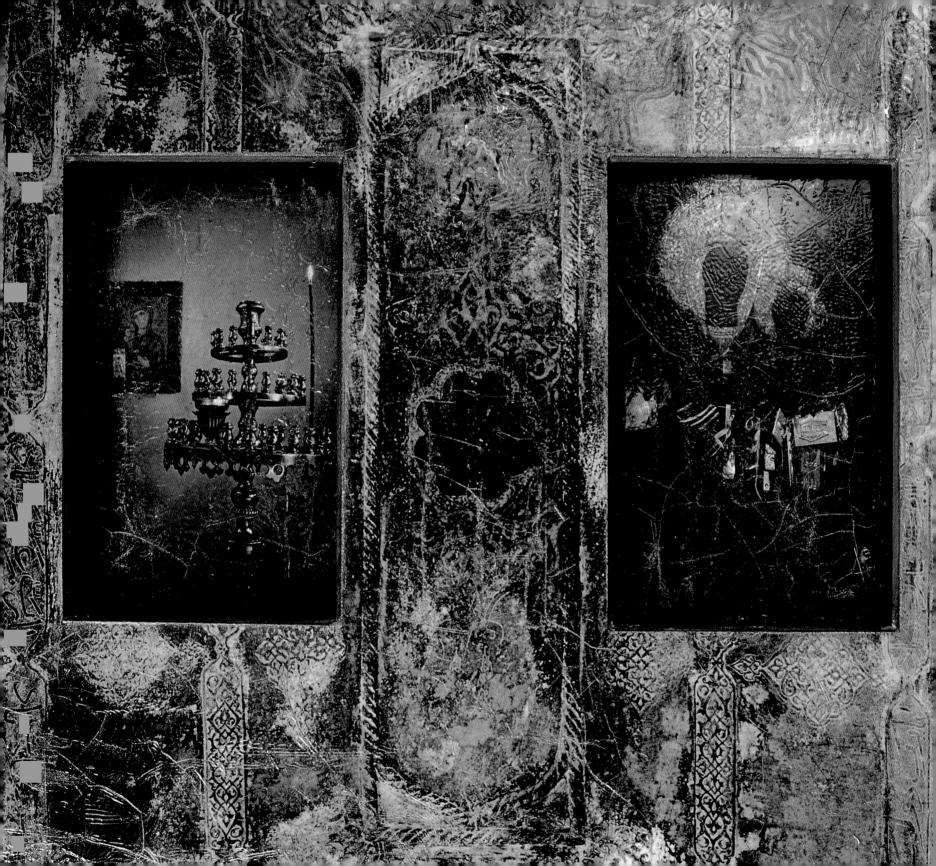

Color and
Varnishes

*C*oloring agents can be applied to the collage at any stage, depending on your desired effect. Such "agents" are very varied and include pencils, charcoals, inks (spirit- and water-based), paint powders, poster paints, oil and acrylic paints, latex paints, textured paints, paper and cloth dyes, marker pens, colored varnishes, and acrylic gel media, to name but a few. Always take extreme care when you are applying additional color to your montage, as some brands may dissolve or discolor previous layers of glue, thus causing parts of the image to dislodge. Also, elements of the collage may absorb too much of this applied color and cause the original color to bleed, or, at worst, dissolve. Mistakes often occur, and coloring agents with very strong pigments may be impossible to remove once they have been painted onto the surface, thus wrecking the image. Having said this, many interesting effects can be achieved by mixing different media, as the images displayed throughout this book clearly demonstrate.

There are various products on the market that can be used to enhance and protect the surface of your image once you have assembled your collage and once all the elements are in their final position. Varnishes come in many different forms and not only change the quality of the image but also seal the collage and protect it. They are available in matte, semi-matte, and gloss finish, and you can apply them either with a brush or as a spray. Some varnishes give the collage an "aged" quality, which can be very alluring, while others have a strong coloring agent within the varnish which will affect the whole of the image if it is applied uniformly (it may be better to coat only parts of the image to highlight or subdue particular elements).

There is a varnish that produces a "cracked" finish over the surface of your image that is very similar in appearance to that of an "old master's" oil painting, where the paint has aged and cracked. This varnish is available in two parts: *vernis à vieillir* (aging varnish) and *vernis à craqueler* (crackle varnish). Both are applied to the surface of the image and, depending on the order in which they are applied and on the room temperature at which they are left to dry, can produce very different results. The secret lies in the fact that one is water-based, while the other is spirit-based. The spirit-based varnish dries faster than the water-based varnish and this causes the surface to swell and crack. The final result is often stunning and unexpected, but you will probably need to experiment beforehand in order to produce accurate results.

Left: Genuflection was created from two photographs, a piece of wood, a sheet of glass, and a color photocopy of a Turkish manuscript. These elements were painted with crackle varnish and gold leaf to give them an aged finish. (Simon Larbalestier)

Above: Crackle varnish was applied to the surface of this detail of Deesis to give it an aged, distressed appearance, like that of an old icon. The damp, varnished surface was then coated with sealing wax and gold leaf to complete the antiqued look. (Simon Larbalestier)

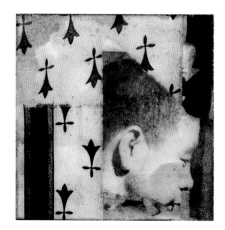

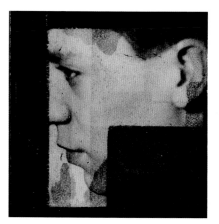

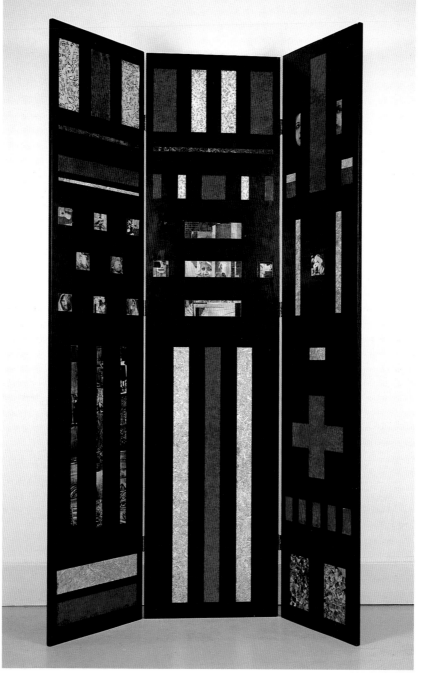

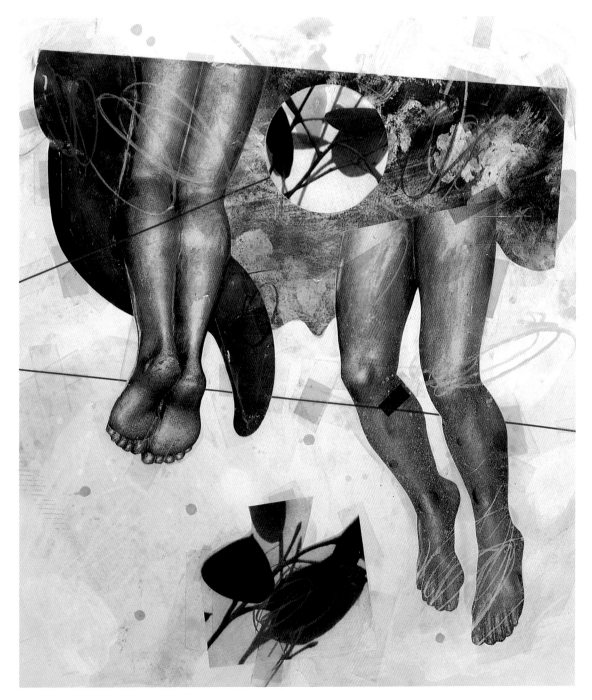

Left: Photographs, varnish, newsprint, and watercolor paint were used to embellish this large wooden screen. The small details shown opposite reveal the unusual finishes and effects that the artist has applied. He coated the photographs with varnish and the newspaper cuttings with a watercolor and varnish wash. (Richard Caldicott)

Left: Commissioned by the English National Opera, Ariadne on Naxos was created from wax, spray paint, photographs, crayon, varnish, and transparent tape. The image needed a classical appearance to reflect the mood of the opera, so varnish was dripped over it to evoke a sense of texture akin to the effect of a painted surface. (Dirk Van Dooren)

Mark-Making

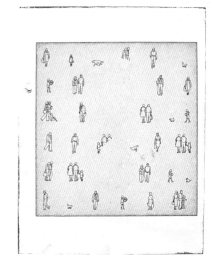

The process of creating signs and symbols that convey ideas and impart information is known as mark-making. These marks may take the form of hand-drawn lines, dots, blemishes, streaks, scratches, and emblems. Marks can be familiar codes that we all understand, such as numbers and letters, or they can be very personal – your signature is an example of a mark that is unique to you.

This chapter looks at some of the ways contemporary artists combine hand-drawn marks with collected collage materials as a means of extending their pictorial language. For example, in David Blamey's images from his Bookwork project "Day in, Day in" (see above right) the drawn outline that forms the silhouette of a found object, in this case an ice-cream scoop, complements that object rather than the object representing the image. Sometimes applied marks convey texture and create further harmony between the surface qualities of combined ephemeral papers.

One potential pitfall for any collagist is that it is very hard to be better than the materials you are working with. For example, sometimes the nature of a found material is more interesting than your original concept, and you then run the risk of becoming a slave to what you collect. Furthermore, the excitement of creating fresh ideas becomes difficult to repeat. Dan Fern often re-examines his image-making process by retracing his steps to find the point at which the process of making images loses its individuality and becomes anonymous. Having retraced to this point, Fern begins the pictorial process again, but this time he approaches it in a different way. For example, Dan Fern's "drawings" evolved from charcoal

Left: Two drawings based on rubbings from wooden letters. The left-hand image combines grease pencil with collage, while the one on the right is made with sanguine. (Dan Fern)

Above: Pages from a Bookwork project, entitled Day in, Day in (see p.25). This page uses adhesive rub-down symbols of people – the kind architects employ to illustrate spaces designed for habitation on plans. The image on the left has been taken directly from the space in the middle of the right-hand image. (David Blamey)

and graphite rubbings, which he carried out over his early collages (this process simplified the collage by reducing its original relief surface to a single-colored surface). He then added physical marks to the rubbings by wiping over their surface with a cloth soaked in mineral spirits or an eraser (see above). Finally, he attached collage elements and, as the new image evolved, recreated the thrill of juxtaposing disparate elements.

The process of making pictures is entirely intuitive – an artist uses type forms, envelopes, and other found materials in exactly the same way as a painter may use a brushstroke or select a particular color. Combining paint media and found printed matter provides infinite possibilities for collage-making. For example, in Richard Caldicott's screen on p.38 he combines found images – in this case encyclopedia and magazine photographs – with the fluid characteristics of paint and varnish. Sometimes the materials are chosen through a subconscious desire not to fully relinquish the selected image or element: i.e. it still becomes

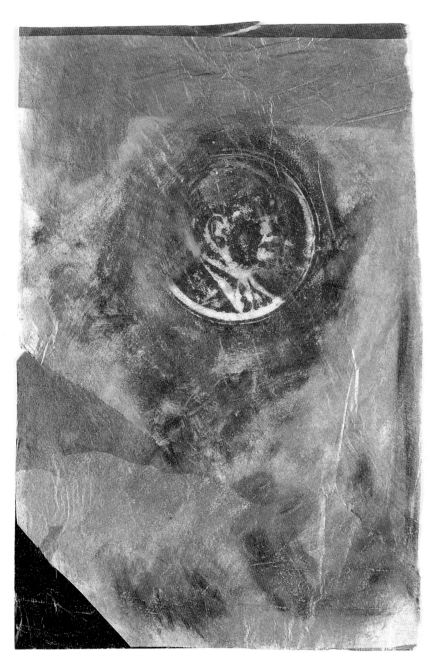

"retrievable" if an unresolvable action were to occur. In this way the use of extraneous materials, such as varnishes or lacquers, allows for a certain degree of control over a creative process which can be predominantly left to chance maneuvers. Varnishes can also be used to change the quality of collage material. For example, "aging" varnish will radically "age" a surface, giving beautiful yellow hues to something that originally might have been quite bright, while "crackle" varnish will produce hairline fractures reminiscent of "old master" paintings and Russian icons (see "Genuflection" on p.36).

Danusia Schejbal exploits the ambiguities that arise from combining paint media and found materials in her collage work. For her, collage is a springboard for the development of an image which often stems from the connection made between disparate realities. For her collage work, she combines materials such as oil pastels and plaster with found articles like cloth fabrics and threads (see pp.44-55). The creative process of mixing paint media is central to Schejbal's design, since she prefers to create physical marks herself instead of using "ready-made" source materials. The paint media Schejbal uses range from oil sticks and soft pastels, which she applies with spatulas and cloth rags, to plaster and paint pigments. The found elements that she incorporates are viewed simply as tactile surfaces which react to or against her hand-made marks. Influenced by working in the theater, Schejbal draws attention to the foreground pieces by "dressing" them up with fabrics and plaster. Although her images are given a three-dimensional effect by their relief surfaces, they are primarily interpreted as single surfaces – just like a painting or photograph – and the paint media and gestural marks that she applies simply help to preserve this illusion when real materials are incorporated. Often the relief surfaces become apparent only when light is directed on them, just as a theater set comes to life when the stage lights come on.

At first glance Carolyn Quartermaine's collages look like an assemblage of ancient paper, yet a close inspection will reveal that all the marks and surfaces are created by hand. Quartermaine manufactures all her source material by hand, screening colors, textures, and scripts over paper and reassembling them as rich collages (see right). These surfaces are then distressed using crayons and pigments to give them a rusted and aged look, or they are embellished with waxes or gold leaf. Hand-drawn marks often take on the same characteristics as paper textures, and this is what attracted Quartermaine to working in this field: "I started printing on silk that was glued onto layers of paper and what I liked about working in this medium was the ambiguity of these images and also the fact that they looked decayed and ancient and had a mysterious, historical quality, when in fact they weren't at all."

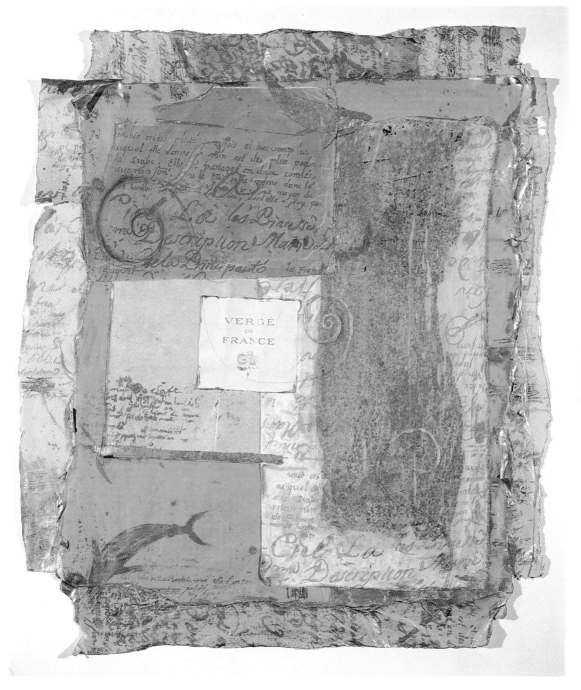

Left: The artist made this collage/frottage, entitled V. I. Lenin, during a visit to Russia in the 1980s. It formed part of an exhibition on the theme of Russia and is created from a variety of different collage elements and oil paints.
(Christopher Corr)

Left: This richly colored collage, called Lettres Impériales, was crafted from hand-printed and painted silk and paper. The artist distressed the surface of the collage with crayons and pigments and then embellished it with gold leaf and wax.
(Carolyn Quartermaine)

Top right: Oil sticks, crayon, plaster, paint, and pigments are applied to the surface of this collage with a spatula or cloth rag to give it a tactile, relief appearance.
(Danusia Schejbal)

Bottom right: The artist draws attention to the objects and figures that she places at the foreground of her pieces by "dressing" them up with cloth, lace or plaster, while the background forms a mysterious veil.
 In this instance, the feline features are defined with plaster.
(Danusia Schejbal)

Far right: This theatrical collage, entitled The Devil's Dance, *is a mixed-media piece incorporating plaster, canvas, oil sticks, pastels, cloth, and a feather.*
 The artist took her inspiration for this dramatic work from her dreams, which are often frequented by strange visitors and are impossible for her to describe in words.
(Danusia Schejbal)

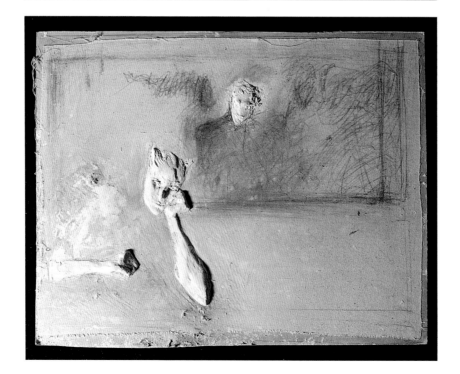

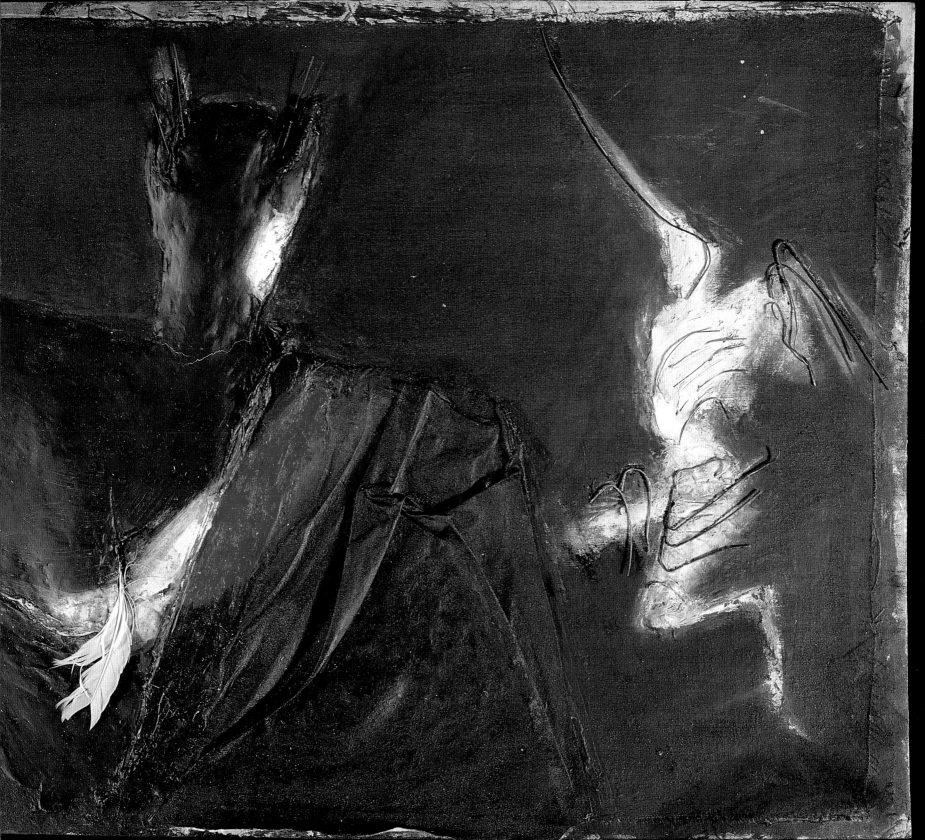

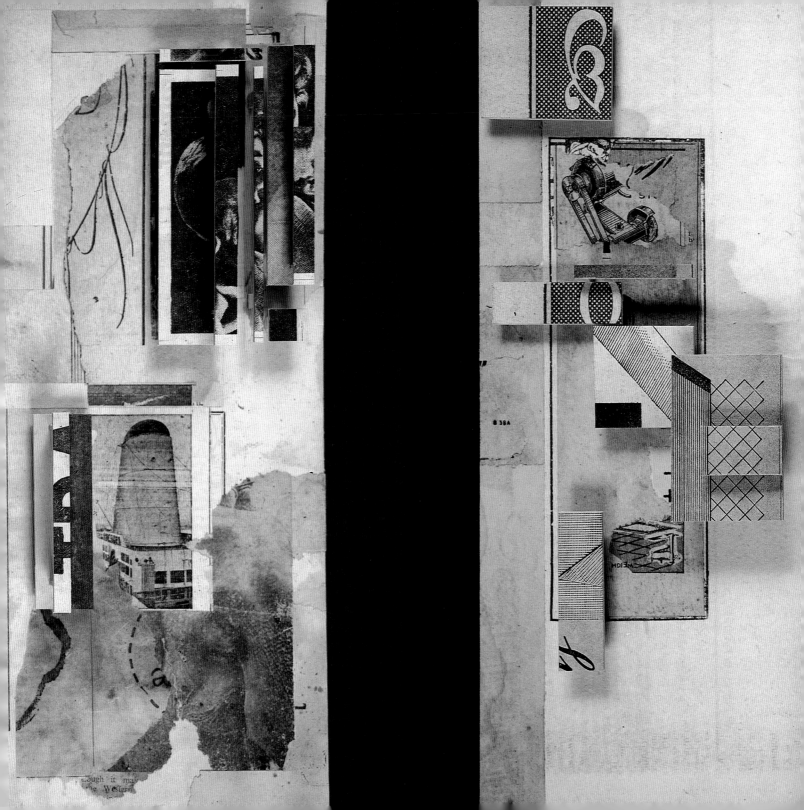

and Found Images

Any text-bearing materials that have been manufactured and mass-produced – for example, tickets, currency, stamps, newsprint, typography, books, and magazines – can be described as printed matter, whereas "found images" refers to pictures that have been mechanically reproduced from original photographs or drawings, such as newspaper or magazine illustrations. Found images are usually made up from a dot screen, ranging from a course, obvious dot such as those found in inexpensive reproductions (newspapers and old encyclopedias) to very fine dot screens like those found in high-quality, full-color reproductions (for example, magazines, posters, and advertising imagery).

Found images are a perfect source material for collage. These images, which range from photographs to engravings, can either be monochrome or "duotone" (i.e. when they are reproduced they are given a brown or blue tone,

Opposite: The newsprint that was used to create this collage has discolored with age – and damp patches have rendered the type illegible. (Richard Caldicott)

Left: Two unrelated images take on new meaning when they are placed on a single page. Although they fit neatly together, a visual gap is created by their idiosyncrasies. (Dirk Van Dooren)

Above: Two collages
created entirely from banknotes. Since these are expensive materials, any mistakes can be costly, and the trepidation the artist feels when he cuts them into tiny pieces is part of his enjoyment. The images on this page are more than twice the size of their original artworks, so precision is essential when working to such a small scale.
(David Loftus)

for example, instead of just black and white). A montage can be interpreted in a variety of different ways, depending on how you arrange your found images on a page. Dirk Van Dooren creates collages by placing two unrelated images on a single page (see p.47). Together, the images take on a new meaning through their visual and mental associations. This combination evokes a randomness which, according to Van Dooren, is somewhat like "switching channels on a TV."

David Loftus's images are made up entirely from printed matter, particularly banknotes, which he uses in their original form. The tactile surface of a paper banknote – the engraving of the figures and the accurate reproduction of minute detail and color – is so significant to Loftus that to reproduce it would result in the note losing its intrinsic value, thus becoming something else. Banknotes are perfectly suited to his design because they incorporate classical elements, figures, architecture, and a muted color range. More importantly, they are valuable as real tangible objects, commodities, which invests in them a sense of preciousness. Banknotes are both obscure and unique – they come in a

Right: These details, which form part of the screen on page 38, take on a new meaning when they are viewed out of context. Seen like this, the space between each row of found images appears resolved enough to constitute a new image. It is this aspect – working with disparate images – that makes the process of collage-making so appealing.
(Richard Caldicott)

BODEY'S BOOKS
DAVIS, CA.
THANK YOU

10•13•95
15:42
№0045

2 •15•30 I
 •15•30 ST
 15%
 •2•30 I
 —

 •13•00 ST
 •13•00 TA I
 •0•94* I

 •13•94 ST
 •20•00 CN AT
 •6•06 CG

diverse range of designs and from numerous countries. The actual size of banknotes is central to Loftus's design; they allow him to work on a very tiny scale, which results in a very intense image (see left and p.31). Fragments are given their own space, but in tightly defined perimeters. The fingernail tear of an image from a banknote strips it down to its simplest configuration, while still maintaining its identity. The spaces within the collage, in between the fragments, become continually partitioned as smaller fragments are incorporated to define smaller boundaries. The edges of the image – where the image ends and meets with the white or neutral color of the background – are treated with as much consideration as the central area of the collage. Symmetry, too, plays an important part in the composition of a collage. For Loftus, it can evoke architectural lines and structures which convey precision. More importantly, symmetry imposes a degree of control over random creative decisions and becomes a marker, a pivotal point of reference, for the collage.

Apart from the thrill of juxtaposing contradictory images and cutting up banknotes, found images and printed ephemera have other applications. Papers that contain ready-made marks – such as printing defects or marks caused by damp or ageing – are often the starting point for making a collage. Indeed, some artists prefer to work with marked or stained paper. As David Blamey points out, "On a perfectly stretched canvas where do you start?" "Utility papers" are greatly favored by Blamey, since these inexpensive papers are vulnerable to all sorts of imperfections – be it in the way in which they are manufactured or the way that they are stored. These imperfect surfaces often provide a base for other utility objects, such as rubber bands and adhesive dressings combined with "rubdown" symbols of people.

Richard Caldicott produced a series of collages entirely from fragments of discolored foreign newspaper which he found in an old chrome foundry (see p.46). He was attracted by their rich, yellow-ochre color, which was the result of years of discoloration, and by their poor reproductive and parchment-like qualities. More importantly, they had accumulated layers of dirt and mottled damp patches over the years which made the print illegible in its discolored state. Caldicott exploited this factor in his designs, selecting individual letters and fragments of words that were attractive in their own right – in shape and surface form – not because they made up an appropriate discernible word.

Dan Fern also works with found letter forms, especially the cut-out letters that make up a child's alphabet. By employing each letter on its own, he is able to exploit the shape of that letter, instead of grouping them in prearranged words or sentences. He may combine these typographic forms with the textured surface of an old book cover or spine, or the handwritten marks on envelopes.

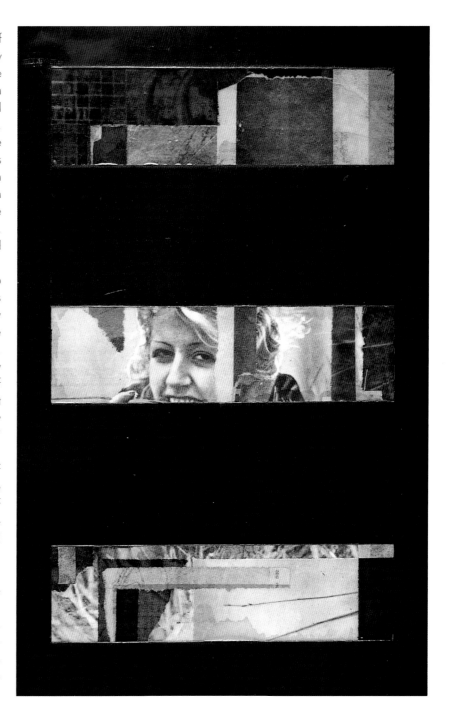

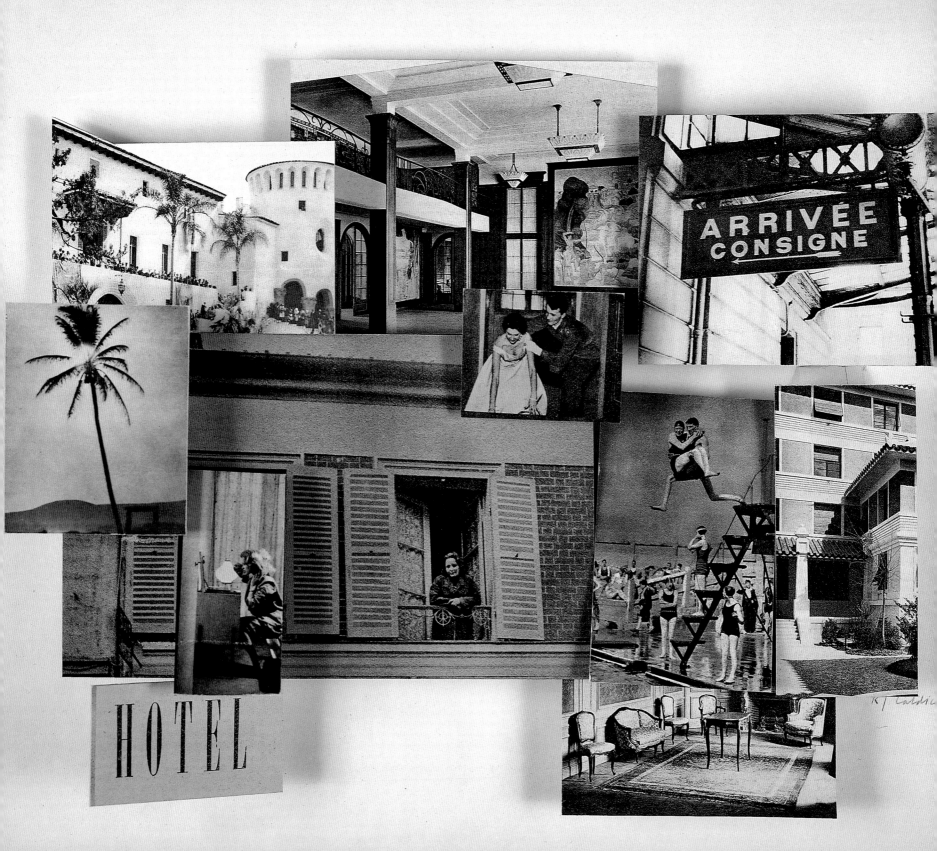

Three-Dimensional Constructions

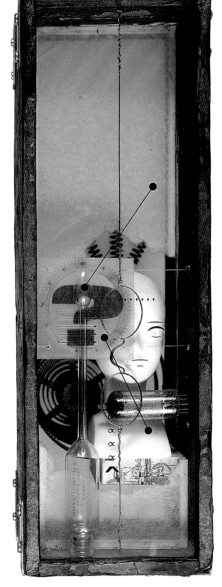

\mathcal{Y}ou will find that three-dimensional objects offer many opportunities for creative expression, since their size and form often introduce new feelings of depth and space into a "flat" montage or collage. However, the physical weight and bulk of many three-dimensional objects often present the artist with creative dilemmas, since objects are usually more difficult to attach than printed matter or found images.

There is a wide variety of products on the market that can be used to attach three-dimensional objects to a baseboard. "Superglues" are ideal for fixing small, delicate items and will provide a strong permanent bond. Epoxy resins (two-part glues), which are made up of one part adhesive to one part hardener/catalyst, are very powerful and are sold by art supply, hardware and do-it-yourself stores. They come in versions for use with metal, glass, china, leather, plastic, and wood. Epoxy resins are "contact" adhesives, so it is important that you apply the resin to both surfaces that you are joining. Leave the glue to become tacky for a short time before you push the surfaces together.

Left: *The designer of Hotel gave found images a three-dimensional quality by gluing them onto poster board and assembling them at angles.* (Richard Caldicott)

Right: *A side view of the box featured on the far right. The peeling paint gives the piece a distressed appearance – like tattered posters in a subway.*

Far right: *Eyeglasses, a clock spring, and a model head have been wired into place in this unique box construction.* (Andrew Hirniak)

Epoxy resins will produce a permanent bond and are non-removable after contact, so always exercise extreme care when working with them, and don't let them come into contact with the skin.

Your choice of objects is infinite and immediate; in fact anything that comes to hand can be incorporated within a montage. Once you have collected all the elements for your collage, your first step is to decide how you are going to house them. You may choose to follow the example of Archer/Quinnell and construct a special frame around your finished collage or you may prefer to "house" it in a found box. Andrew Hirniak often creates a unique background for

his sculptures from wood or metal – by soaking, burning, and treating the surface with acidic substances – so that it harmonizes with his assembly of objects.

You don't have to use entirely three-dimensional objects for your collage – you may prefer to combine a variety of different elements. In fact, many of the images featured in this chapter contain both printed ephemera and three-dimensional objects. Andrew Hirniak combines fragments of found images and diagrams of machine parts in his sculptural pieces. His choice of three-dimensional objects echoes his fascination with medical and scientific apparatus, which he often juxtaposes with natural forms such as animal bones, especially

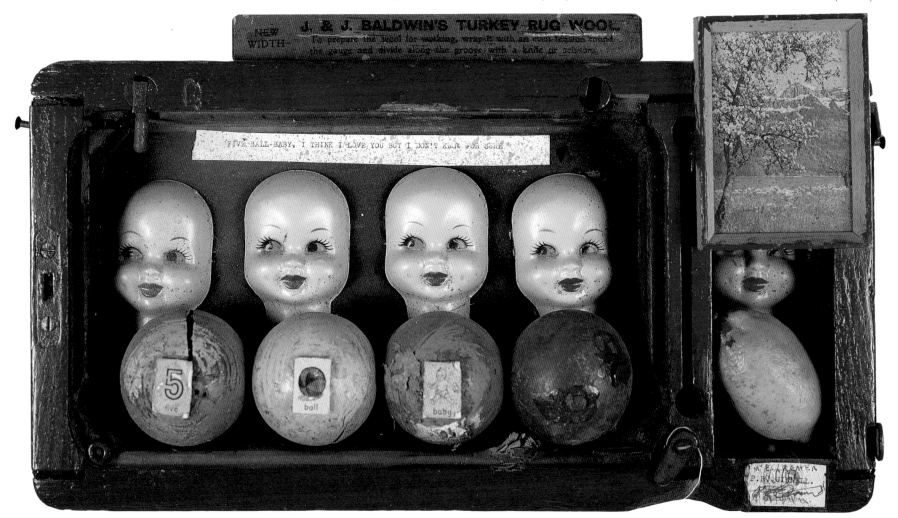

skulls. He constructs his sculptural work as a series of flat planes with objects suspended on thin wires between layers of printed ephemera. The collages are meticulously assembled, reflecting the precise function for which the apparatus he incorporates was originally designed. As a visual aid, Hirniak adds graphic symbols to his work to provide a reference point for the eye to follow.

In contrast, the objects that Archer/Quinnell use in their box constructions often convey a mood of fun, humor, and irony, and they frequently design and construct the frames that enclose their montages so that they harmonize with the objects that make up their work. For example, irregularly shaped pieces of wood with sloping sides can give the objects unexpected dimensions (see left and p.23). The characteristics of the wood must match the qualities and nature of the objects it surrounds: "Wood yard wood is so dead and cold." The impurities of secondhand found materials add further richness to their work. They like to use discarded wood that has been previously painted for their frames, and the glass that protects the contents is often secondhand. Archer/Quinnell often employ typography as an object in its own right: single letters as well as whole words and phrases (these are frequently a source of humor) are incorporated for their shape as well as for the language that they represent.

Jon Boatfield uses all forms of paper for his three-dimensional constructions – from wrapping paper and consumer packaging to cardboard, food cartons, and butcher's paper. His collages begin as drawings, which he spreads over several pieces of paper. However, once he joins the pieces together they evolve into a new three-dimensional construction (pp.54-55). "When you start laying papers on top of each other you haven't just got a flat surface, you've got a slightly raised surface . . . when several are put down . . . you can pick it up . . . it's an object . . . and you can make an entire environment out of it For me a flat piece of paper has no character to it . . . it has nothing else to it." Boatfield's criterion for selecting paper is simple: "that which comes into the house by natural causes, unmarked by the human hand." The development and speed at which his vision matures are left to chance encounters and spontaneous decisions as the various elements are assembled: "For me, the thing I hate most, is to know what I am going to do before I do it. I want to be surprised."

Left: Dolls' heads, painted wooden balls, and a reproduction painting are housed in this construction, entitled Five Ball Baby. *(Archer/Quinnell)*

Right: Bandages soaked with gesso, a feather, and some plastic seagulls form the basis of this "one-off" collage. (Andrew Hirniak)

Overleaf: Chaos and Old Night, a three-dimensional environment, is made by laying pieces of found paper against each other. (Jon Boatfield)

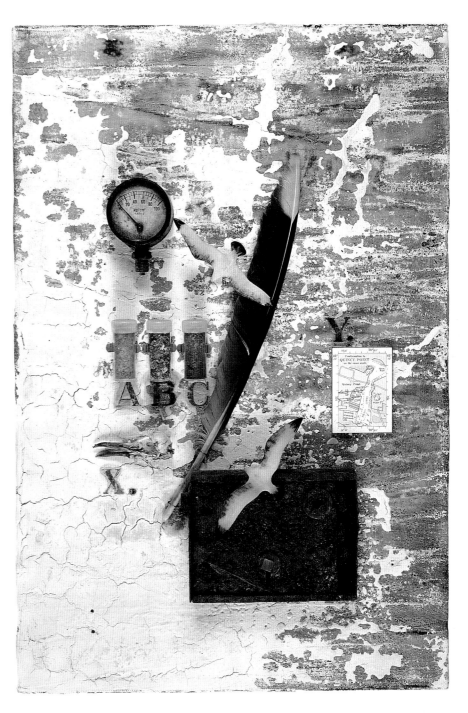

Making a three-dimensional construction

When you construct a three-dimensional artwork, you don't have to incorporate actual objects into your design. Paper itself can be manipulated and developed into a three-dimensional structure; an approach that greatly extends the notion of simply sticking one piece of paper on top of another to create a relief surface. The unusual results can create an ambiguous impression of space, depth, and form.

This spatial effect can be seen in the work of Richard Caldicott (opposite), who constructs three-dimensional shapes by pasting various cut and torn two-dimensional elements such as magazine photographs, newsprint, and old encyclopedia images onto matboard and assembling these as a series of flat planes. He builds the stiffened images up on top of each other somewhat like a pack of playing cards in order to create a layered or tiered effect (see opposite).

The depth of his constructions can be as great as 4 inches from the base – the collage on the right is 1½ inches. This height allows the eye to pass over and through the assembled elements. Caldicott originally took his inspiration for his three-dimensional artworks from theater stage sets, which are normally constructed as flat panels and rely on the effects of *trompe-l'oeil* for a suggestion of background and foreground.

Jon Boatfield also exploits the versatile qualities of paper in his three-dimensional collages. Working in a manner similar to that of Caldicott, he creates extensive three-dimensional structures by layering pieces of found paper on top of each other in order to create large-scale environments (see *Chaos and Old Night* on pp.54-55).

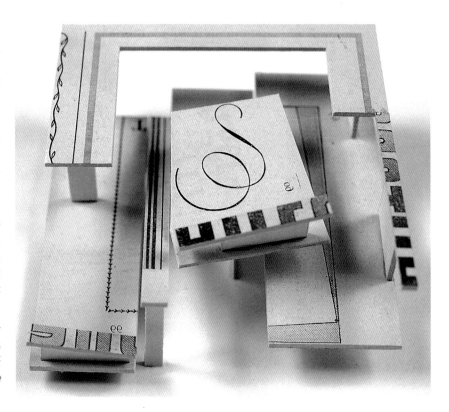

This three-dimensional collage, with its intriguing angles, was made from small fragments of found papers which Richard Caldicott glued onto matboard and then assembled in a three-dimensional con-struction. He selected aged papers, decorated with interesting graphic symbols and patterns, for this piece and used a craft knife to cut them into straight-sided shapes, before gluing them onto the matboard.
The white or off-white board that supports Caldicott's work was selected because it reflects the soft shadows of the tier construction, which heightens the quality of the work.

The three-dimensional effect is achieved by glueing small strips of poster board onto the underside of the stiffened images. These supports act as stilts (see bottom right) and allow the artist to tilt the cut-out shapes at different angles, thus creating a series of planes. This gives the finished con-struction a feeling of depth, as one cut-out fragment overlaps another. The overall height of the collage can vary, depending on the height of the paper stilts that support each layer. The finished tiered artwork resembles a model theater set because the layers of cut-out shapes stack above each other as if designed for the movements of actors.

Top: This top elevation shows the shape and angle of the cut-out fragments.

Below: A side view reveals the small pieces of card that support the layers.

Right: In this view, the shadows are visible where the elements overlap.

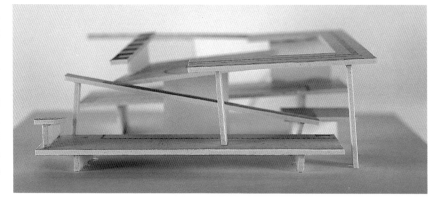

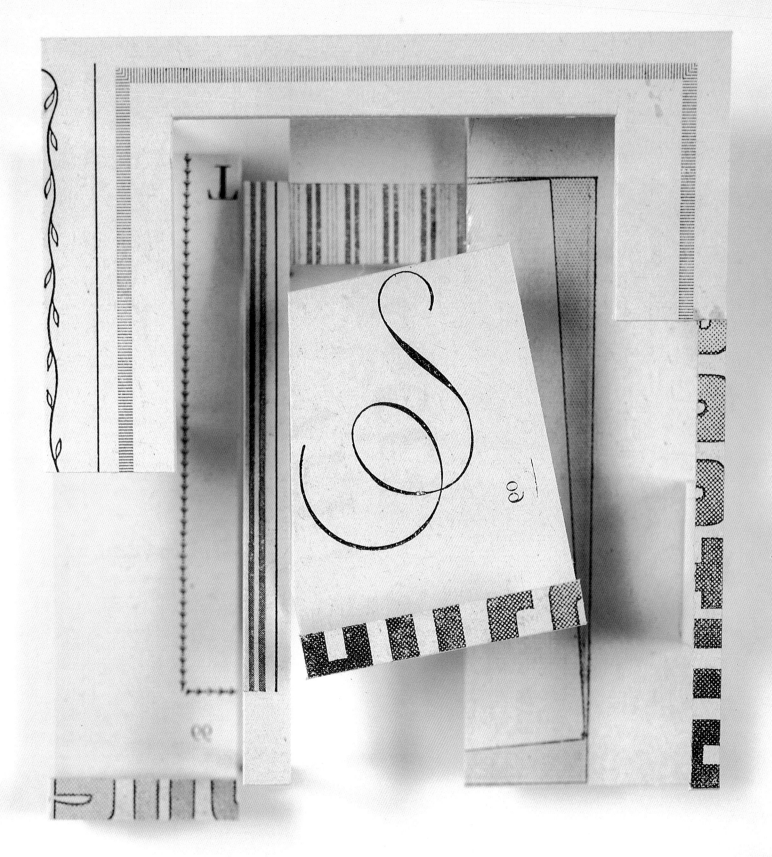

Mechanical Reproduction

Working with found materials – from Japanese tissue to rare photographs with no original negative – can be frustrating, as you are often limited by their "fixed" nature. For example, suppose you want to enlarge the head in the photograph, or you have accidentally cut the tissue in the wrong place. If your found image was an original, how can you incorporate it into your montage without damaging it? Certain reprographic tools allow you to duplicate and modify these precious articles. Suddenly, your creative possibilities are enhanced as your choice of materials and their appearance become much broader.

This section examines some of the machinery that you can employ to produce seamless, mysterious images that would be impossible to duplicate using traditional techniques. There are various reproductive machines on the market, all of which are publicly accessible, although some are more popular than others. For example, you can use an office photocopier to change the size and shape of an image or even reproduce it as a negative, while color models are able to produce full-color reproductions of an original image which can then be cut and pasted into a montage or manipulated further using the myriad sophisticated programs that such machines offer.

One limitation of photocopying is that you can reproduce only an original that corresponds to the size of the copy-glass screen. And since photocopiers were designed to copy flat originals, they are often unsuitable for reproducing three-dimensional objects – hence the advantage of the camera. Photography is perhaps the most accessible reprographic medium, as most people own a camera of some description. Cameras offer many possibilities for image manipulation, and although the processes are often long and unpredictable, the results hold great potential for further development, especially when you combine photography with photocopying or print-making techniques.

Design Approach

Photocopier

Found images are widely used in collage work, although these materials are not always incorporated in their original form. For example, Terry Dowling collects a wide variety of printed matter which he stores in "sourcebooks" and boxes until he requires it for future projects (some pages are devoted to hundreds of price tags, while others contain newspaper reports and photo-fit descriptions). However, he doesn't incorporate the original images in his collages; instead he modifies or manipulates them using reprographic equipment. By photocopying or photographing a page or article from his sourcebook, Dowling takes the process of collage-making a stage further: "What interests me now is reinventing the world I have already invented. To my mind, a piece of work is never finished, in that I will often go back and redo pieces . . . or add to them or change them. One of the nice things about making a collage is that you can photograph it and then pull it all to pieces and remake it . . . and change the story." This is why collage-making is often interpreted as a dialogue between yourself, the materials, and the machines that you manipulate and reproduce images with. In effect, by modifying these images you are rewriting and reinventing the narrative time and time again.

Although artists often use photographic or photocopying techniques to manipulate an image, the original identity of that image is usually preserved. Only its surface quality, size, shape, or color will change. One of the main advantages of using photocopiers is that you can reproduce several copies of an image quickly, which gives you access to a wide variety of creative options. In

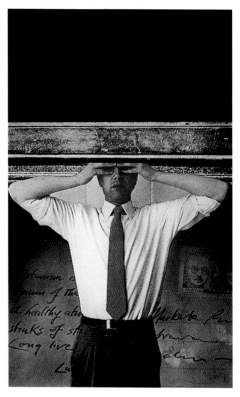

Previous page: Green Bicycle *incorporates 2nd- and 3rd-generation color copies of a model cyclist.* (Terry Dowling)

Right: This cover image for Milan Kundera's book The Joke *was made by photographing a small photomontage on Kodalith film and laying it over a pastel and acrylic painting.* (Andrzej Klimowski)

Far right: Found images were combined to create this collage, entitled Foto Album (Geneva). *The textural background was produced on a photocopier.* (Andrzej Klimowski)

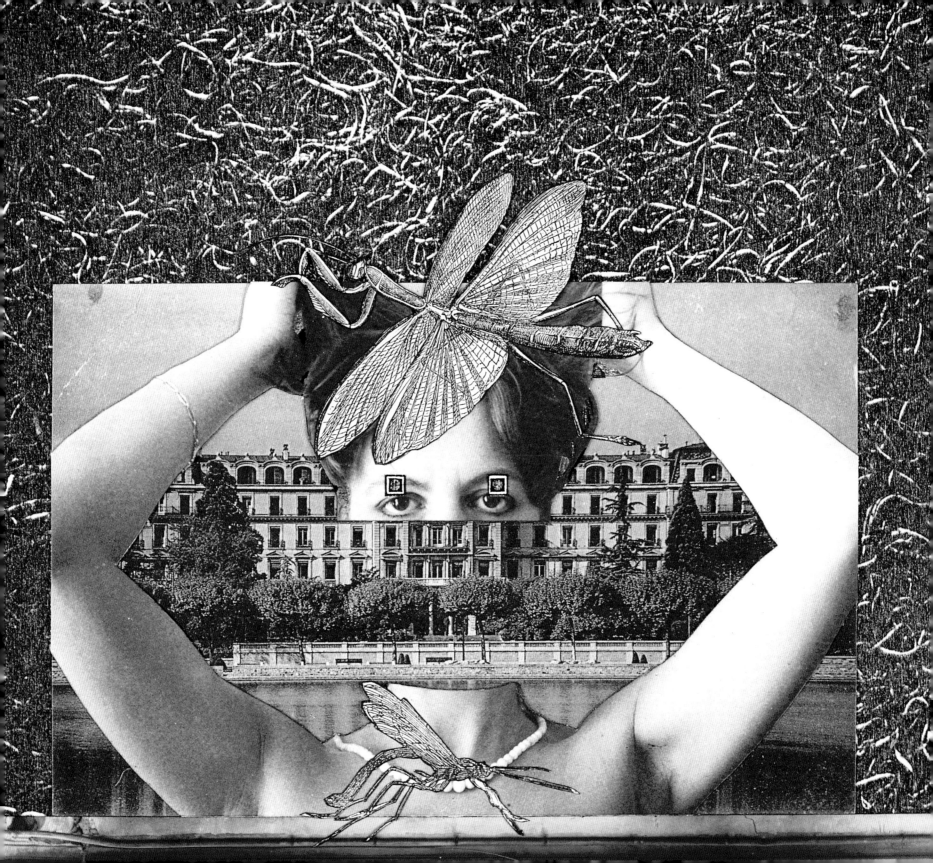

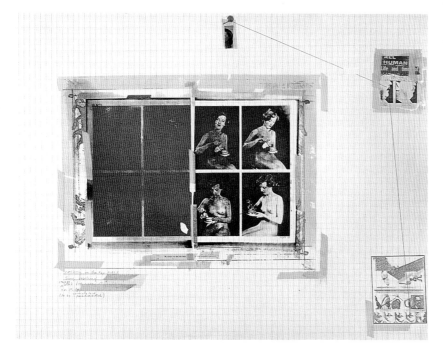

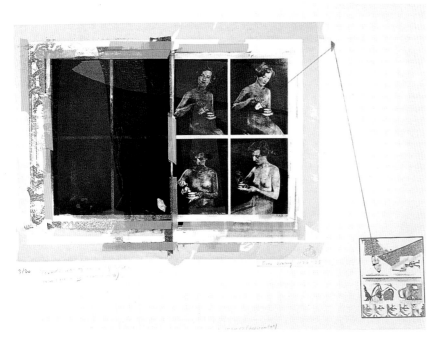

general, when you copy an image you reach a point in the photocopying process when you know what is going to happen to that image – you will cease to be surprised by the machine process itself. However, sometimes machine errors result in unpredictable consequences, and these errors come to suggest new and exciting routes for the direction of your montage. It is this unpredictability in the performance of a reproductive machine that prevents the automation of a machine program from becoming too dominant.

The sophistication of reproductive machines and their ability to transform images is not their only advantage. Sometimes it is the inherent basic functions in these machines that attracts artists to working with them. Andrzej Klimowski uses "enprints" (usually 5 x 7 inches), taken with a basic 35mm camera, as source material for his montages. Using a black and white or color copier, he is able to manipulate these images further, modifying their colors and reassembling them as collages which often combine tiny objects. Such mechanical processes enable Klimowski "to make images which in their composition and meaning are quite direct, yet in their fabric are diverse and quite subtle." These images may also be developed into paintings (see p.131). However even after manipulation each result retains some identity of its original source image.

The ability to manipulate color is one of the most significant factors when creating images using reproductive tools. The sophistication of color photocopiers and their print quality make them an ideal choice for developing an image. This can be clearly seen in the imagery of Muirne Kate Dineen, who enlarges photographs or details of them onto art papers (all within the 50-lb. weight limit) and alters the color balance to adjust the tonal balance of the image (see p.63). Her striking results would be impossible to achieve using other means because their color range is affected by both the surface and color of the art papers she selects (Dineen favors Japanese rag papers). When she has achieved a satisfactory color on the color copier, Dineen enlarges the new original to its maximum size (400 percent) and, using the C.L.C.'s "multi-page enlargement" function, prints the image over multiple sheets of paper and reassembles them on large boards. Sometimes she adds drawn elements and gold paint over the surface until it becomes difficult to tell what is paint and what is photocopy (see p.75). Some images are developed into stone frescoes, while others form large murals.

Montages made using reprographic machines give you the visual power and impact of a single image, yet on close inspection they reveal infinite variations in their subtlety of texture. Even the mechanical, chemical, or electronic errors inherent within these machines can produce marks and stains that take on their own peculiarities and personalities, just as a scar or mole can serve as a distinguishing mark on a human being.

Far Left: Nailing on the Top Piece *(top)* and Towards Nailing on the Top Piece *(bottom)* were produced in different ways using screen-printing techniques. *(Terry Dowling)*

Below: Three photographs taken in India and edited on a color photocopier. *(Muirne Kate Dineen)*

"Night Raid" Andrzej Klimowski '91

Materials and Equipment

Left: The artist of Night Raid pasted real teeth and a color copy of a paper airplane onto another color photocopy. Finally, he painted the underside of the plane's wings with fluorescent paint. (Andrzej Klimowski)

The full selection of photocopiers available for reproducing images is too great to examine in detail in this book. However, this chapter outlines some of the advantages and limitations of different makes and models.

The black and white photocopier is perhaps one of the most accessible reprographic tools. These machines range from basic "office" copiers, designed to simply copy a document, to the more sophisticated "laser" copiers which allow programmed image manipulation. Some black and white models have multiple functions which are capable of putting dot screens over an image, distorting an image's shape and producing a negative print.

Most of the color-copied images in this book have been produced using Canon copiers, which are all able to reproduce high-quality images (400 d.p.i. [dots per inch] x 400 d.p.i.). The Canon Color Laser Copiers (known as the C.L.C.s) offer an unprecedented range of features for image manipulation and are available in many photocopiers'. Models include the C.L.Cl.1 and the C.L.C.500, with its Intelligent Processing Unit (I.P.U.), which allows you to link it up with electronic sources such as videos and computers. Among the smaller versions are the C.L.C.300 and the C.L.C.10, which is small enough to fit onto a desktop and can be linked up to a host computer using the I.P.U. Postscript accessory.

The tone (color) of a photocopied image is made from powdered toner. The density of the black can vary, depending on the model you are working with, so it is often best to experiment with different models beforehand. Black and white photocopiers use only black toner, while color models use cyan, magenta, yellow, and black. Sharp, Xerox, Minolta, and Canon produce models with interchangeable color cartridges which enable you to reproduce an image in a single color, such as blue, red, green, or brown. (Models include the Canon NP2020, Toshiba 3210, Sharp SF8570, and Rank Xerox 5028Z.)

Your choice of paper will vary according to the machine you are working with. For example, color copiers can usually cope only with papers of a maximum weight of about 50 lbs. This is because these machines have a complex printing process – for each copy the paper must pass four times around the drum – so papers that are heavier than the recommended 50 lbs. cannot maintain an electric charge and get jammed in the machine. However, you can feed heavy paper (up to 130gsm) through black and white copiers, as the temperature of the fuser roller inside these machines is great enough for the toner to fuse successfully to a heavy paper's surface.

Never feed highly textured papers through a copier, as their rough surface can disrupt the electric charge and cause the image to smear. Size is another important factor to consider when selecting an appropriate paper. Most copiers take papers up to A3 in size (12 x $16\frac{1}{2}$ inches). And, although they are not as widely available as A3 copiers, it is possible to find color and black and white models in both A1 (33 x $23\frac{1}{2}$ inches) and A2 ($23\frac{1}{2}$ x $16\frac{1}{2}$ inches) sizes.

Clear acetate can be used to overlay one image over another. You can feed it into black and white copiers in A4 ($8\frac{1}{4}$ x $11\frac{3}{4}$ inches) and A3 (12 x $16\frac{1}{2}$ inches) sizes, although color models limit its size to A4 only.

Using Black and
White Photocopiers

Although the office copying machine was designed for the speedy duplication of business documents, it also holds great potential for image generation. Not only are office copiers simple, inexpensive, and fast to use (most models can visualize an image in seconds, and the monstrous Rank Xerox Docutech can print 135 copies a minute), they are also easily accessible in photocopiers', libraries, schools, colleges, and businesses.

Photocopiers are frequently updated by their manufacturers, so you may find it difficult to obtain some of the models mentioned in this book. However, you can obtain information on curent models from a photocopiers' or an art school, and if a particular model has been discontinued, you can usually find a similar model that is still in use.

Most office copiers are based on the "indirect" method, which involves exposing the image to a photo-conductive drum that holds an electrostatic charge. Powdered toner adheres to the drum and is transferred onto the paper by giving it an opposite electrostatic charge. (As the paper passes between the two heated rollers, the toner fuses with its surface.) The density of the image can be controlled by increasing or decreasing the electrostatic charge, which is regulated using the photocopier's exposure-control button. Original images are easy to reproduce using a black and white photocopier. Place the original face down on the copy-glass screen (platen) and press the "start" or "copy" button. The machine will automatically expose and reproduce the original image as a black and white, dry-paper copy.

*Left: The yellow background for **The Stolen Bacillus** was created from a speckled silkscreen which the artist chose to offset the stark black and white photocopied images. He used a black and white copier to produce the textured effects. (Jonathan Hitchen)*

Right: The artist transformed a landscape photograph by reproducing it on a black and white copier. The white broken lines tha run vertically across the image are caused by a poor electrostatic charge. (Stewart Knight)

Most photocopiers reproduce an original as a line copy, and these machines are generally known as "analogue" copiers. They first reduce the image to a series of black tones, and the highlight areas are represented by white base paper. This process allows you to make copies from photographs (continuous-tone images) and reproduce them as high-contrast photocopies (i.e. any subtleties in gray shades are heavily compressed and may be lost during reproduction). The photocopying process breaks the image down to its simplest configuration, and every time a copy print is recopied as a new original it becomes more abstract and broken up. The majority of models allow for a degree of enlargement and reduction (usually 50-200 percent). However, if you recopy and enlarge an image repeatedly, the resulting image will eventually break up into a series of textured patterns that resemble calligraphic marks. The results form textured backgrounds for collages (see p.72).

Compared with color photocopiers, black and white machines tend to be rather limited in their range of creative features. However, Sharp, Canon, and Toshiba produce models with an edit facility, which enables you to print only a selected area of your image. This editing process is carried out using a magnetic pen on the edit board (situated on the lid of the copier). You can use this technique to select and copy rectangles, while the Canon 4080 and the Sharp SF8400 allow you to select and print circular areas.

Digital photocopiers offer a more sophisticated range of functions than "analogue" copiers. Some models have a "photo-mode" facility which can copy photographs effectively by reproducing them with a dot screen. These half-tone photocopies offer a scale of grays quite unlike other black and white photocopies and, once enlarged and recopied, offer further opportunities for abstracting the original image. Some digital machines enable you to print an image as a negative, while others allow you to enlarge or reduce the X and Y coordinates independently, which results in a stretched or condensed image (see p.87).

You can achieve unusual effects by using black and white photocopies to reproduce objects and textured surfaces in the same manner as an instant camera. Anything that can withstand being pressed against the platen – from the human hand to insects and flowers – can be photocopied. However, objects usually register as abstract shapes or patterns. Some copiers can detect objects that are quite deep, although the surrounding area will reproduce as black.

Most black and white photocopiers have a "manual-feed" function which allows you to feed the copy paper through the machine several times. This facility enables you to build up an image layer by layer. And if you want to copy an image again – to boost its overall density or to suggest misregistration – you can feed it back through the machine. It is also possible to feed clear acetate into

Above: This picture postcard, called Souvenir of London, *was produced by feeding colored paper into a black and white photocopier and pasting the resulting colored images together.* (Lawrence Zeegan)

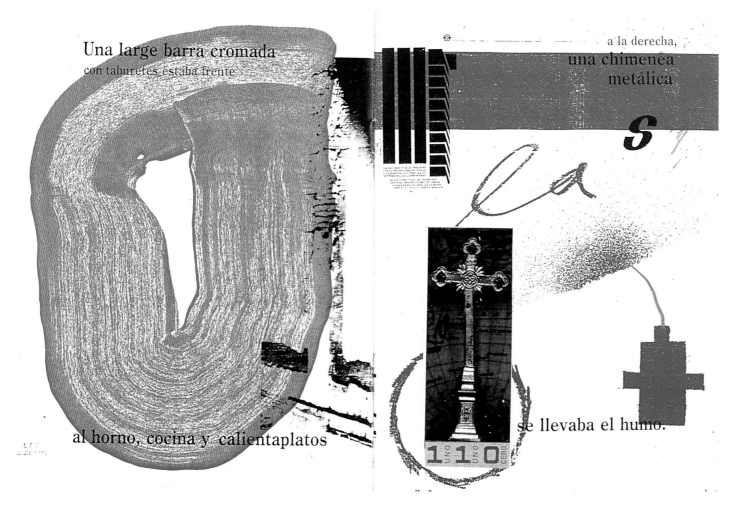

Una large barra cromada
con taburetes estaba frente

al horno, cocina y calientaplatos

a la derecha,
una chimenea
metálica

se llevaba el humo.

1 1 0
UNO UNO CERO

black and white machines using the manual-feed function. This produces a semi-transparent image which you lay over your collage so that the material beneath shows through. Acetate prints can also be used as negatives for photographic prints, especially contact prints, where the acetate is placed in contact with photographic paper sandwiched between glass. The density of toner on the acetate film is usually less than that of paper, so short exposures are necessary to prevent the image from becoming too dark.

You can produce interesting distorted shapes by moving your source image as it is being scanned by the copier. As the "light band" (scan lamp) moves across the screen, the copier will record these movements, and a blurred image will result (see pp.70-71). Horizontal movements across the screen will stretch the image and produce long movements, while vertical movements tend to produce wave-like blurs. It is often difficult to repeat a blur, as each movement tends to be slightly different, depending on how much you move the original.

Once you have mastered the basic techniques of working with black and white photocopiers, you can experiment with all manner of combinations and permutations. You could combine all the methods featured here to create a unique image; color black and white images by hand, using inks, crayons, and pastels; or manipulate images further using color photocopiers, photography, or print-making techniques.

Blurring images

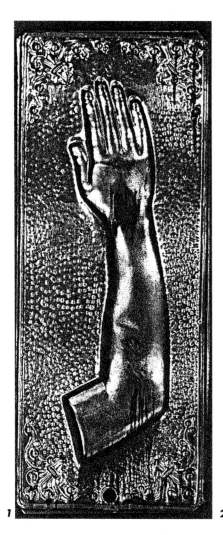

1

2

3

*I*f you move your original source image as it is being scanned by the copier, the copying machine will record these movements and a blurred image will result. For example, a slight movement suggests a sense of speed within the image, while the more you drag the original across the screen the more elongated and distorted the resulting copy will appear. This process holds great potential for image manipulation, as it is easy to control the degree of blur or movement by first carrying out a number of experimental prints. If, on completing your image, the result isn't quite what you anticipated, you might collage the results together and recopy them until the image becomes more resolved.

1 *A simple reproduction of a metal arm.*
2 *A horizontal movement across the screen will stretch the image laterally. In this instance, the metal arm was dragged to the left as the "light band" moved across the screen.*
3 *A sudden, exaggerated movement across the screen distorts the image further.*
4 *Vertical movements tend to produce a series of wave-like blurs. You can achieve this*

thin, elongated image by moving the arm very slightly up or down.
5 *Vertical movements are more difficult to control than horizontal movements since the copier abstracts the image. Here, the image is so distorted it is barely recognizable.*
6 *This image shows the same technique as in step 5, (a slight vertical movement), but a totally different result is achieved every time.*

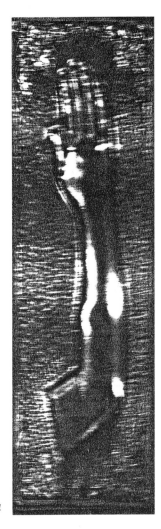

4

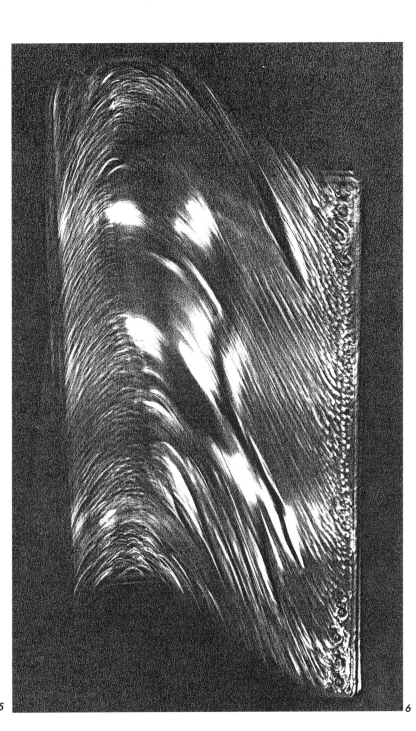

*Above: These images have
been blurred by moving a
metal arm manually across
the copier screen. If you are
not satisfied with the result,
you could manipulate the
image further with a color
copier or a camera.
(Simon Larbalestier)*

5

6

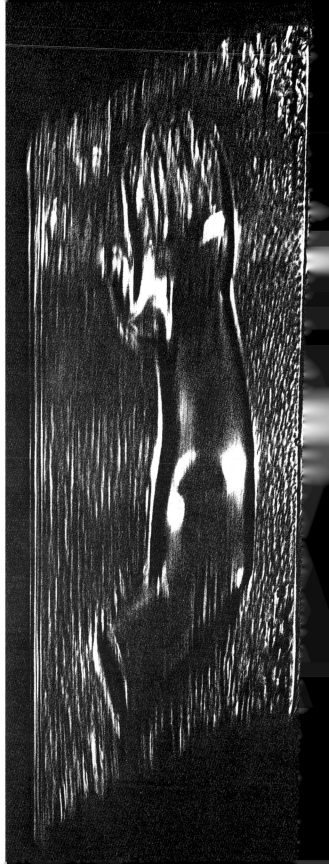

Multi-generation photocopies

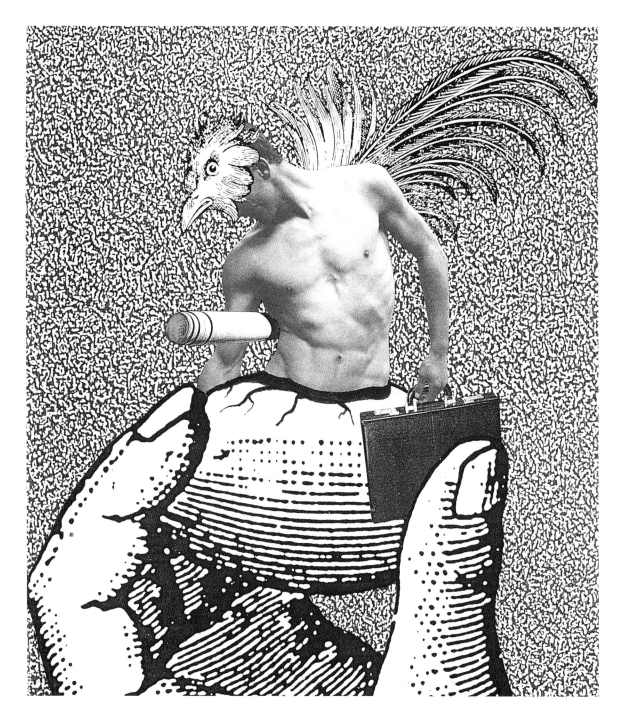

1 I selected a metal arm for this image because it had a relief surface that would reproduce faithfully and permit abstraction. To create this 3rd-generation print, I placed a small Greek metal votive on the copy-glass screen (platen) and copied it. I then used the photocopied image as a new original and recopied it twice to produce a 3rd-generation copy. (The original 1st-generation image is shown on p.94.)

Right: Interesting distortions occur when you repeatedly reproduce a copied image, like the metal arm image on the left, using a black and white photocopier.

This process, known as multi-generation copying, reduces the areas of black tone in the image and impairs the pictorial quality until the image resembles a linear calligraphic design.

Multi-generation is a fast and effective way of abstracting images, and it is particularly suitable for creating textured backgrounds for collage work. You can produce further distortions by repeatedly enlarging an image or fragment of it. (Simon Larbalestier)

2

3

4

2 The differences between this 8th-generation copy and its original on p.94 are already quite apparent; the heavy black tones have started to break up and fragment, which gives the background a textured finish similar to crackle glaze.

3 The background of this 15th-generation copy has become quite distorted, and the bold outline of the arm is the only definitive shape.

4 This 26th-generation copy is completely stripped of its tonal separations and linear delineations and looks more like an aged stone relief pattern than the embossed metal object that I first placed on the platen. Multi-generation copies like this one make ideal backgrounds for collages. However, if you are not satisfied with your image at this stage, you could color it by hand with pencils or crayons or distort it again using a color photocopier.

Far left: **New Artists Breaking Out** *was created from black and white copies. The artist repeatedly enlarged and photocopied these until the background started to break up and take on the appearance of brushmarks. (Andrzej Klimowski)*

Using Color

Photocopiers

Once an expensive and limited reprographic tool, plain paper color photocopiers are now widely accessible in most photocopiers' and educational institutions. As a tool for design and sales presentations, they offer accurate color reproduction and design features of unrivaled sophistication. Several companies, including Canon, Xerox/Rank Xerox, Sharp Electronics, and Panasonic, market full-color machines. Most color copiers are able to use only papers of a maximum weight of about 50 lbs., although you may be able to find one that will produce prints on heavier papers. Some companies, including Konica Business Machines, also produce copiers that use a special light-sensitive photographic paper instead of conventional "dry" plain paper. Of the dry-paper photocopiers, the machines that have been most consistently used for image-creation throughout this book are those manufactured by Canon (especially the C.L.C.1 and C.L.C. 500 models), and these can be found in many photocopiers', art schools, and colleges. As with black and white copiers, these machines are regularly updated, with new models replacing older ones, so it is a good idea, if you are planning to buy your own photocopier, to do a little research into the models that are currently available from various manufacturers before selecting a specific model.

Apart from their most obvious function – to faithfully reproduce a full-color original – dry paper color photocopiers have a number of built-in programs designed for image manipulation. For example, the Canon Color Laser models have a myriad sophisticated creative features that are designed to

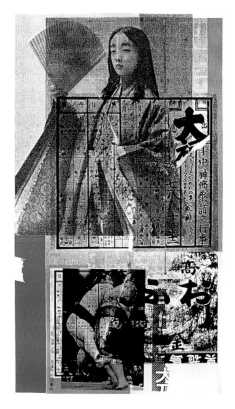

Right: The artist photocopied several found images onto acetate and then combined the acetate images on a copier to produce a layered effect (Richard Caldicott)

Far right: This piece, entitled Green Cow with Mendi, *is produced from color copies embellished with drawing inks and gold leaf. To produce this image, the artist reproduced a smaller version, enlarged it on the Canon C.L.C. using the "Multi-Page Enlargement" facility, and printed it over nine separate sheets. (Muirne Kate Dineen)*

change the shape, color, and size of an original image in minutes. The photocopies that Canon machines produce are generally referred to as "color copies," and you can produce highly complex color montages by combining them with conventional elements such as photographs, found images, printed ephemera, and certain three-dimensional objects. You can then use the color copier to join these collage elements seamlessly in such a way that the joins become an integral part of the final piece.

Perhaps the most widely used Canon Laser Copier feature is the "Color Balance" mode. This simple program, which is explained in more detail on pp.78-79, allows you to alter the color and tone of a source image. Another interesting way of distorting source images is the process known as multi-generation prints. Using this method, you can create unusual abstract images by photocopying a source image and using the photocopy as an original; every time you recopy the photocopy, the details within that image become more fragmented.

The color copier has a number of labor-saving devices which can all be applied to collage work. For example, you can use the "Framing" mode to select and alter a specific area of your image – this allows you to edit an image at the primary stage instead of copying an entire source image and then manually cutting out an area. The "Zoom" facility, which is operated at the touch of a sensitive control panel, will also alter the size of an image. Using this program, you can reduce your source image by as much as 50 percent or enlarge it to 400 percent in a matter of seconds, provided that the image will fit onto a standard paper format. You can also create interesting effects by distorting the shape of your image as a result of enlarging or reducing the horizontal (X) and vertical (Y) axis independently (see p.87). This feature allows for accurate manipulation because it enables you to stretch or condense an image in one percent increments. And "Multi-Page Enlargement" (exclusive to the C.L.C. series) allows you to photocopy an image over several sheets of paper (see p.75).

While most machines can enlarge an image by only 400 percent, it is possible to enlarge an image by as much as 1,500 percent using the Canon BJ-A1, a bubble-jet-ink printing photocopier. This machine offers creative functions similar to those of the other Canon Laser Copier models and is capable of producing huge distorted images that can span several yards.

Another very useful feature that can be found on several brands of color copier, including models by Rank Xerox, Ricoh, Sharp, Kodak, and Canon, is the reproduction from 35mm transparencies. Check with your local copy shop to find out which models carry this facility. Using this attachment, you can mount a 35mm slide in a conventional slide mount and insert it into a unit that projects the image onto a special silvered mirror, angled at 45 degrees, and reflects it into the machine's scanner. Projector units for the Canon C.L.C. series can handle film sizes from 35mm up to 8 x 10 inches. This facility opens up many more possibilities for montage – you can sandwich films together to create multiple prints or reproduce them as color negative or positive prints. The capacity to reproduce transparencies is especially useful if you don't have access to a darkroom, as it enables you to print from negative films and add colour to black and white negatives.

Most color copiers are designed to function only with lightweight papers (up to 50-lb. weight) which can be a limiting factor, especially if you want to transfer your image onto a heavy-duty drawing paper. However, you can use a solvent for this purpose (there are various "screen-wash" solvents on the market). Apply the solvent to your color photocopy – the solvent will soften the fused tone on the copier paper – and lay the copy carefully over your drawing paper. Pass this paper sandwich between the rollers of a heavy press that has the right pressure to facilitate accurate transfer (such as a stone litho press). This transfer will soften the image and its colors; it removes the digitized photocopier quality and gives the montage a more painterly quality. Another advantage is that if you transfer your image to a larger drawing paper, you can increase its overall size and remove it from the restrictive A3 (12 x 16½ inches) and A4 (8¼ x 11¾ inches) paper sizes that are ubiquitous to most color-copied images.

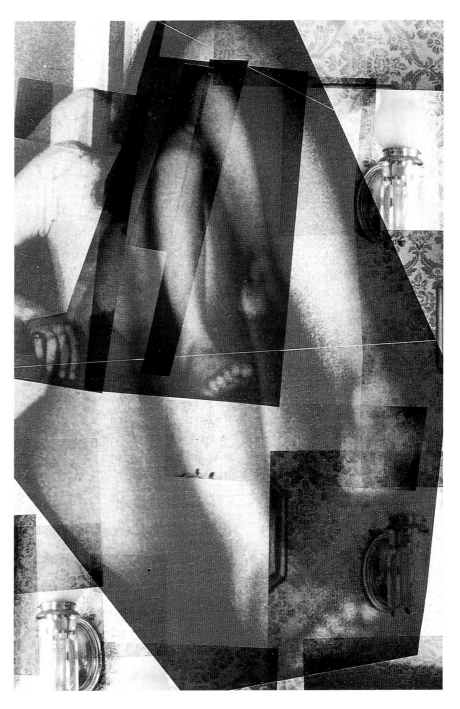

Left: **A Pair of Dancing Shoes,** *on the left, shows the original color copy, while the one on the right is a transfer print made wth silkscreen solvents.* (Pui Yee Lau)

Right: A variety of different images was color-copied onto special acetate sheets and collaged together to create **The Enchanted Hunters.** *The artist used a* Perspex (clear plastic) sheet *to allow the translucent and rich colors of the acetate sheets to blend into each other when they were laid over each other.* (Fusako Akimoto)

Shifting the color balance

1

2

3

*O*ne of the simplest ways of manipulating an image on a color photocopier is to adjust the "Color Balance." Whenever you reproduce an original image using a color copier, the resulting color will always be an approximate copy. However, certain color copiers, especially the Canon C.L.C. series, have such a high resolution of d.p.i. (dots per inch) that their degree of color reproduction is very faithful to the original. Images that are already made up of a four-color dot screen – such as magazine photographs – are easy to reproduce because the photocopier is able to make an exact replica of their dot screens. However, photographs and other continuous tone images usually assume a new color identity, albeit a very subtle one, when they are photocopied. Every time you recopy a copy of a photograph, the color becomes intensified and the color saturation becomes greater. As the contrast of the image increases, the color tones become condensed, which results in a darker, richer copy.

1 I selected an old Turkish handwritten page for this exercise because it had neutral colors and fine handwritten details.
2 Working in the "Color Balance" mode, I increased the cyan, magenta, and black color levels and set them at +8, while I reduced the yellow to a –8 setting. This process shifted the color to a blue-brown tone.
3 To achieve this mustard-yellow color, I increased the cyan, magenta, and yellow to +8 and left the black as normal.
4 I produced this radical shift in color by recopying the print produced in stage three

twice (3rd-generation) and changing the color levels. I set the cyan, black, and yellow at +8, which reduced the image to predominantly green and black areas. Notice how the handwriting and creases that were visible in the original and the shadow tones seen in print 2 now blend into black marks.
5 I achieved these intense reds by taking a 3rd-generation copy of print 3 and maintaining the color levels of the magenta, yellow, and black at +8 and reducing the cyan to –8. Notice how the color changes when you remove one color (in this case the cyan).

4

Right: Color adjustment is one of the most dramatic and significant ways of modifying your source or final image. The five prints featured here show only the most basic of color shifts; you can create very subtle changes in color by adjusting one or two of the color levels by as little as one increment or even half. The image on the far left shows the original source material (an old Turkish manuscript). This has been manipulated by altering the "Color Balance" in order to produce a wide spectrum of different colors. The radical shifts in color were achieved by recopying the original image twice and adjusting the color levels. (Simon Larbalestier)

5

Coloring black and white images

1 For best results, select a soft black and white print that exhibits a full range of gray tones and has no white "holes."

To encourage the photocopier to recognize it as a color image, I printed this photomontage onto Kodak Rapid Lith paper to give the image a very slight color hue. If the image is too contrasty in black and white it is hard to achieve a significant color shift because the black becomes too dense and the lack of middle tones reduces the areas that are able to accept additional color.

2 To produce this result, I adjusted the "Color Balance" levels. I set the yellow and magenta to the highest position and reduced the cyan and black to the lowest level.

3 In this 3rd-generation copy, the color is intensified and the image has taken on a mysterious, fiery glow.

4 I copied a 2nd-generation print (not shown) in three colors instead of four (known as "S Color" on the C.L.C.1 and "3 Color" on the C.L.C.500). The darkest areas of the print appear black because the mix of the three colors – cyan, magenta, and yellow – produces a more saturated color to compensate for the lack of true black.

5 I incorporated the most interesting elements of prints 3 and 4 in this collage and pasted them together using wallpaper paste. Finally, I sealed the montage with varnish.

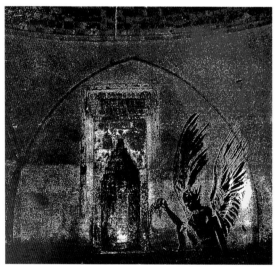

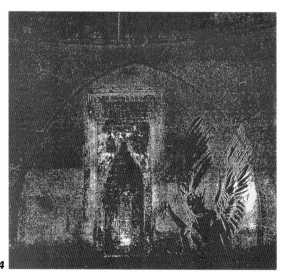

You can create interesting effects by reproducing a black and white image in full color on the color copier. I made the *Temptation of Saint Anthony* (see above) in this way. During the scanning process, the machine takes a separate reading for each color – magenta, cyan, yellow, and black – and prints them accordingly. The resulting copy exhibits subtle hues and tints of each color.

For a more dramatic finish, you can adjust the "Color Balance" to increase the shift in an individual color (see pp.78-79). The tinted copy can then be used as a new original and copied again with a new color balance shift to intensify the colors. As with multi-generation copying, every time you recopy a color copy, the machine will simplify the tones and saturate the colors until the image degenerates to the point at which it is either unreadable or too strong a color. Because the copying process is so fast, you could produce several versions of a print within minutes. You can then cut and paste the copies together and recopy them until the image takes on a new identity.

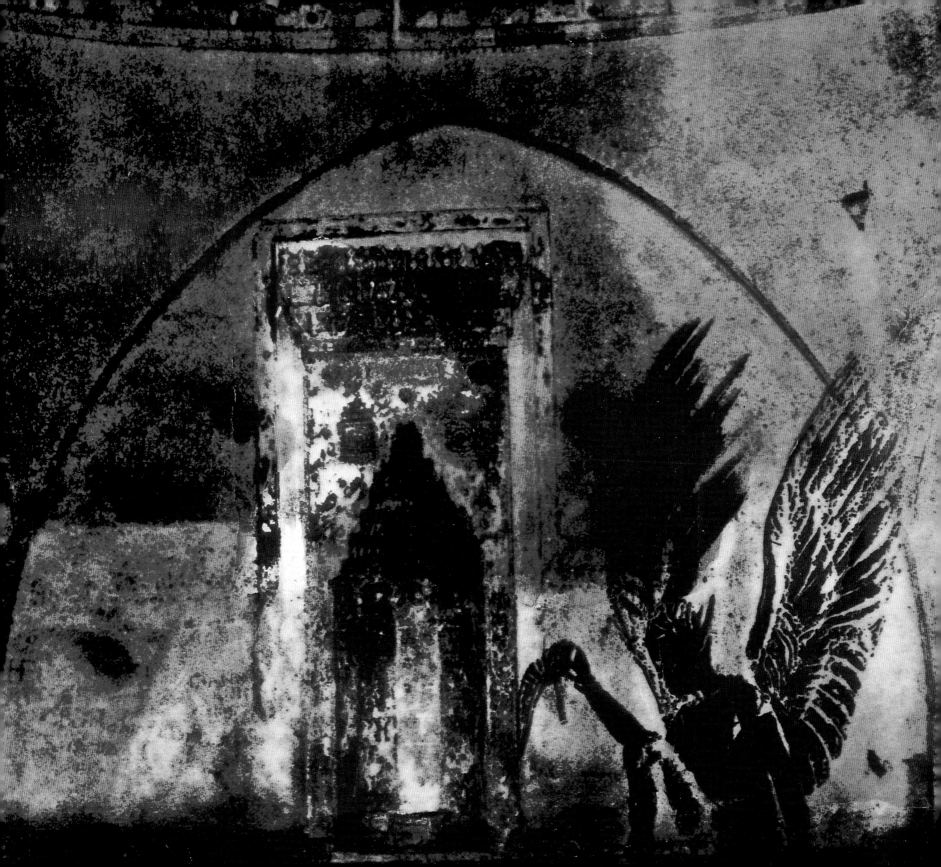

Distorting images

1a and 1b The artist, Richard Caldicott, selected tiny, found encyclopedia portrait photographs which were poorly reproduced, with defects seen as white stratches or feather-like blemishes, for this series of images. Using the C.L.C.500, he enlarged the photographs by 200 percent and adjusted the tone using the "Color Balance" mode (see pp.78-79). He increased the cyan and magenta levels to give the black and white reproductions a blue-brown tone and finally pasted the two resulting photocopies together to form a new "artwork."

2 To produce this image, Richard Caldicott recopied the new artwork to the same specifications as the original and adjusted the color toward blue tones

Recopying the artwork degrades the image slightly, and as the contrast of the image increases and the dot screen inherent in the original source photograph expands due to the saturated color, the print defects that were evident in the original source images begin to blend with the facial details.

The C.L.C.500 has a higher resolution than the C.L.C.1 (400 x 400 d.p.i. instead of 400 x 200 d.p.i.), so it is worth considering using a C.L.C. 500 if you want to preserve the quality of 2nd- or 3rd-generation prints. Another advantage is that the tonal color range of the C.L.C.500 is wider than that of the C.L.C.1, and therefore it can make the color changes appear more subtle or saturated.

3 This 3rd-generation print is considerably darker than the original source image; the colors look more saturated and the original printing defects now appear indistinguishable from the facial features.

This image has been flopped to face in the opposite direction using the "Mirror" mode (found on the control panel). You could also use this program to fold the image symmetrically or asymmetrically.

4 This image is also a 3rd-generation print. Again, it has been flopped using the "Mirror" mode, but in this instance the artist has used the "Image Segment" facility to select an area within the image – the eyes of both subjects – and alter it. To do this, place the "artwork" on the edit board (which is found on the copier

1a **1b**

lid) and mark out an area using the electronic pen. Next, transfer the artwork to the copier platen, select the "Color Mode," and adjust the controls so that the designated area is reproduced as a "Black Negative."

5 This montage was made in the same way as the image in step 4, although a different area was selected using the "Image Segment" mode, and this was reproduced as a black and white negative image.

The magnification and abstraction of the heads was enhanced by rephotographing the image and printing it as a 40 x 60 inch Cibachrome color print (not shown).

Color photocopiers have a wide variety of creative programs which can be used to manipulate or distort the color and content of your original source image. (Contract your local photocopiers' for information on the creative functions of different machines.) Multi-generation copying (see pp.78-79) will distort the colors within an image to a certain extent, although there are also a variety of more specific methods which can be employed to change the individual features of your source image. For example, you can reproduce an area in black and white so that it contrasts with the full-color areas; you can reproduce an image as a positive or negative area which will break up the image and make it appear more complex; or half of the image can be mirrored and reproduced to face in the opposite direction. Using several functions of the control panel simultaneously, you can create a totally new montage and make it appear as though it was built up from a number of different source images.

Using the "Image Segment" mode on the C.L.C.500, it is possible to pinpoint a specific part of your image and manipulate or edit only that designated area. Place your original or photocopied image in the top right-hand corner of the "Edit Board" (a registration arrow indicates the position on the lid of the copier) and use the attached electronic pen to pinpoint two corners of the area you wish to alter. Next, place your image on the copy-glass screen so that it is adjacent to a corresponding registration mark and press the copy button. In this way, image manipulation can take place solely on the edit board, thus replacing the need to cut and paste.

The Canon range of photocopiers is unrivaled in the field of image manipulation. Two useful models are the Canon Color Laser Copier (widely known as C.L.C.1) and the Canon Color Laser Copier 500 (known simply as C.L.C.500). Richard Caldicott created the images on this page using a C.L.C.500.

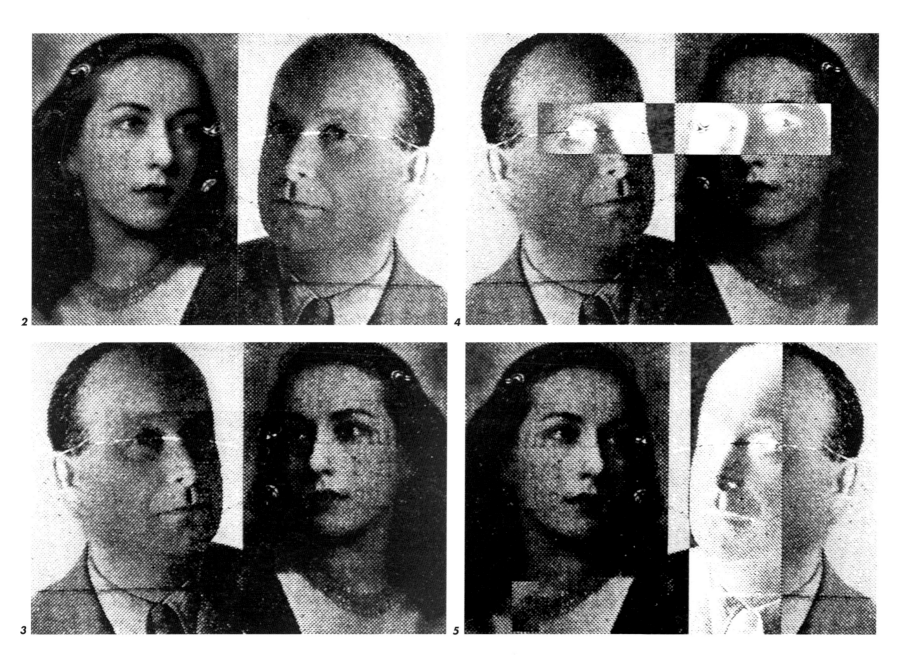

2

4

3

5

1) Two images were copied, enlarged to 200 percent, and tinted.

2) The artist pasted these two 2nd-generation copies together.

3) A 3rd-generation copy was flopped using the "Mirror" function.

4/5 The artist manipulated these 3rd-generation copies using the "Color Mode," "Image Segment," and "Negative" programs. (Richard Caldicott)

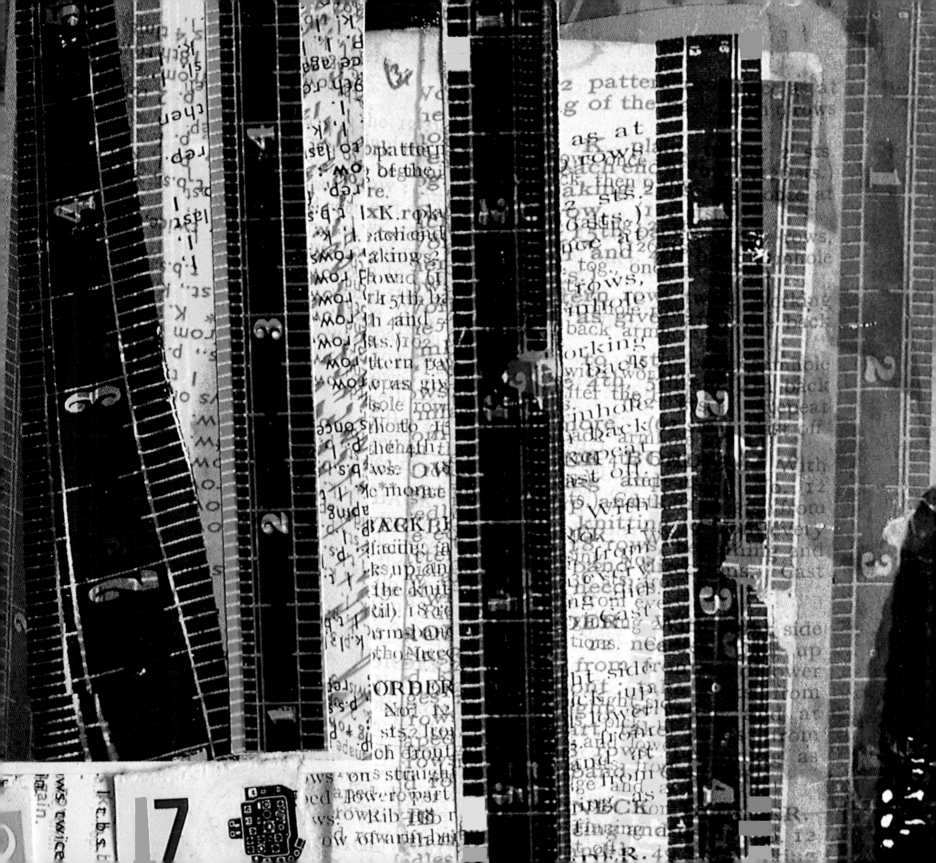

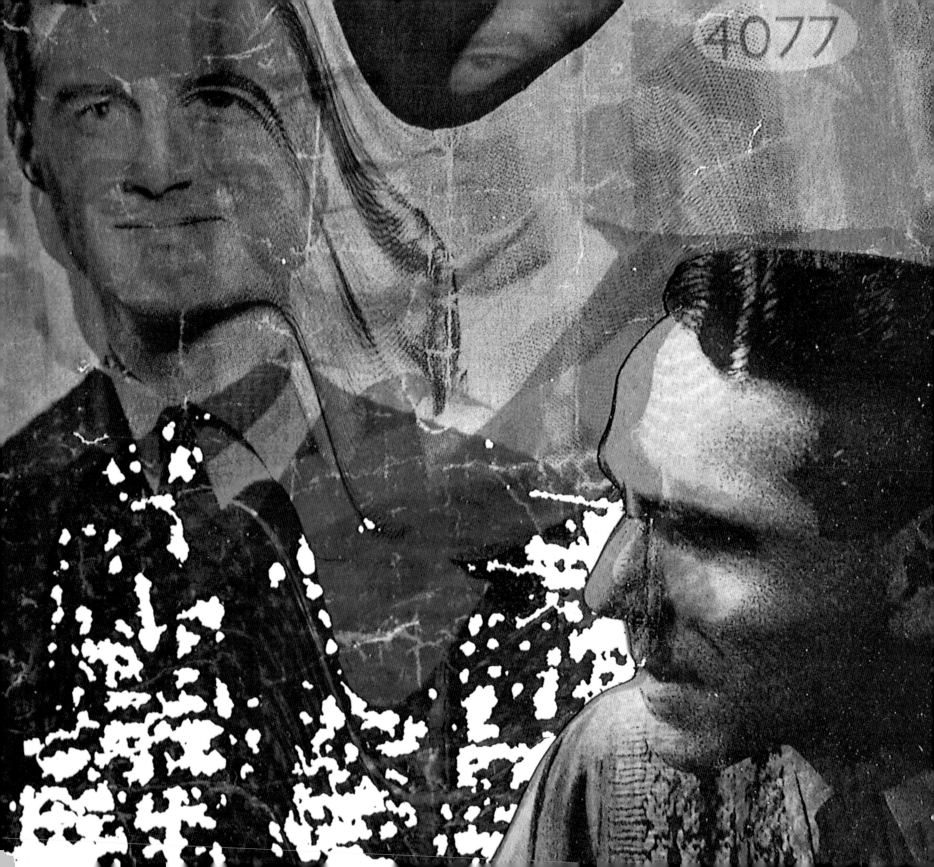

Distorting images

1a and 1b *The metal ear (which is similar to the Greek votive arm shown on p.72) was photocopied on the C.L.C.500 several times to increase the saturation of the blue tone. The print shown in illustration 1b is a 3rd-generation copy.*

2 *I used the "Zoom" mode to stretch this 3rd-generation print horizontally and squash it vertically. In order to do this, I selected the "Independent X/Y Zoom" and keyed the percentages into the control panel.*

3 *To produce this effect, I reduced the vertical (Y) axis by 60 percent and enlarged the horizontal (X) axis by 170 percent.*

4 *To achieve this result, I reduced the vertical (Y) axis by 50 percent (which is the minimum reduction you can produce in a single step) and enlarged the horizontal (X) axis by 200 percent (the maximum is 400 percent).*

5 *I distorted this 3rd-generation print using the "Image Angle" mode. To produce this tapered result, I keyed in an image angle of −35 degrees.*

1a

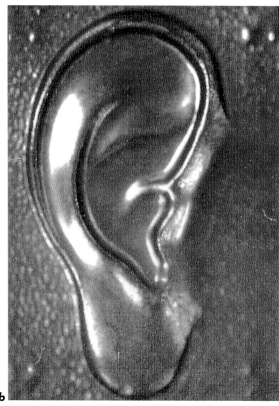

1b

*E*ven basic photocopiers can record slight movements when you move an image or an object across the copier platen. However, because these random movements are frequently based on guesswork, it is often impossible to anticipate what results you will achieve beforehand. For example, in both steps 5 and 6 on p.71 I tried to produce similar results by moving the Greek votive to the same extent, but a different result occurred each time.

The simple exercise on this page reveals how, using a more sophisticated photocopier with a special range of functions, you can plot and record a precise degree of distortion. Known as "Anamorphic Zoom" on some machines, this process allows you to independently enlarge or reduce the horizontal (the X axis on the C.L.C.) and vertical (Y) axis so that it appears as though the image has been either stretched or condensed (depending on which axis you alter). This feature is particularly useful if you need to fit an image into a particular space. If you are using a C.L.C., simply measure the height and width of the space you need to fill and key it into the "Zoom Program" mode along with the

measurements of your original image. The machine will automatically work out the independent percentage enlargement or reduction ratios to fit the space. And using the "Image Angle" program on the C.L.C.500., it is possible to transform a rectangular format into a triangle. This action is perhaps the farthest point of distortion that you can realistically achieve in a single stage. If the original image is placed at a slight angle as it is laid on the copy-glass screen when it is under the independently designated zoom ratios, it is possible to shift the perspective of the entire image to create an oblique copy. The more acute the angle at which the original is placed, the greater the severity of perspective distortion.

Image blurring is more difficult to perform on a color copier than on a black and white model because of the color-copier technology. Canon models have a complex rotary system which electrostatically transfers each of the four process colors onto the paper in a particular order. This means that if you move your image while it is being copied, the four colors will misregister and only one color will blur (see pp.84-85).

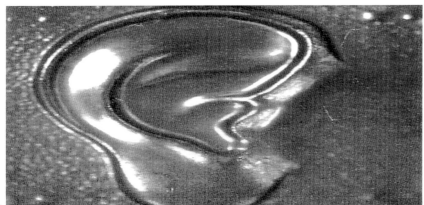

2

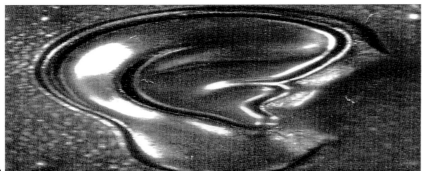

3

4

5

6

7

6 It is possible to stretch your image laterally by reducing the horizontal (X) axis to a minimum of 50 percent and enlarging the vertical (Y) axis by 150 percent.

7 Increasing the height of this print distorts the image even further. To create this effect, I reduced the horizontal (X) axis by 50 percent and increased the vertical (Y) axis to 265 percent.

Previous pages: This misregistration was created by moving the artwork while on the color copier. As with black and white machines, the results can be unpredictable.
(Mack Manning)

Alternative originals

When you combine several different artworks on the copier platen, the resulting montage is often referred to as an "alternative original." This is because the arrangement of artworks is only temporary – the pieces are not glued in place – so when you disassemble them (e.g. to copy another item) you are effectively breaking up your assemblage. The photocopy image is therefore the only record you have of your montage.

The idea of creating something that can be realized only as a color-copy presents intriguing possibilities. The very nature of the color copier's printing system allows you to create montages on the platen that would be impossible to reproduce using other means. Jonathan Hitchen created Robokoptf (see above) from four black and white artworks which he manipulated by exploiting the machine's printing order. The C.L.C. uses a "4-color rotary development system" which scans the original first to determine the color separation, and then the electrostatic drum rotates four times, during which process each toner – magenta, cyan, yellow, and black – is electrostatically transferred one after the other onto the paper's surface. Manipulations that exploit this effect have to be accomplished in a short space of time (about 25 seconds).

1-4 The artist, Jonathan Hitchen, created a series of four separate black and white artworks, each representing different tonal values, by photocopying a computer image (the robot head) and adding white paint and "Letratone."

These original artworks were later combined and manipulated (see steps 5 and 6).

5 To produce this effect, Hitchen took the four different "artworks" and copied them consecutively on the copy-glass screen. The copier scanned every image once for each color and recorded each color as full-color original; i.e. the first image is scanned in magenta, the second in cyan, the third in yellow, and the fourth in black.

The artist had to work quickly because he had to replace one artwork with another before the next "light band" (scan lamp) passed across the screen (otherwise a solid color image would result due to the machine recording the surrounding ambient light rather than the selected artwork).

6 The order in which the copier prints the colors – i.e. magenta, cyan, yellow, and black – is fixed and cannot be changed. However, by swapping the order in which you place the black and white artworks on the platen, you can create many different color combinations. In this example, the color mix of the four colors has changed because the different tonal values of the originals causes each original to register differently in each of the four colors.

5

6

7 Any one of the resulting color prints can be used as a new original and be modified further on the color copier. You can distort them (see p.87), reproduce them as a mirror image, and print them as a negative (as with this stage), re-color them, or even cut them up and paste them into a new collage – the possibil-ities are endless.

Effectively, every color print that is made in this way represents an original image because it isn't reproduced from any one previous image. The closest way to achieve a similar result would be to produce four separate color plates and send them to a conventional printer to reproduce, but this method would be extremely time-consuming and expensive in comparison.

Above (left to right): Robokoptf was produced as part of a research project into the graphic applications of the Canon Laser Copier. The artist's motive in producing this series was to investigate the capabilities of the C.L.C. For this reason, the actual design for the image (the robot head) is secondary to the technology that he was exploring – in this instance, color separations. (Jonathan Hitchen)

7

Alternative originals

1-5 *The artist, Pui Yee Lau, produced four black and white versions of the same image and copied them on the Canon Color Laser Copier in the four separate process colors: magenta, cyan, yellow, and black.*

The C.L.C. always copies in this specific color order, so if you want to change the color of your final image, you must place the four black and white artworks on the photocopier platen in a different order. The order in which you print and register your individual artworks is crucial when you want to obtain an exact tone or hue.

Each of the four original artworks represents a tonal value and color percentage value and the decision to place it on the photocopier screen first in the sequence, second, third, or fourth, determines the final color and density of the new image. If you want to produce a predominantly light pastel image, you must work with very light artworks, while dark images will result in richer, more saturated colors.

1

2

3

4

𝒫ui Yee Lau creates her complex montages using a similar process to that used by Jonathan Hitchen (see pp.88-89). She draws four or more original images by hand on separate sheets of paper and then combines them on the copier platen to produce a single layered montage. Lau established this routine when she started working for the Hong Kong magazine *Ming Pau Weekly*, while studying in London. Lau was commissioned to provide the magazine with an image on a weekly basis, and the most practical way of sending these images was by fax, as a series of "color-plate separations." (This term applies to a black and white artwork that has been designated a percentage process color – for example, 40 percent magenta.)

Lau provided each separate image with a specific color percentage, and the printer in Hong Kong composed the image on a printing press using four separate films. However, unlike conventional printing systems, this method did not allow the dialing of a specific percentage number (such as 40 percent magenta) into the color copier that Lau used (the C.L.C.1). This is because the percentage

levels are already set and calibrated within these machines to provide the user with an accurate average tonal balance. In practice this meant that Lau's first experiments with the C.L.C.1 produced heavy saturated color images which lacked the subtle shades that were evident in the original images that she faxed to Hong Kong. Faced with this problem, Lau concentrated on producing a variety of separate artworks that took this standard color-percentage level into consideration.

She discovered that the most effective method was to create four black and white artworks (made using a combination of collage and drawing techniques) and then photocopy them on a color copier as single process colors (see steps 1-4). The percentage proportion could then be manually altered by adjusting the exposure value on the copier. In order to create a cyan image that would constitute a high percentage in printing terms (e.g. 85 percent), Lau set the exposure to produce a dark print. To create a light version she exposed the image to a lesser degree. These sheets were then used as artworks and placed

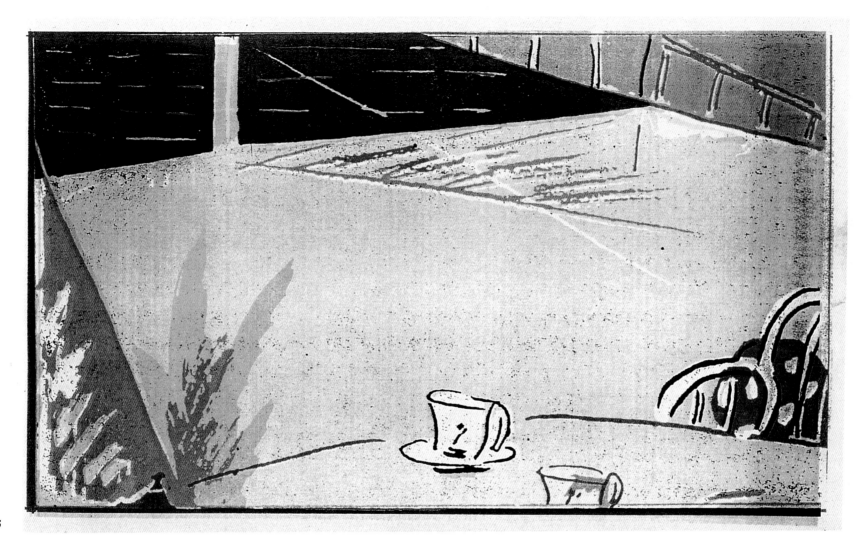

5

on the screen to produce step 5, using the same method as Jonathan Hitchen's (see pp.88-89). Often, she cut up and collaged the prints from these artworks into new forms, sometimes with a dot screen copied onto their surfaces.

It is important to realize that the images on this page are only an initial stage toward producing a modified image. As the images become more resolved and you transfer them onto other paper surfaces (using special solvents, see pp.92-93), they begin to lose their digitized electronic surface quality and take on the soft painted gestural marks that the artist's source images exhibited.

Above Tea for Two *is an original one-off image that the artist created from four separate black and white artworks. It was one of a series of images that she produced on the Canon C.L.C. for an exhibition,*

entitled "Original Copies," while studying Illustration at the Royal College of Art. (Pui Yee Lau)

Overleaf: The Red Doubles *is a color-copy transfer. The artist applied a special*

solvent to the surface of two separate color copies and then transferred them onto high-quality art paper by passing them through the rollers of a heavy stone litho press. (Pui Yee Lau)

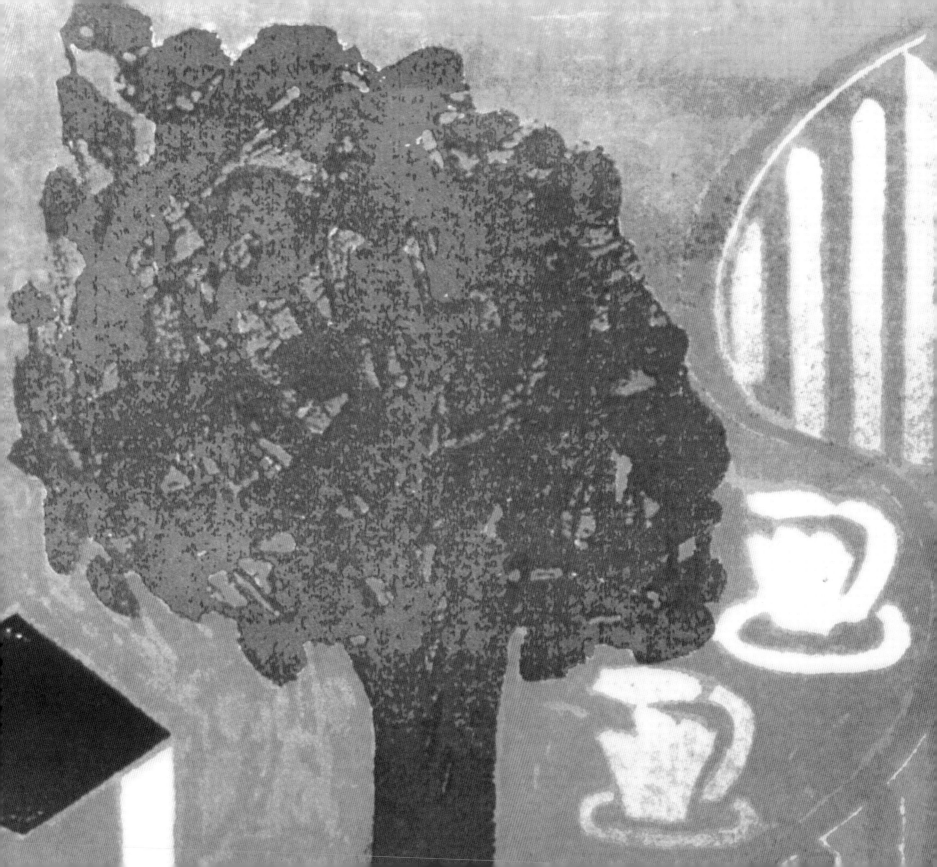

Using the color photocopier as a camera

 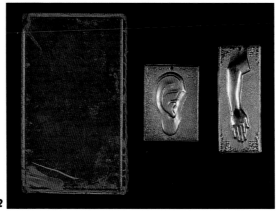

1 & 2 *These two images show the source materials. I selected a Greek metal votive arm and ear, a broken book cover, and a stamp album for this image because they were less than $^3/_4$ inch deep. This meant that the color copier (in this case the Canon C.L.C.1) could faithfully record their details.*
3 *When I placed the metal ear on the photocopier platen together with the stamp album, the combined depth of the two objects was greater than $^3/_4$ inch. This meant that although the detail on the ear would record, the blue texture of the album would register only as a gray blur or smudge (not shown). In order to produce a satisfactory result, I had to copy the blue stamp album and brown book covers together first and resolve their color tone before adding the arm and ear.*

Next, I copied the metal arm and ear by themselves. (This was because each required a different color shift). I shifted the color balance of the ear toward the blues and the arm toward the reds (see pp.88-89 for information on "altering the color balance").
4 *Once I had achieved a satisfactory color, I assembled the color-copied elements and pasted them together to create a new* *artwork. I enlarged this 12 x 16$^1/_2$-inch artwork by 400 percent, using the C.L.C.'s "Multi Page Enlargement" facility and printed out 16 12 x 16$^1/_2$-inch sheets. After pasting these together, I glued them to a plywood base using a water-soluble adhesive (in this case wallpaper paste). Finally I varnished the ear and the arm to complete the image.*

*Y*ou can achieve similar results to those produced by an instant camera by building small-scale assemblages on top of the copy-glass screen and reproducing them as color copies. Photocopiers can reproduce an image in seconds, and the vast array of creative programs that color models offer enables you to adjust the color balance quickly, without having to wait for the film to be processed (as with conventional cameras). The main drawback of reproducing objects in this way is that, unlike a camera lens, the focus of a color photocopier cannot be adjusted.

It is important that you consider the following points when using the color copier as a camera: make sure that your chosen object fits onto the copier platen; select an item that will fit onto a standard-sized photocopier paper; and choose something with at least one flat surface and a maximum depth of $^3/_4$ inch. This is because the laser scanner is unable to recognize objects that are deeper than $^3/_4$ inch – anything deeper tends to register as a black mass. I chose a stamp album, a book cover, and two small Greek votive offerings for this collage. I selected these particular items because they vary in color and texture and, more importantly, they are not very deep, so the color copier is able to record their details.

The Canon C.L.C. series is ideal for photocopying objects in this way, and although its focus depth is limited, its speed of recording, digital processing, high resolution, and infinite color modifications make it an interesting alternative to any camera. You can reproduce flat or textured surfaces with great accuracy using this method – from books and glass to leaves and bones. You can also use this technique to copy several small objects at the same time; the immediacy of the print allows accurate positioning and color or exposure control. If you place a black cloth over your assemblage of objects, the copier will record only the objects that are closest to the screen; the areas between the objects disappear into the black. These prints can then be recopied and reassembled into new collages until their composition and color saturation are resolved. This method doesn't replace the freedom or control over the sharpness of an image offered by photographic processes. However, its immediacy and versatility makes it an interesting alternative if you don't have access to a color darkroom.

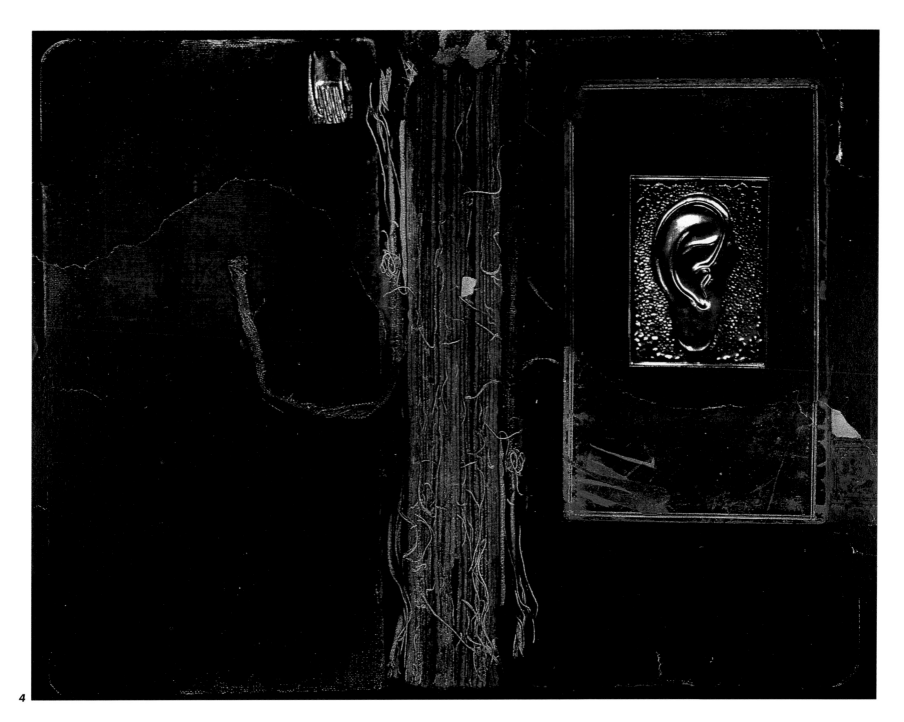

4

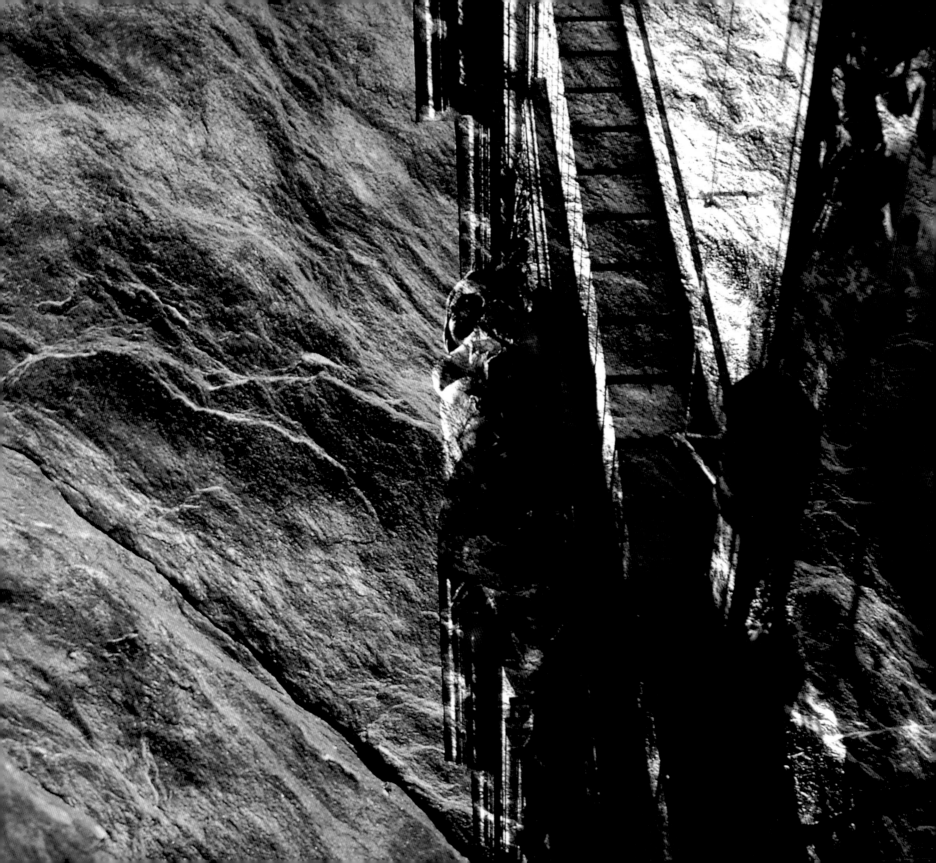

Introduction to *Photographic Processes*

*P*hotography is one of the most accessible and diversified media we have for image generation. Almost everyone has a camera, and most towns have "photo labs" capable of processing and printing your films in about an hour! However, this is photography in its most immediate and conventional form. The next few pages explore a range of photographic processes that are more specialized in nature and require the use of a darkroom.

The making of a photographic image can be a many-staged process. First, the image has to be recorded on film. This may involve setting up the subject matter – for example, a still-life tableau or an event acted out by friends. The next stage is the photography itself – and here again there are many choices open to you. For example, you may decide to shoot in color or in black and white, or you could decide to expose the film to more than one image prior to processing. Once the film has been processed, the next stage of image manipulation is known as "post-productive" (i.e. it is carried out after the picture has been taken), and this stage controls the way the latent image will appear: as a print in color or in black and white; its final color bias; and whether it is a straight reproduction from the negative/positive image on film or whether it becomes a heavily contrived image. Film images may also be combined by printing them one at a time onto the same sheet of paper (multiple prints), or film images can be physically combined in an enlarger and printed simultaneously (film sandwiching). There are no set rules for working in the photographic medium, and processes may be combined to achieve specific effects.

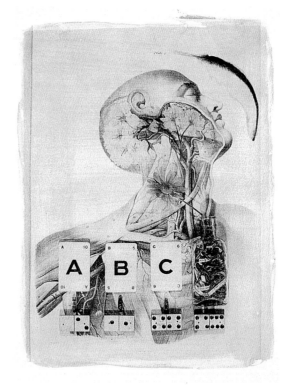

Far left: Two different negative transparencies were sandwiched together to create Sierra Toulouse *(see p.124 for instructions on how to make a film sandwich).*
(Lol Sargent)

Left: An old engraving and an assortment of objects are the subject for this still-life photomontage entitled The Love Series. *The artist printed the image onto watercolor paper using the photographic emulsion Liquid Light (see p.116).*
(Emma Parker)

Photography: *Design Approach*

\mathcal{T}he power of the photographic image and the flexible processes that are involved in creating such images make photography an ideal medium for the would-be montage artist.

You can reproduce a photographic image in a number of different ways: as a color photograph, a black and white image, or even a combination of both. Photographs come in all sizes – from an inch to several feet or yards – depending on the paper size that you choose to print them on. Photography gives the artist a huge degree of control over how much of the image is reproduced on paper or film. For example, you can print only a tiny fragment of your negative or positive film and enlarge that area to the point at which the grain becomes so magnified and its detail so abstracted that its original source is virtually indiscernible; or you could print the entire image using the edges of the film as a border. Another advantage of working in this medium is that it enables you to capture and control the amount of light that falls on the subject and use it to creative effect. The camera can record whatever is placed in front of its lens and, in doing so, creates a "living" document of what it has recorded – a photographic truth. However, the creative process doesn't stop here, because you can go on to manipulate the truth using complex darkroom processes such as lith printing and bleaching or toning, and this is what makes cameras such versatile tools for montage work.

Perhaps the simplest method of creating a photomontage is to place two different photographs next to each other on a single page. David Cross uses this technique as a means of addressing current environmental issues in his work: "Photomontage seemed the best way to bring to the work a degree of visual realism without imposing the sort of perspective offered by a single viewpoint." He divided his disturbing image of a blazing fire and a frenzied blur of foliage, entitled *Both Worlds* (see right), into two in order to suggest the split-screen device that is used in film and television to show both parties in dialogue. Cross deliberately chose to record the foliage as a blur because it helped to abstract the image before it was incorporated into his photomontage. The vibrancy of the two colors (the orange of the flames and the green of the foliage) demonstrates the photographic power of color: "I used photography to vividly depict color and texture of material things while also evoking a more sensual experience." These colors can be manipulated at the printing stage for greater saturation. At every stage in the image-creation process – from the taking of the photographs to the pasting of the photomontage – you have the chance to control the degree of

Right: Artists often use their work as an outlet for expressing their political or environmental feelings. David Cross wrote the following text to accompany Both Worlds:

"Combining short rotation forestry with advanced bio-fuel technology to produce alcohol, gas or charcoal offers great potential to use wood as a renewable energy source.

Besides helping to stabilize global carbon dioxide levels, the new 'energy forests' would filter out dust particles and pollutants, improving local air quality." (David Cross)

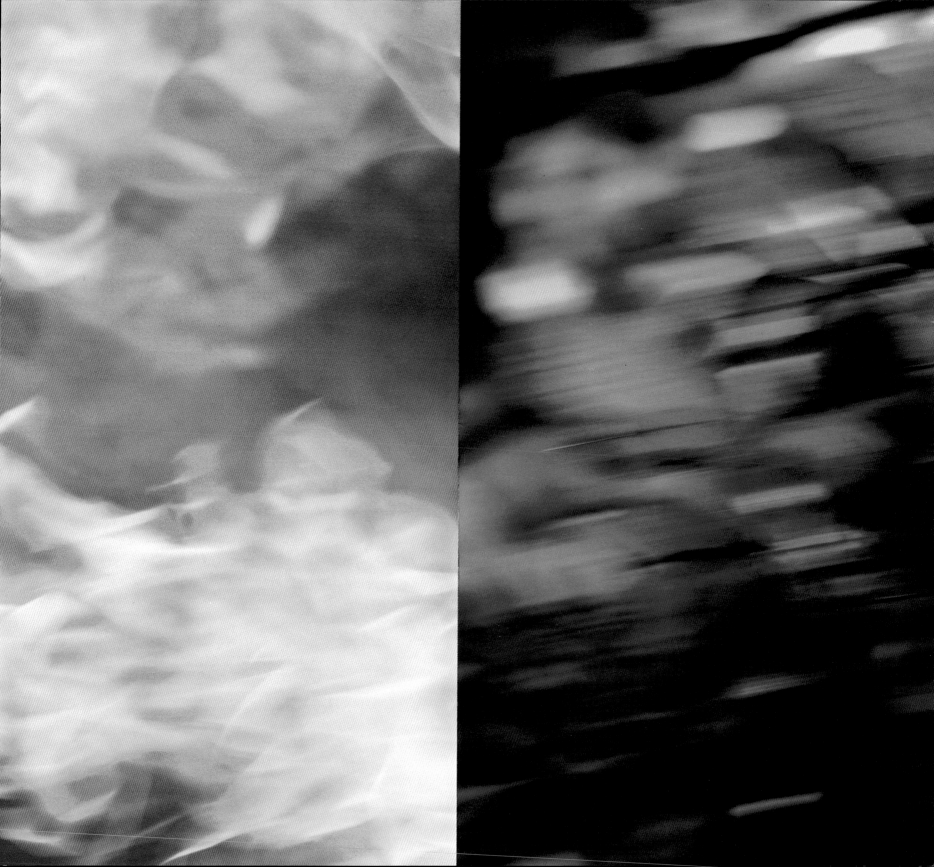

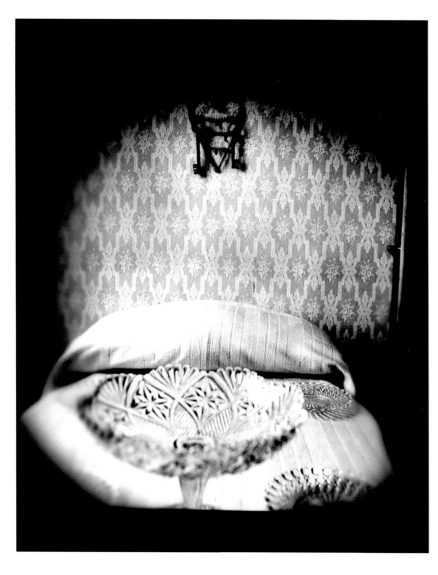

Above: Several photographs were combined with the use of Polaroid film to create Dai Nommi (Tuenno), *which was inspired by the artist's dreams.* **(Diana Grandi)**

manipulation until the image reaches a point at which you feel that it is resolved. Another very important aspect of Cross's photomontage work is his use of photographic images with text. Unlike the work of Archer/Quinnell and Richard Caldicott, in which text or fragments of words are incorporated for their shape as much for their language, Cross's work incorporates text that relates "to our consumer society and to aspects of the natural and social environment on which it depends" (see previous page).

Montage and darkroom processes can be used as vehicles to express our more subconscious desires. Dreams and menace are two themes that consistently prevail in photographic imagery. Photographic truth gives way to fantasy which echoes the Surrealist themes of the 1920s and 1930s. Darkroom manipulations can create bizarre imagery which is sometimes greatly removed from the original image, sometimes not. An image can be subjected to a torturous series of post-production techniques such as solarization and bleaching; or it can be printed and then toned to give it a subtle finish that captures the eye.

The Italian photographer Diana Grandi is obsessed with expressing her dreams in her work. Grandi exploits the power of the black and white image and, unlike David Cross, modifies her work with complex darkroom techniques. "The accidental elements occurring between the first and second stage together with chance have always played a crucial role in my photography." Grandi prints the first images (or sections of the final image) as black and white prints and then rephotographs them onto Polaroid film. The Polaroid is peeled apart and the resulting transparent film is used as a paper negative from which Grandi makes her prints. Often, she applies this negative to another sheet of paper after "combing" it first with water. The wetting process causes part of the image to print clearly while other areas print as a mottled blur. This process gives Grandi's photographic images a mysterious, shadowy haziness – the kind that is often associated with dreams. The results are hard to repeat, and this makes them unique, not only in their externalization of Grandi's most personal dreams, but also as printed images.

Whereas Diana Grandi explores themes of sensuality and mystery in her photographs, the sense of the bizarre and an uneasy atmosphere of menace prevail in the photomontages of Nicolas Georghiou. He distorts photographic truth by combining a variety of seemingly unconnected images (for example, a boy and a shoal of fish) and skillfully manipulates them until he produces an uneasy mood. Uneasy in the sense that the exact composition of the environment that holds his image is undiscernible by the viewer: are the fish and child perching precariously on a kind of solid rock, or are they submerged in a unidentifiable liquid? His use of scale and texture is deliberately ambiguous, making it difficult

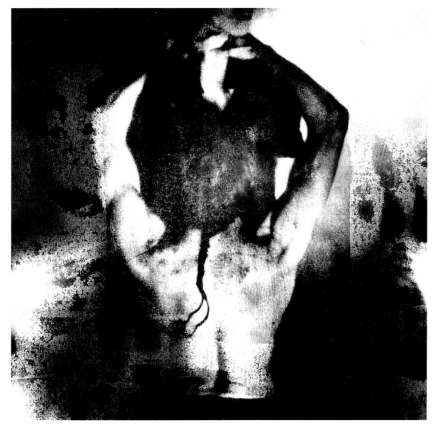

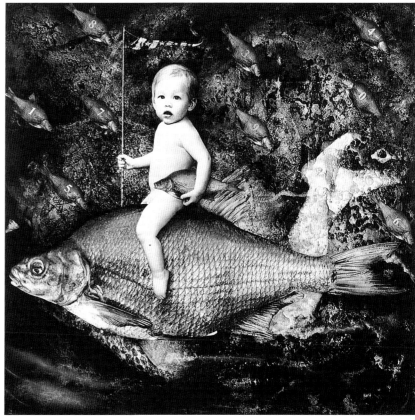

Above: Darkroom manipulations often result in bizarre dreamlike images, like this piece which is entitled **Man is Woman.** *(Diana Grandi)*

to distinguish between background and foreground. Georghiou's use of photographic toners further disrupts the smooth surface of the print and gives his work a sense of the third dimension.

You can also use photographic lighting effects to create color montages in a way similar to a multiple exposure. This approach is evident in the photographs of Steve Wallace, who uses color filters to create, strengthen, or mute the colors that define a subject and fill the shadows with complementary colors. His lighting sets are only temporary – he dismantles them once he has taken the photograph, at which time the assembled objects become redundant. Wallace has to rely on his previous experience and knowledge of "light mixes" in order to work in this way. He interrupts the flow of light using opaque and semi-translucent objects which cast elongated shadows and auras across his tableaus: "I light sections in different ways in one shot, exposing each lighting situation on top of another."

Above: Photomontage and multiple printing techniques have helped to distort photographic truth in this image, which is entitled **Boy on Fish.** *(Nicolas Georghiou)*

Materials and Equipment

Photographic

Left: Polaroid film was used to recreate a snapshot feeling when old photographic portraits were superimposed on photographs of suitcases. The artists used a grid as a device to suggest large numbers of people. (Douglas Brothers)

Camera formats can be divided into three categories: small format, which covers 35mm cameras and the smaller 110 cameras; medium format, which includes roll-film cameras, the most common being 6 x 6cm and 6 x 4.5cm; and large-format cameras, encompassing field, technical, and monorail models, which use sheets of film measuring up to about 11 x 14 inches. From the user's point of view, each type of camera has advantages and disadvantages.

Small-format cameras — the most familiar and by far the most popular being the 35mm camera — offer lightness, speed of operation, and convenience. Two types of 35mm camera exist. Compact cameras have a direct-vision viewfinder positioned above a permanently mounted lens. This lens may have dual focal length of, say, 28mm and 45mm, or it may zoom between about 35mm and 70mm. These cameras are often highly automated, with autofocus, autoexposure, and motorized film transport. The other type of 35mm camera is the single lens reflex (SLR). This is a more flexible instrument, often used by professionals because it can accommodate an enormous range of different lenses. And because the scene is always viewed through whichever lens is on the camera, the viewfinder is very accurate indeed. The main drawback on the 35mm camera is that the film itself is small, and so large-sized prints made from it may lack fine details.

Medium- and large-format cameras have the advantage of a larger film area than 35mm, resulting in sharper, crisper enlargement with a wider range of tonal values. The disadvantages of working with these cameras is that they are expensive to buy and run and they are also bulky and heavy to use — often, the use of a tripod is mandatory. Medium- and large-format cameras are not usually electronic and so require manual adjustment of the shutter speed and aperture, which slows down the picture-taking process. Many of these cameras will accept Polaroid backs, and the resulting instant pictures often make good collage material.

The process camera (also called a photomechanical transfer camera) is another good reprographic tool that is widely suited to montage work. The main drawback of these machines is that they are not as accessible as cameras and photocopiers. Process cameras are designed to produce line prints and films, but they can also be used to convert images into dot screens from which screenprint stencils are made, a technique used by Carolyn Quartermaine (see p.43). They are also useful for recording compositions of collage elements, which can then be manipulated during processing (see Vaughan Oliver's work, pp.106-107). And as Andrzej Klimowski has shown on p.105, the films from process cameras can also be used as collage devices in their own right.

The variety of photographic materials is too great to examine in detail here, but the following list should give you some idea of the materials that are currently available. Photographic films are produced in a variety of sizes to fit all camera formats. These include 35mm film (in exposure lengths of 36, 24, 20, and 12); 120mm and 220mm film, which covers the 6 x 4.5cm, 6 x 6cm, 6 x 7cm, and 6 x 9cm formats (and enables the maximum of 12 or 24 shots); and single-sheet films in sizes ranging from 4 x 5-inch to 16 x 20-inch.

Photographic films are available in both black and white and color and in a variety of different "speeds." Film speed is a measure of its sensitivity to light – the more sensitive (or faster) it is, the higher its ISO number. An increase in film speed is usually accomplished by using larger grains of silver halide material within the emulsion. As you increase the size of an enlargement made from a negative or positive (slide), so the visual appearance of these grains becomes more intrusive, especially with faster types, and the less subject detail and tonal definition can be recorded. A film of ISO 25 has grain that is barely perceptible when enlarged, while the grain of an ISO 3000 film may appear "golf ball" size when enlarged to the same degree.

Photographic papers are equally varied. Black and white papers are available in a range of finishes – from plastic-based, resin-coated types, which offer speed of processing and drying, to fiber-based kinds available in various weights which, although requiring longer washing times, produce a wider range of tones and often respond better to post-production techniques. The surface finishes of these papers range from glossy types to softer "orange peel" surfaces. Papers for color prints are all resin-coated. For printing slides, a commonly used paper for budget prints is known as an "R type," while more expensive prints from slides are known as "Cibachromes." Prints from color negatives are known as "C types."

Chemicals for both print and film processing are produced in many varieties and under a multitude of brand names. Basically, a developer is used to bring out the latent (invisible) image produced either on the film (by its exposure to light from the subject) or on the paper (by its exposure to light from the enlarger shining through the film original). Next, a chemical "stop" bath is used once the film or paper image has reached the correct stage of development, and then a "fixing" agent is used to render the paper or film insensitive to further exposure to light.

Colored toners are available in a wide variety of colors to suit the effect you want. These range from blues (iron and gold toners), browns (sepia), red/brown (copper and gold toners) and greens to yellows and any permutation in between. Bleaching agents, such as potassium ferricyanide, remove the silver within the print image, producing a pale buff color. You can also use metal toners, such as selenium and gold. When diluted, these give subtle shifts in print contrast and provide archivally permanent images. In addition, there is a selection of dyes that can be used to hand-color the surface of a print.

The light source used to expose the photographic paper is an important factor in determining the appearance of a final print, especially for techniques such as photograms where an enlarger lens is not necessarily being used. The simplest light source is a low-wattage lightbulb, somewhere in the range of 15-25w. Low-power sources are useful if you want exposure times long enough to enable you to manipulate the image being created on the photographic paper. Flashlights are another possible light source, and instead of being fixed in one position, as most lightbulbs are, can be moved around so altering the angle of the light being reflected off or transmitted by the objects on the paper.

However, the most controllable light source is that from a photographic enlarger, since it allows accurate, repeatable exposures. Enlargers designed for black and white work can be divided into two main categories: those that use condensers to focus the light before it reaches the enlarger lens and those that use a cold cathode light tube. Enlargers designed primarily for color work employ a diffusion system that thoroughly mixes all the wavelengths of light coming from the enlarger light source before passing it through to the lens. From the user's point of view, a condenser enlarger produces images that are sharp and crisp and that have good contrast between the different shades of gray that make up a black and white image. Cold cathode and diffusion enlargers use a type of frosted glass or plastic to mix and diffuse the light source. These enlargers produce a slightly softer result than you would get from a condenser type, but this isn't necessarily a disadvantage since it may suit your subject matter.

With all types of enlarger, you control the duration of the exposure via a mechanical or an electronic timer. Exposure is governed not only by the length of time the enlarger light remains on, but also by the aperture of the enlarger lens. This lens focuses the image of the film original, positioned in a special holder between the light source and the back of the lens, and projects it onto the photographic paper on the enlarger's baseboard below. Selecting different lens f-numbers, as you would on a camera, changes the diameter of an aperture inside the lens and so allows different amounts of light to pass through. Changing f-numbers also affects "depth of field" – the range of subject distances that all appear sharply focused – with small apertures (high f-numbers, such as f11, 16, 22 and 32) having inherently greater depth of field than large apertures (low f-numbers, such as f2, 2.8, 4, and 5.6). If you stop the lens down to an f-number such as f32 in order to maximize the depth of field of a film original, you may have to compensate for the light lost by significantly increasing the exposure time, thus making the whole process very time-consuming.

Right: This photomontage, entitled Disguise, *was shot on Kodalith film. (Andrzej Klimowski)*

Overleaf: Process cameras can be employed to produce startling montages, especially when

their chemicals have been exhausted, as this haunting image shows. (Vaughan Oliver)

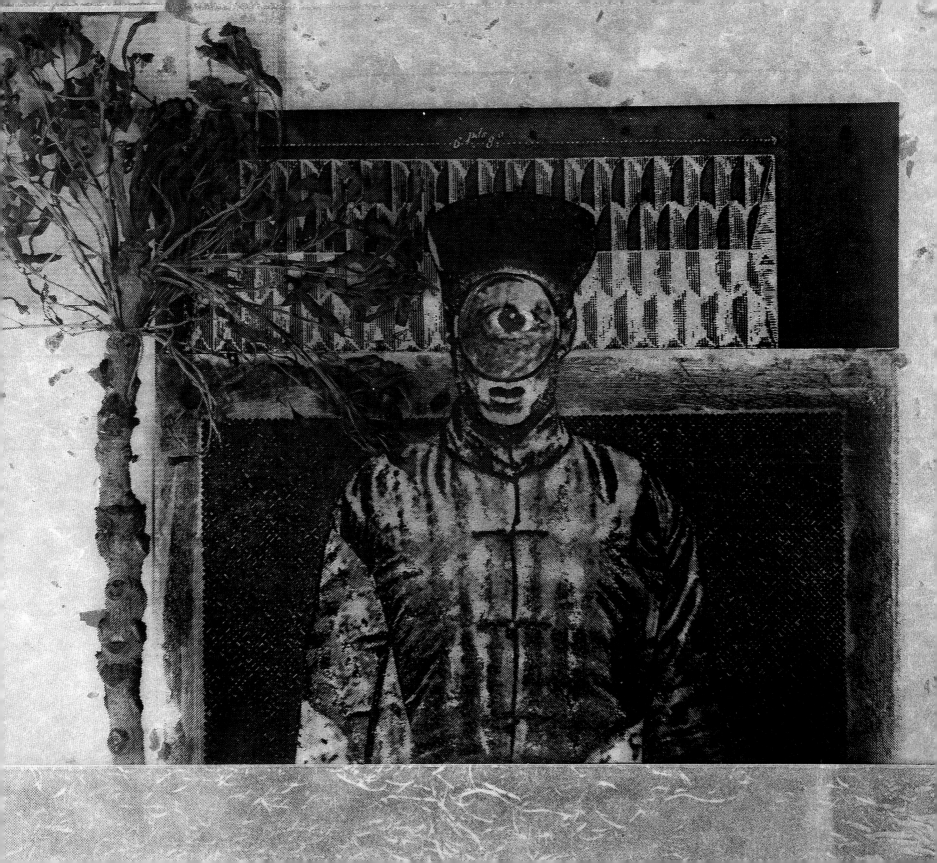

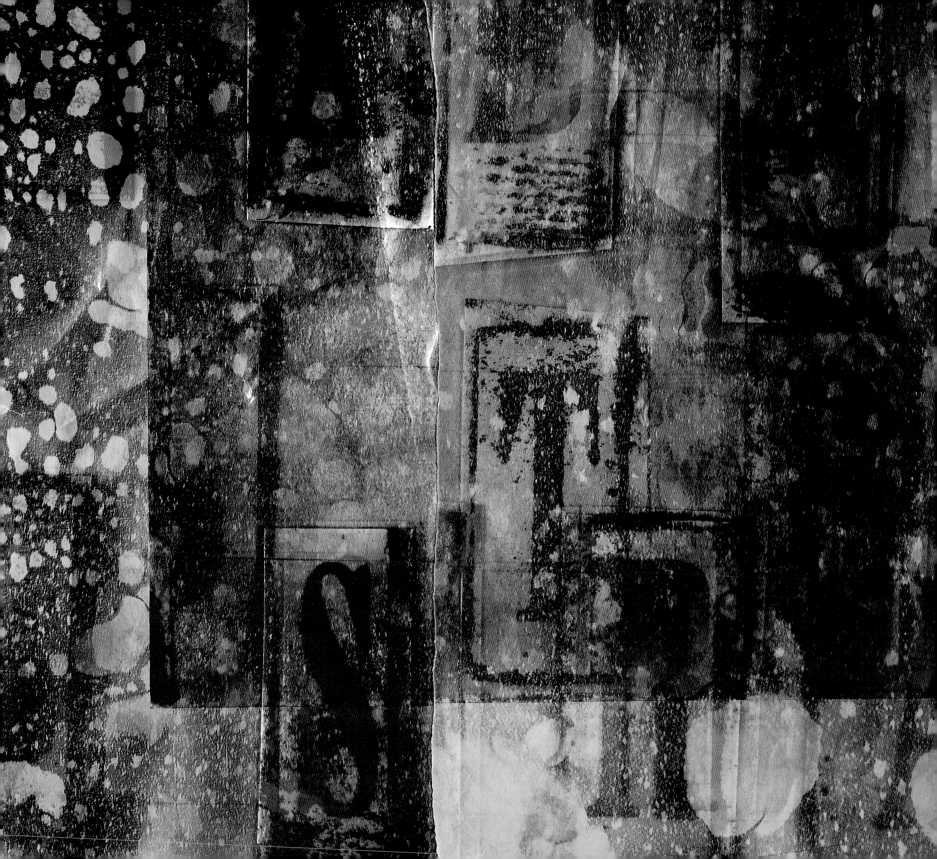

Bleaching *and Toning*

At its simplest, bleaching and toning consists of just the two stages the name of the process implies. First, you apply a bleaching agent (commonly a solution containing potassium ferricyanide) to the print in order to reduce the visible image to a pale buff, and then you apply a colored toning agent. The most commonly used toners are sepia, which produces a range of browns, and iron blue, which gives a generally cold-blue image tone. Even when used without a toner, bleaching can be an extremely effective technique (see right). The bleach gradually eats away at the image, and if it is applied locally with a cotton ball, you can easily control the appearance of small areas of the image. By manipulating the tonal values of important areas of the subject, you can see how the look of the whole print could be substantially altered.

On a broader scale, it is possible to suppress unwanted parts of the subject completely by gradually bleaching them away to the white base color of the paper, perhaps creating a soft-edged vignette. Dark, underexposed parts of the print can also be lightened, with new textures emerging out of the formerly dull shadow areas. Colors such as peachy browns may also suddenly appear as the bleach eats back the black image tones. As with many darkroom processes, the only rule is to experiment. Not every printing paper and developer combination reacts favorably to being bleached.

Split toning

There are several toners that, when combined, produce an attractive "split-tone" effect. For example, if you were to partially develop a print in selenium toner,

wash it for 20 minutes, and then place it in a bath of gold toner, a curious color effect would occur. When the selenium takes to the silver emulsion, the print develops a rich brown color; but where the gold toner takes hold (usually in the image middle-tones) a blue color emerges. Used individually, both selenium and gold toners are effective for protecting prints against the harmful effects of ultraviolet radiation and are thought to retard print deterioration. And both toners increase the overall contrast of prints, making them appear crisper and more punchy. Selenium on its own produces purple to brown tones, and on some papers it gives a split-tone effect as the image blacks warm and color creeps into the middle-tones, while the lighter image tones are preserved as pure grays. The gold toner shifts print color toward a cold blue hue, but not a blue as intense as you would achieve by using iron-blue solutions. Even after you have toned a print, bleaching is still possible, but bear in mind that results will be unpredictable.

Sun prints

The decision to bleach and tone a print is usually made after the printing stage, and it may be unnecessary if, for example, the image is intended to be cut up and collaged into something else. However, there is one image-manipulation technique that cannot be fully achieved without the use of toners. This procedure can be hard to repeat, but the results are well worth the struggle.

The prints from this process are sometimes known as "sun prints" because the images are made using sunlight or some other strong ultraviolet light source. A black and white negative is placed in direct contact with special paper known as P.O.P. (Printing Out Paper). Since the negative and paper are in contact, the final image will always be the same size as the film original. Usually 5 x 4-inch and 10 x 8-inch negatives are used, since anything smaller may produce a print that is very hard to read. (If necessary, smaller originals can be duped onto larger film formats, although this process may result in loss of detail and sharpness). A suitable negative and the P.O.P. paper are placed in a contact printing frame, which is specially designed to press the negative paper together. The frame has a split back that enables half of the image to be inspected during the exposure (best done in subdued light), while the other half of the paper is held in firm contact with the negative. The exposure can vary from minutes to hours, depending on the density of the negative and on the intensity of the light source. Once the image has been suitably exposed and the print has reached the required density, you must wash it to remove excess silver nitrate and then gold tone it to prevent it from fading and losing its beautiful color.

The colors from sun prints can vary enormously, ranging from shades of brown to violet/red blacks. Although the sun printing process is unpredictable and the availability of the special paper needed is unreliable, it has the appeal

of representing one of the older photographic processes, one that was commonly employed by portrait photographers at the turn of the 20th century. The rich tonal range and colors produced are aesthetically very appealing and quite impossible to produce in any other way.

WARNING: Some chemicals used in bleaching and toning may cause skin irritations. Gloves should be worn when handling poisonous substances such as selenium. The need for adequate ventilation cannot be overemphasized. Manufacturers' instructions must be followed.

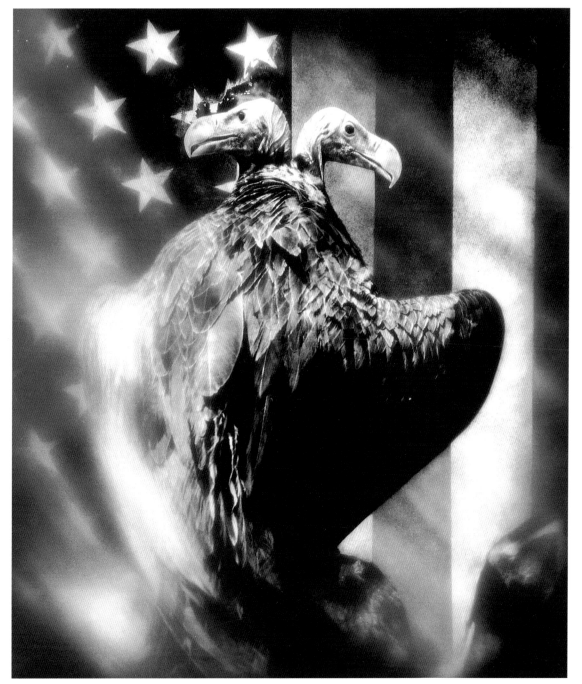

Left: This image was reproduced on Printing Out Paper and then exposed to an ultraviolet light. Sunlight is a good alternative if you don't have access to ultraviolet lights. After exposure, make sure that you store your sunprint in a dark place. Applying gold toning to your sunprint helps to protect its surface and retains the delicate tones that are inherent in this ancient printing process. (Marguerite Suto)

Left: It is possible to produce a three-dimensional effect by split-toning a photograph. The "split" usually occurs between the dark and middle tones. However, if you use more than one toner the split becomes more noticeable and produces rich tones. The artist combined selenium and sepia to produce this multiple print, which is entitled Two Headed Vulture. (Nicolas Georghiou)

Below: I created this image by photographing a medical eye onto Polaroid film and subjecting it to heat to solarize the image. Changing the exposure and extending or reducing the development time enables you to control the overall contrast of the image. (Simon Larbalestier)

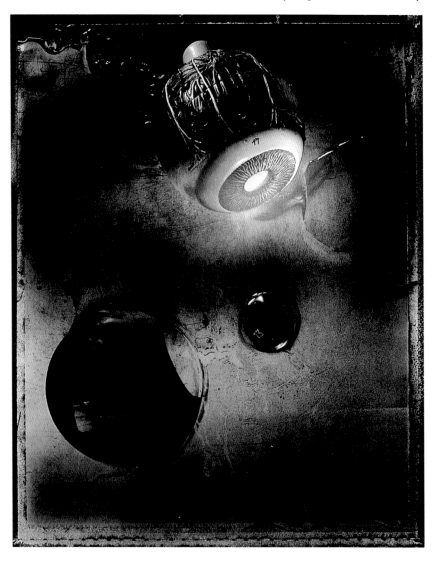 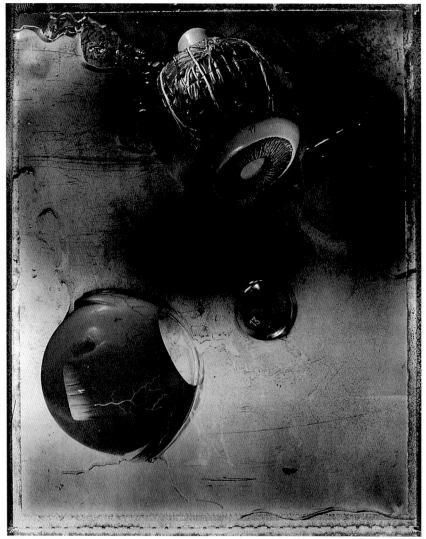

Lith Printing

There is a method of processing paper types so that each will produce a distinctive result when further manipulated using such techniques as bleaching and toning (see pp.108-111). This method is known as lith printing. Lith film, paper, and developer allow you to make high-contrast graphic images from conventional continuous-tone negatives. The results from lith printing are contrasty to the point where the image is either black or white, with no gradations of tones between the two as you would usually see in a normal image. However, there are also ways of producing continuous-tone prints that can later be toned so that each density of tone on the original reproduces with a distinctive color. This form of lith printing relies on the fact that the lith developer is the most influential ingredient in the whole process, and if you sufficiently dilute the developer, specific results are possible, depending on the paper type being used.

Determining the degree of dilution that the lith developer needs for this technique to work is a matter of experimentation, and the strength of the developer required can vary depending on the type of image you are working with as well as on the paper being used. As a general guide, if a dilution of 1 part developer plus 3 parts water (1 + 3) is used to make a normal high-contrast lith print, then try dilutions of between 1 + 6 and 1 + 20. When determining the length of time the paper needs to be exposed under the enlarger, you will need to give an exposure time that is at least twice the normal length, effectively overexposing the image, in order to compensate for the reduced strength of the developer being used.

During the exposure, you will need to give the highlight areas of the image (corresponding to the dense parts of the negative) as much additional exposure as possible to allow them to develop at the same rate as the shadow areas (corresponding to the thin areas of the negative). This means that you may have to retard the exposure of the shadow areas by holding your hand, or a piece of cardboard, so that it interrupts the light from the enlarger over these selected parts. This technique of holding back certain areas of a print is known as "dodging."

Once the exposed paper is immersed in the developer, nothing should happen for about three to four minutes. After that time, the print starts to develop very rapidly, and a flat, soft image begins to emerge. The highlights, which received the extra exposure under the enlarger, should develop at the same rate as the dodged shadow areas, and there then comes a point where the entire print appears overexposed and lacking in contrast. Then, if you have got the exposure and the developer strength correct, the black within the image starts to creep into the shadows and spread into the middle tones. This is the stage where the print builds up contrast and the color of the print is determined. This type of image development is known as "infectious development," since areas of black visibly spread across into other areas. As soon as this point of development is reached, you need to remove the paper from the developer tray and immerse it in a stop bath of 80 percent acetic acid. This will instantly curtail development and so prevent the image from darkening any further. The paper can then be fixed in the normal way and viewed in ordinary white light after about a minute in a fixing bath.

It may be that the print has not worked just the way you wanted, and so you may have to make another using different exposure times for the highlights and shadows or slightly different ratios of print developer to water. If the image is too dark overall, it needs to spend less time in the lith developer. If the image is too contrasty and the highlights are not sufficiently developed, more exposure is needed at the printing stage. If the print is too flat and generally lacking in contrast, less exposure time is needed to increase overall contrast. As a rule, the longer you expose the paper under the enlarger, the greater the range of tones in the resulting image and the richer the print color. Once the print has been satisfactorily developed and fixed, it must be thoroughly washed to remove any chemical residue that may degrade the image over time. Washing may take as long as 90 minutes with some fiber-based, triple-weight papers.

Making *Photograms*

Right: Fruit and vegetables are dramatically transformed when they are laid directly over photographic paper and exposed to light. Their abstracted negative shapes blend into each other to create a surreal montage. All animate and inanimate objects offer potential for making photograms, although translucent or transparent items are often the most successful. (Diane Gray)

The making of photograms is one of the most direct methods of creating "layered" imagery (e.g. images that blend into each other) by photographic means, and the materials required are relatively simple and easily accessible – photographic paper, a light source, and a range of semi-translucent objects.

The objects you intend to use to make your photogram must first be placed on top of a sheet of unexposed photographic paper and then exposed to light, either from an enlarger or from some other light source. The light will pass through your source materials to varying degrees, depending on their composition, before reaching the paper beneath, where ghostly negative represenations of the objects will be seen on the paper's surface once it has been developed. When using black and white paper, you can use a special orange/yellow or red-colored safelight, which allows you sufficient illumination to work by.

The processing procedure for a photogram is exactly the same as for any conventional black and white print. Development takes approximately one and a half to three minutes (depending on the type of paper and developer used and the length of the exposure), after which time the print must be immersed in a solution of acetic acid (stop bath) and then fixed for several minutes before being washed thoroughly to remove any fixer residue. You may view the print in normal white light after it has been in the fixing bath for a minute or two.

The list of materials that are suitable for making photograms is endless – so long as it is semi-translucent it has potential. Natural forms, such as flowers, leaves and feathers, as well as materials made from plastic, glass, resin, latex, silk, and paper can all absorb light as well as allowing a certain amount to filter through. The more opaque the objects used, the more light they stop, and the result of using a completely opaque object is a white silhouette (known as a "highlight") in which no light reaches the paper at all. Conversely, very transparent objects, such as glass products, allow light to pass through virtually unhindered and so produce a range of dark gray to black tones on the paper.

A variety of unusual effects is possible by continually moving some of the objects on the paper throughout the exposure. Once developed, the print will show ghostly half-images that seem to blend into the images of the fixed objects. And by placing some objects on a sheet of clear glass above the paper, you can create an overlapping effect as the images of the elevated objects combine with those of the objects beneath. Indeed, it may be difficult even to visualize how you created the effect or which objects you used to produce the photogram.

This leads to one of the most important creative factors in the making of photograms – the unpredictable nature of the process. You cannot always previsualize how much light an object is going to transmit, and the edges of the object itself may not correspond to the edges of the image that appear on the paper. Therefore, a composite montage image has to be built up, one that demands that you experiment with the exposure, the translucency of different objects, as well as their placement on the paper, until you achieve the desired result. Creative decisions are often made after exposure and processing, not necessarily when you first arrange the composition.

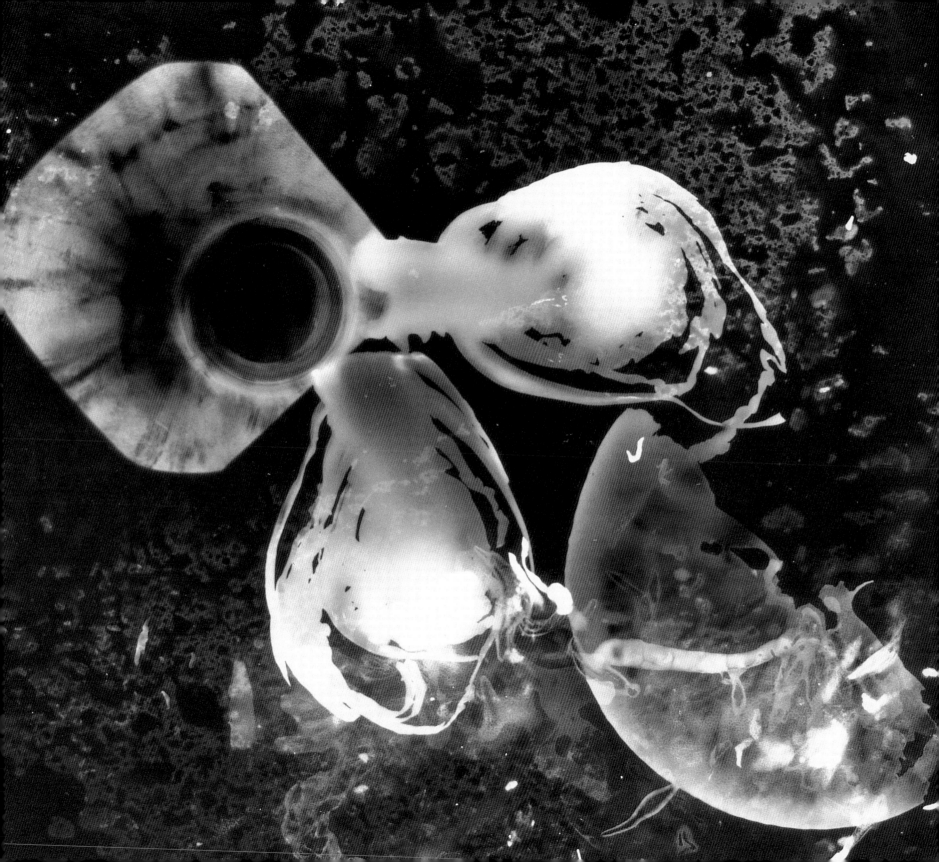

Using *Liquid Emulsion*

In any collage project there comes a point when the papers available simply do not fit your requirements – and the same is true with photography. Although photographic papers are available in an extensive range of sizes, weights, and finishes, it is sometimes necessary to print onto unconventional surfaces, such as wood, glass, fabric, canvas, ceramics, and even three-dimensional objects. To achieve this, a liquid, light-sensitive emulsion, known as "Liquid Light," is available from specialist photographic suppliers. Before applying it to your chosen surface, make sure that you read the manufacturer's instructions thoroughly.

The emulsion is applied with a brush or spray gun in a darkroom lit by safelights. Before it can be applied, the emulsion (which is solid at room temperature) has to be heated until it becomes liquid. It is extremely important that you achieve an even coating; otherwise the image will not reproduce properly on the sensitized surface. Warming the surface to be treated before applying the emulsion will ensure a more even coating, since it tends to solidify too quickly on a cold surface. Some surfaces, such as wood, are very porous, and these are best sealed with a sealant first, while others, such as glass, need to be free from grease before the emulsion will adhere evenly. Once you have applied the emulsion, leave it to dry in total darkness for at least 12 hours before printing on it, otherwise the surface may blister. Once dry, it can be exposed in the same way as photographic paper, although longer exposures may be required since its sensitivity to light will vary and consistent results cannot be guaranteed.

Left: The artist applied a photographic emulsion (such as Liquid Light) to the peeling painted surface of a piece of wood to create The Magician. *(Steve Wallace)*

Right: This photomontage was used as the source image for The Smiling Illusions of A Tragic Reality *which is featured on the far right. The artist printed a negative of the original photomontage onto a large sheet of watercolor paper using Liquid Light and finally embellished the surface with oil paints and varnish. (Emma Parker)*

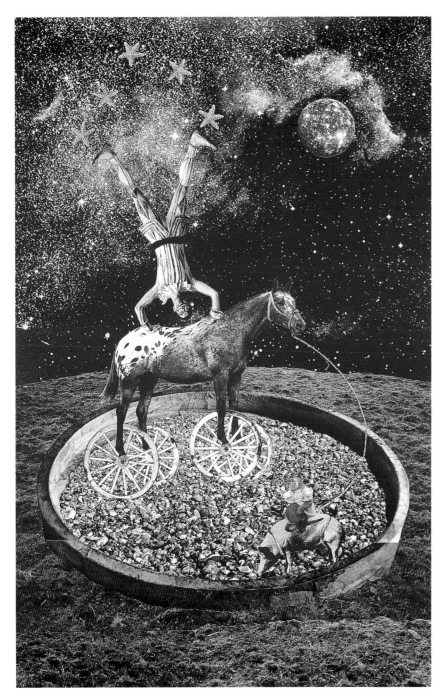
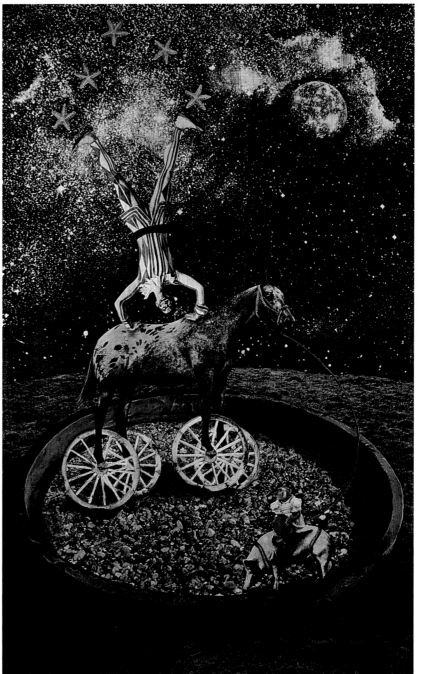

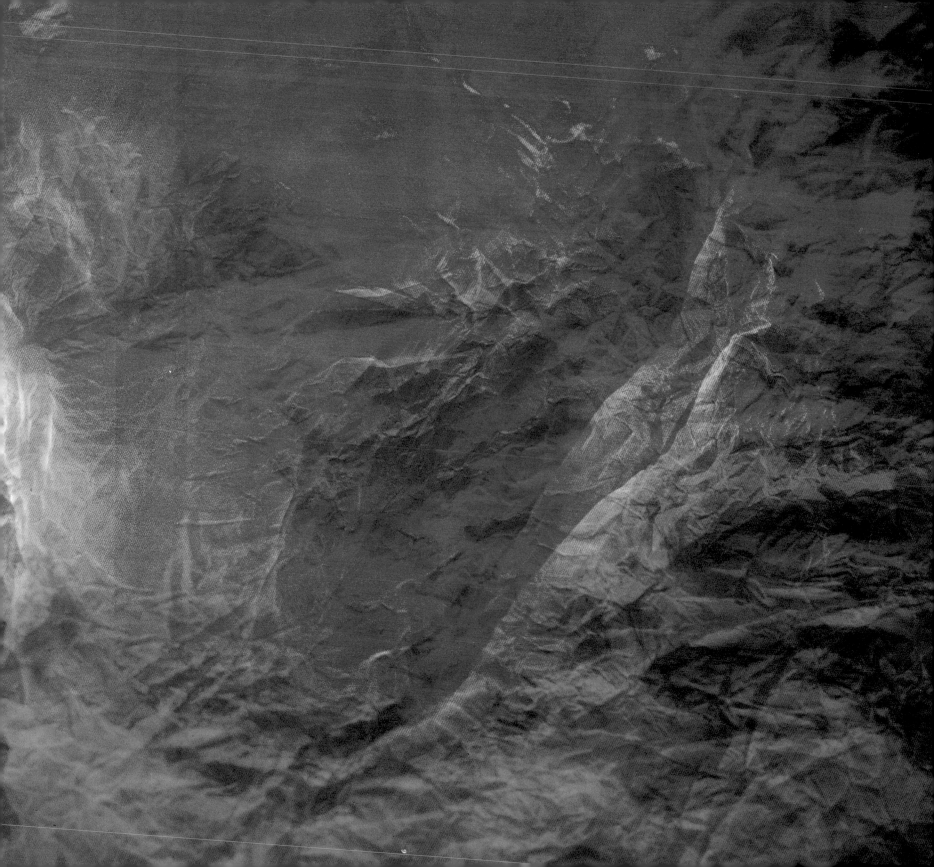

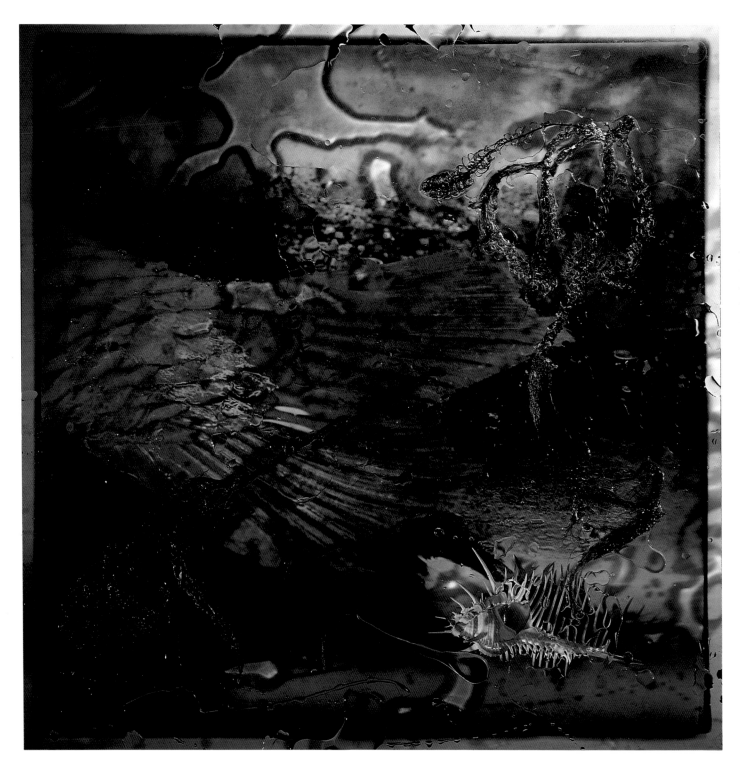

Previous pages: Various transparencies were sandwiched together to create this abstract piece, entitled From the Air. (Steve Wallace)

Left: This image was created by placing objects and various liquids over a blue-toned photograph. The shadows of the liquids emulate those created when light filters through water onto swimming pool floors. (Simon Larbalestier)

Combining *Photographic Imagery*

Y̶ou can combine photographic images – negatives, prints, and slides – in a number of ways in order to create a montage. Even before the film-processing stage, you can use a camera technique known as double or multiple exposure to superimpose images. This can be a powerful and immediate way of creating impossible combinations of subjects and situations and presenting them in the form of photographic documentation. It brings what you can see to be a totally impossible piece of imagery into conflict with the old adage that says that the camera never lies. A way of achieving a similar effect in the darkroom is to expose two or more normally shot and processed film originals – negatives or positives or a combination of the two – on a single piece of printing paper. Another technique for subverting the conventions governing the photographic image is to make "sandwiches" of negative and positive film images and then print them together onto a single sheet of photographic paper. Or you can re-expose this layered film sandwich onto another piece of film to create a single-image dupe. Rephotographing the photograph is another way of manipulating an image. In its simplest form, this can be achieved by placing the original image on the floor or wall and positioning two lights, one on either side, at 45 degrees to the image and copying the image onto film. However, rather than just duplicating this photographic image, it is possible to extend this principle much further by using the original photograph as a base for a completely new image.

Following the *trompe-l'oeil* concept of creating suggestions of depth and distance from flat planes, one can use the information held within a photograph to create a similar effect. In this way, objects can be placed on top of the original photograph, allowing the scale and subject matter to react together as a single image photographed as though they were in fact part of the same subject. Brightly colored objects can be set against black and white backgrounds to create startling juxtapositions and ambiguities. The size of the objects in the background can be manipulated to fit the scale of those being placed on top. In this way the scale of the objects can be carefully controlled, and size can play a major part in the presence and impact of the final rephotographed image.

As important as the subject matter itself is the control you have over lighting these "sets". The play of light can be one of the most powerful ways of manipulating the image at your disposal, and it can make the difference between creating an image that appears flat and one that is three-dimensional.

Projected images

Images can also be combined by projecting transparencies onto a wall and then rephotographing the result in the same way as described above for photographs. However, bear in mind that lighting projected sets can be difficult, since any unwanted illumination spilling over onto the projected image may cancel it out.

The making of audiovisual films and presentations is an intriguing extension of this process. A number of single images can be programmed to be projected onto any suitable surface – such as a screen or white wall – and these images are then dissolved into and out of each other. If available, several projectors can be used to project transparencies at programmed intervals to

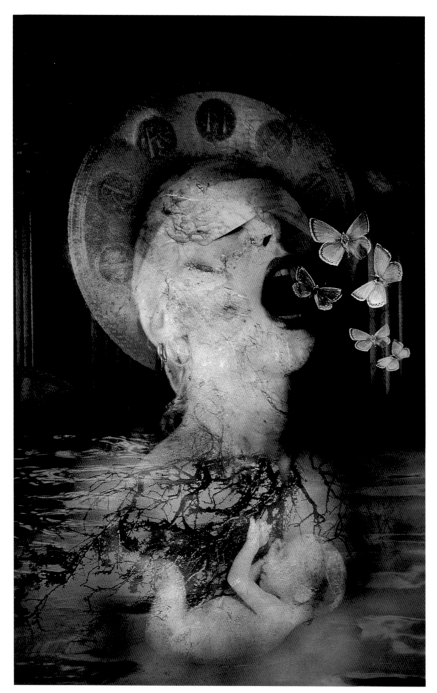
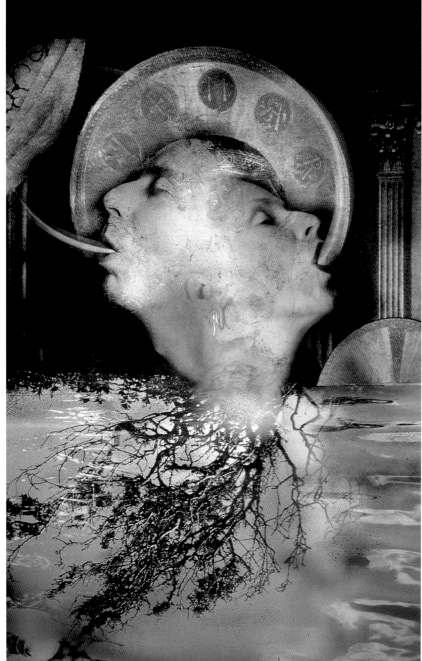

create a continually changing montage. Images produced using this technique are ephemeral in nature, since they exist only at that particular moment in time. Recreating them can be achieved only by taking a series of photographs that catch their ever-changing form.

Types of lighting

Positioning two lights at 45 degrees to the subject is the conventional way of ensuring that the subject receives an even distribution of light and that its colors

demarcations between light and shade within the image. Mirrors and sheets of silver foil can be used to bounce light back into specific parts of the image, providing "catchlights" and filling shadow areas that may be difficult to prevent with a generalized lighting scheme.

Not only the quality of the light but also its color can be manipulated, which is something that will affect the overall balance of your final image. One way of creating unusual color responses is to combine different types of light

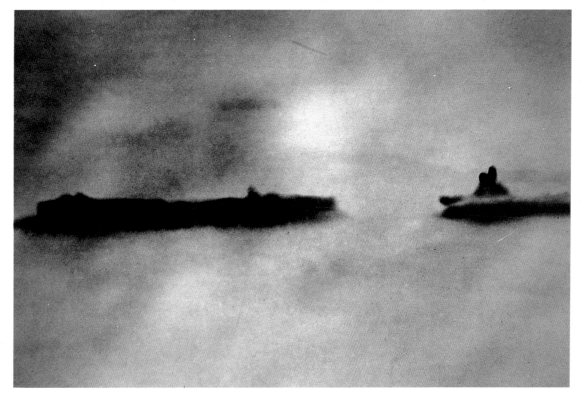

Left: Screaming Butterflies (far left) and Virdus (left) show how the use of projected imagery permits the artist to blend complex multiple sources in order to create seemingly impossible images. These images were part of a multi-screened presentation which was exhibited at the Museum of Modern Art, Oxford, England, in 1990.

Dissolving slides were projected onto the rippling surface of a pool of water situated in the middle of the gallery which reflected the images around the central space.
(Holly Warburton)

Left: A still from an audio-visual film, entitled "Ein Sof," was produced using various manipulated black and white prints. Half of the film used positive images, while the other half dissolved into the negative versions of the same images. This cropped picture represents only a tiny area of the actual image. The artist enlarged and rephotographed this section onto lith film to give a negative result. The foggy atmosphere came about when the image was exposed onto the lith film.
(Smadar Dreyfus)

are faithfully reproduced across its whole surface. Using flash lighting ensures color accuracy when using color film balanced for use in daylight; however, there are other light sources, particularly tungsten lights, that permit alternative ways of illuminating these sets. Spotlights, which produce a focusable beam of light, can provide a crisp, punchy type of illumination and long shadows, whereas floodlights throw a more generalized type of light. If this is still too harsh, you can shine lights through translucent materials, to provide a softer, more diffused effect, which is especially useful if you don't want contrasty results or hard

source. For example, if you were to use film balanced for tungsten light outside in daylight, the image will photograph with a predominantly blue color cast. You would achieve the same result if using tungsten-balanced film combined with flash, since flash is designed to match the color of daylight. Using daylight-balanced film with tungsten light sources will produce a warm, orange-toned effect because tungsten light is deficient in the blue wavelengths of the spectrum. You can also place colored film gels or colored glass in front of the lights or mirrors to allow colored light to spill over into certain areas of the image.

Making a film sandwich

If it is impossible to make a multiple exposure with your particular camera model using the methods described on pp.126-127, or you don't have access to a darkroom, you can "sandwich" two or more processed film originals together in a single slide mount and then rephotograph the projected result.

Sandwiching negative or positive film images together is a very effective way of creating unusual montage imagery. The original films selected for this technique could be all positive, all negative, or combinations of negatives and positives. Nor are you restricted in the type of film originals you can select from – so you could, for example, combine a 35mm negative with a 6 x 4.5-cm film positive. And there is nothing to prevent you from sandwiching color images with black and white ones if the result is the type of image you are trying to achieve.

This method of working is very direct. Unlike many other photographic processes, it enables you to build up the image on a light box or use a projector, judging the readability and density of the image immediately by eye. Often it is not until you have laid several films over one another that you get a clear idea of just how transparent particular film originals are and how suitable the subject matter is for combining. After you are happy with the result you can see projected or on the light box, carefully tape or glue the different layers of film in position.

For best results when combining film originals, use negatives that are underexposed since these contain large areas of clear film that would normally print as black – remember, you will be illuminating and photographing the negative by transmitted light, not printing it onto paper. If you are intending to use transparencies, these must be overexposed. You can then build up the density and contrast of the image until you achieve the desired result. If you use the wrong type of film or place too many images together, the combined density of the originals will make the projected results very dark, and detail will be difficult to see. By carefully positioning negative and positive images together, you should be able to show parts of the positive image in the clear areas of the negative image that would be featureless and black if printed in the normal way.

1

1 Lol Sargent selected a 35mm transparency, shot in the Sierra Nevada, southern Spain, to be the overall background texture for this montage entitled Spanish Pepsi. He exaggerated the color of the rock texture by reshooting the original transparency on duplicating film (see Glossary on pp.138-139).
2 The second image selected for film sandwiching was a transparency of a balcony with a large, three-dimensional Pepsi Cola sign on the wall. This image had two important qualities; first, the wall was light in color, which lent itself perfectly to this technique; and second, there was the ambiguity of the Pepsi Cola sign itself.
As with the first image, the artist copied this transparency onto duplicating film in order to enhance contrast and color. Using a rostrum camera (see Glossary on pp.138-139), he exposed this second transparency onto two frames of film, each frame being about two to three stops overexposed. Next, he sandwiched these two identical frames together, along with the transparency of rock texture, in a single slide mount
3 Notice how on the final image the edges appear soft, almost vignetted. To achieve this effect, Lol Sargent exposed the three frames of film, using the rostrum camera at a normal exposure, onto duplicating film. The aperture of the lens was f11 – i.e. small enough to ensure that depth of field was sufficient to keep all three frames in focus. Next, he removed the film sandwich from the camera and replaced it with a "mask" – in this case, a black and white image (not shown) hand-rendered using

2

graphite and charcoal. He then exposed the mask onto the frame of duplicating film bearing the latent image of the film sandwich. However, the exposure that the artist used this time was three times more than would normally be required. This exposure caused the soft black edges of the mask image to burn out the edges of the first image frame to create the final effect you see.

Above: Spanish Pepsi was produced by sandwiching three separate frames of transparency film together and re-exposing them onto a single frame of film. This process encourages radical shifts in color.
(Lol Sargent)

3

Making a multiple exposure

1 and 2 These two photographs show component images for the planned multiple exposure. The artist, Nanette Hoogslag, photographed them on black and white film and then printed them as two black and white prints. (For clarity, a 6 x 4.5-cm camera was used with 120mm color transparency film.) Each print was then ready to photograph onto the same frame of film at stage 4.

3 For the third element of the multiple exposure, a negative print of photograph 2 (the portrait) was selected for the overall background of the final image. After enlarging it and printing it in sections, the artist toned it brown/black.

Next, she montaged the different elements together using transparent tape to produce a composite image. Notice how the tape is clearly visible – this is an important design feature as it helps to divide the image into designated areas so that the artichoke and a positive print of the subject or portrait can then be exposed into these areas in the next stage of creating the montage.

The artist made some rough sketches at this point to determine how the images might combine in the camera.

4 Finally, all three prints were photographed onto one frame of film. Notice how the artichoke appears as the lightest part of the

1

2

image – this is the area where the film received the highest exposure level, as it is the third exposure.

Nanette Hoogslag used photographic toners to color the individual elements on the resulting print in the same way as for photograph 3 (the negative print of the portrait photograph). As the images combined in the camera, so the colors of the individual prints change depending on how much light is exposed to the film. In this way, a colored image can be produced from black and white prints which evokes a sense of depth and space that would be impossible to achieve when shot as a single photograph.

To make a multiple exposure in the camera, you need to expose the same frame of film – 35mm, one of the 6-cm formats, or, indeed, much larger sheet film – to two or more images. To do this with a 35mm SLR or compact camera, you need a model that allows you to reset the shutter without winding the film on. On some other models, you may be able to disengage the film from the wheeled sprockets and then wind on in the usual way to reset the shutter. Multiple exposures are not a problem with most medium-format cameras and all sheet-film cameras, since the shutter can be reset while the film remains stationary.

On the practical side, the difficult part of making a multiple exposure is getting the exposure right. If you were to take a light reading of a scene in the normal way and expose the film according to the recommended settings, and then do the same for the next image on the same piece of film, then the film would receive many times the exposure it needed. A resulting negative would produce a very light print, while a slide would appear washed-out. To counter this, work out how many exposures you want to take on the frame and divide the exposure for each image by that number.

3

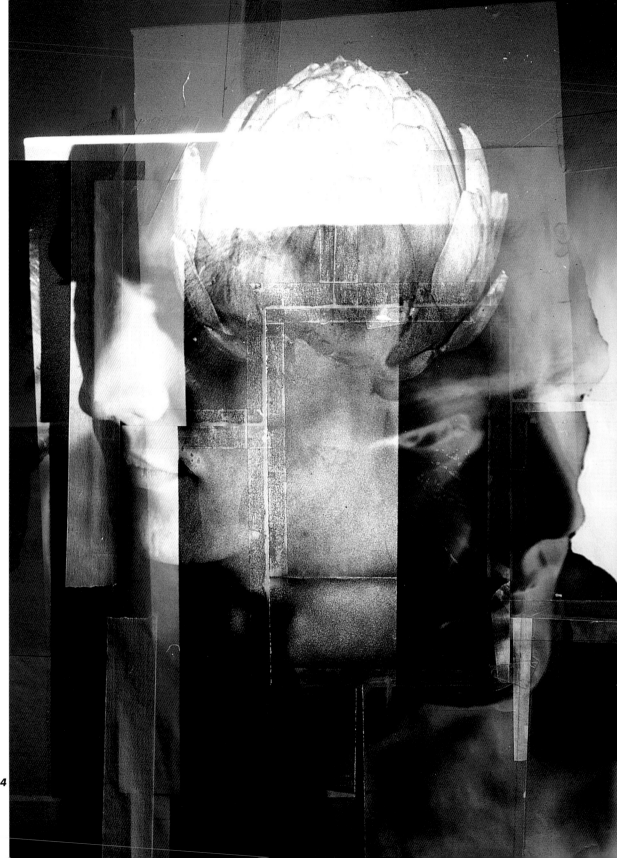

4

Above: In this piece, entitled Portrait of Wouter Kardol, the artist chose to create "an atmospherical portrait based on his character" rather than a more conventional "head and shoulders" photograph. The sitter brought an artichoke with him as a prop; this later became an integral part of the final image.
(Nanette Hoogslag)

Overleaf: The World as I Found It was created using back projection, prisms, brown paper, and string. This temporary assemblage was brought together as a single image through the use of controlled and manipulated light. "The kite-like construction offered us a screen across which to throw many components."
(Douglas Brothers)

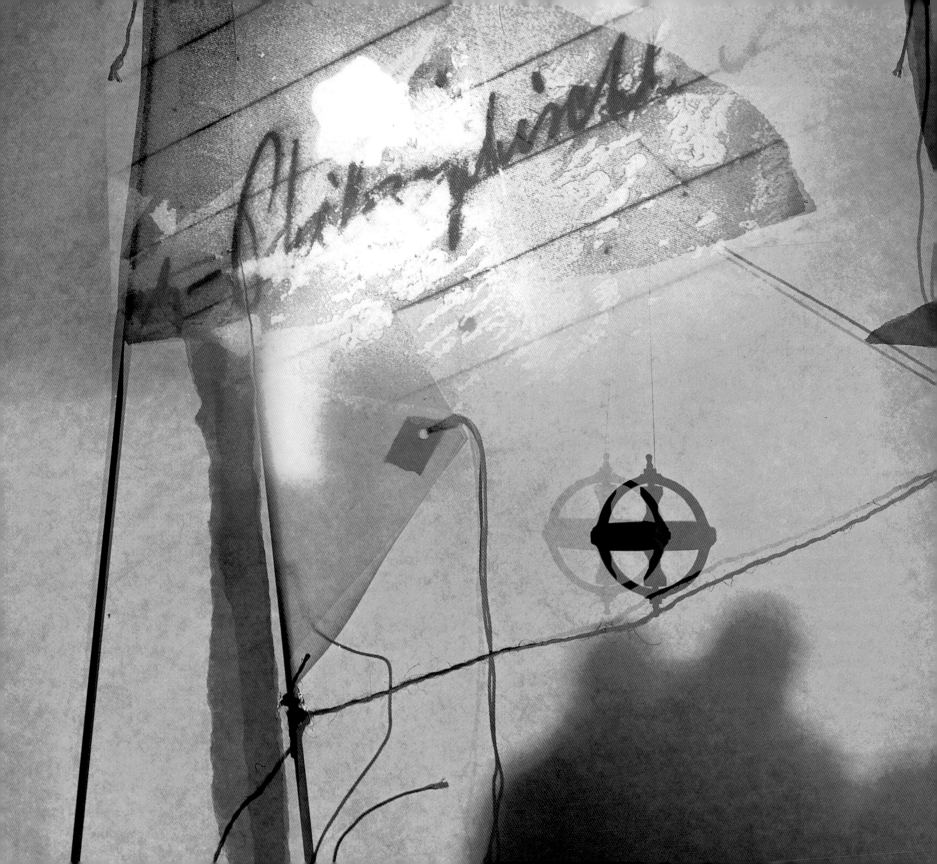

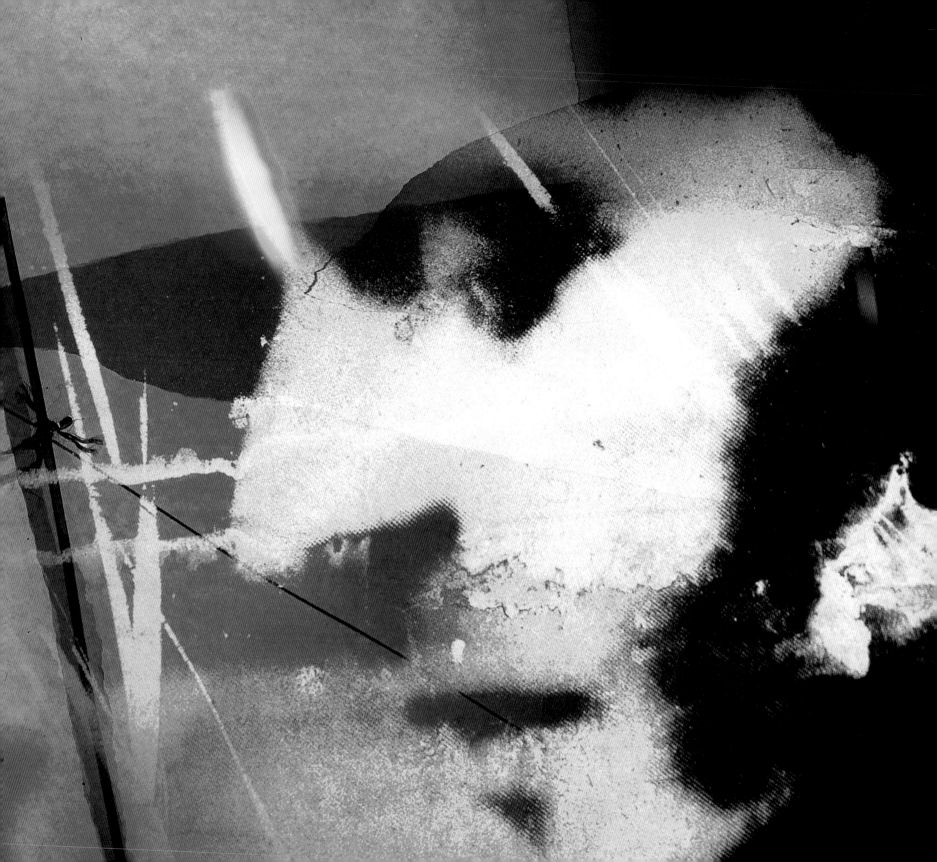

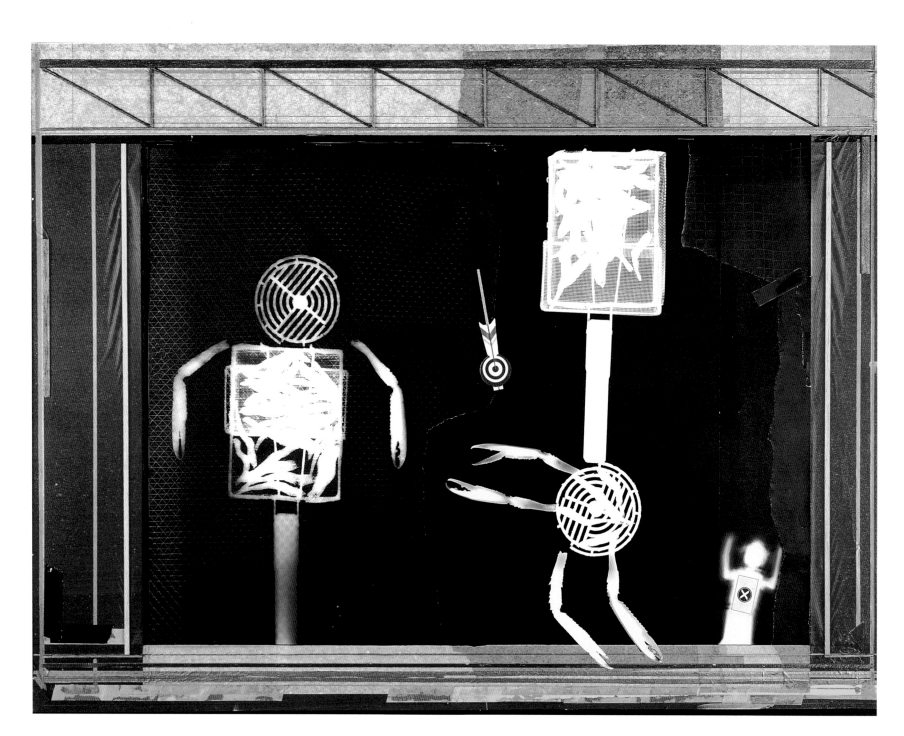

Mixed Media

Throughout this book, various techniques for combining images have been presented and discussed in detail – from conventional cut-and-paste methods to negative sandwiching. However, these processes represent only some of the many that are available to the contemporary montage artist, and space has been insufficient to describe in detail others, such as traditional printing processes, screenprinting and computer-manipulated image making, which are touched on briefly here in this chapter.

Sometimes it is the combination of various techniques that provides spice and gives spontaneity to the process of picture making, preventing images from becoming stifled and trapped within a too-specific medium or way of presentation. Fresh associations may be provoked by juxtaposing photography with, say, painting, color photocopies with three-dimensional objects, and found images with those made by yourself. From the pasting of fragile papers, or the fixing of objects in boxes, to complex darkroom manipulations, each individual method is perfectly suited to the creation of montage imagery. And at each stage, creative decisions need to be made. For example, is the pasting of found images to aged textural papers a resolved artwork, or does it become merely a new source image, one that can be manipulated on a color copier to produce a result that may then be rephotographed and displayed as a large-scale color print? If taken this far, the finished image may bear only the slightest of resemblances to the original image, due to the intervention of the processes and equipment described in earlier chapters.

A common problem anyone working with montage imagery needs to guard against is becoming trapped within the confines of the technology that is being employed. This can be true of color photocopies, which may reduce everything to a uniform, glossy ubiquitous image that is perfectly centered on a plain piece of anonymous white paper. However, there is always the intervention of chance and random error in every process, and these unforeseeable circumstances can reveal new opportunities to reassess the individual image, or indeed the entire concept underlying it.

The use of collage images as reference – as starting points for new images – plays a central role in the work of the artist Andrzej Klimowski, whose imagery is presented in various forms throughout this book: black and white photocopy collages that are akin to calligraphy (see p.72); color-copy collages that invest black and white photomontages with subtle color hues (see p.64); lith-film montages (see p.60); and large-scale works, such as *12 Denier Man* (see p.131) which was reproduced on photo linen with encaustic to give the piece an intensity of color and a surface texture quite unlike any other material. It is by combining various processes that Klimowski is able to create surreal images that suggest ambiguity within their delicate textures.

By contrast, photocopy images take on a completely new meaning as raw collage reference when built into large-scale sculptures, such as those created by Jake Tilson. *First Avenue Cruiser* (see p.134) is a composite of laser-printed black and white negative images depicting American cars which the artist enlarged several times to emphasize the grain inherent in the medium and then combined with found enamel signs and license plates, riveted aluminum plates, and paint. Tilson's images differ from the "ready-mades" of Archer/Quinnell and Hirniak (see pp.23 and 52) in that, instead of employing imagery in its original state, he manipulates certain elements using photocopier technology to give the pieces a completely new identity. These are images created from raw materials rather than from objects collected for their functional, nostalgic, or some other inexplicable, alluring properties.

Other extraneous elements are seen as raw material by Simon Lewandowski (see p.135) and are incorporated into his collages, which exploit such printmaking processess as photo-etchings and woodcuts combined with photocopying. Each process gives him a new and different product, something that is emphasized and made even more apparent when results are cut up and collaged together.

Printing

Traditional printing processes have as much potential for image generation as the more accessible photocopier technology. However, if you do have access to

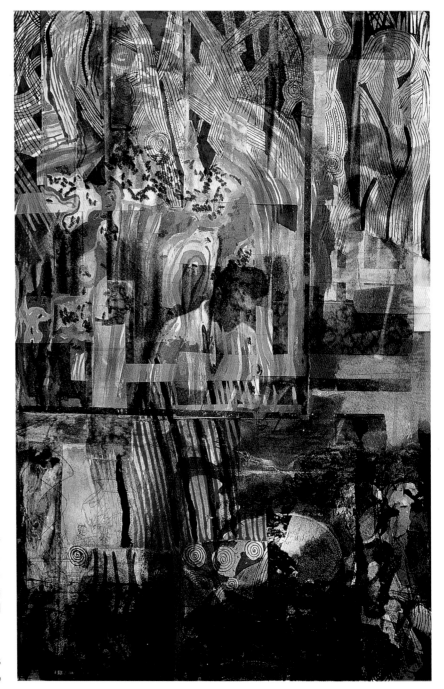

Left: A page from Printed Matter (America/Japan 1989). *The artist created the series on a printing press using some of his own images alongside printed pages he found on the floor.* (Shinro Ohtake)

Below: These two screenprints, entitled Plane *(below left) and* Fish *(below right), are taken from a series of limited edition prints called "Art For Officers."* *Photo-silkscreen printing* offers the opportunity to reproduce detailed images and set them against pure-color backgrounds – pure in the sense that the color remains opaque and can be specially mixed exactly as required. *Once you have achieved a satisfactory background color – in these instances, a clear, sky blue – you can reproduce your prints in limited editions.* (Michael McDonough)

a printworks, you may find it to be a totally new and exciting source of montage material. For example, the floor may be littered with a chaotic mix of images – proofs and run-ons (extras) from various jobs bearing no relationship to each other apart from their place in the sequence to be run through the presses. Often it is possible to create an unexpected artwork using discarded printed sheets from an earlier job and feeding them through the presses to clean the ink off the rollers. The startling montages that result are often built up from dense layers of unconnected images. These may be misregistered and totally abstract, yet they are often rich and subtle from the myriad combinations of the four process colors: cyan, magenta, yellow, and black.

The Japanese artist Shinro Ohtake created a whole bookwork project, entitled *Printed Matter (America/Japan)*, by printing his own images over sheets of discarded paper that were waiting to be run through the printing press (see p.132), which he collected off the printer's floor.

Screenprinting

The process of screenprinting offers yet more montage possibilities, and it is often seen as a suitable medium for the realization of the end product of photomontages and photocopy collages. Modern photo-silkscreens allow the reproduction of the fine detail contained within photographic and photocopy images, while at the same time giving you the option to change totally the colors of your original

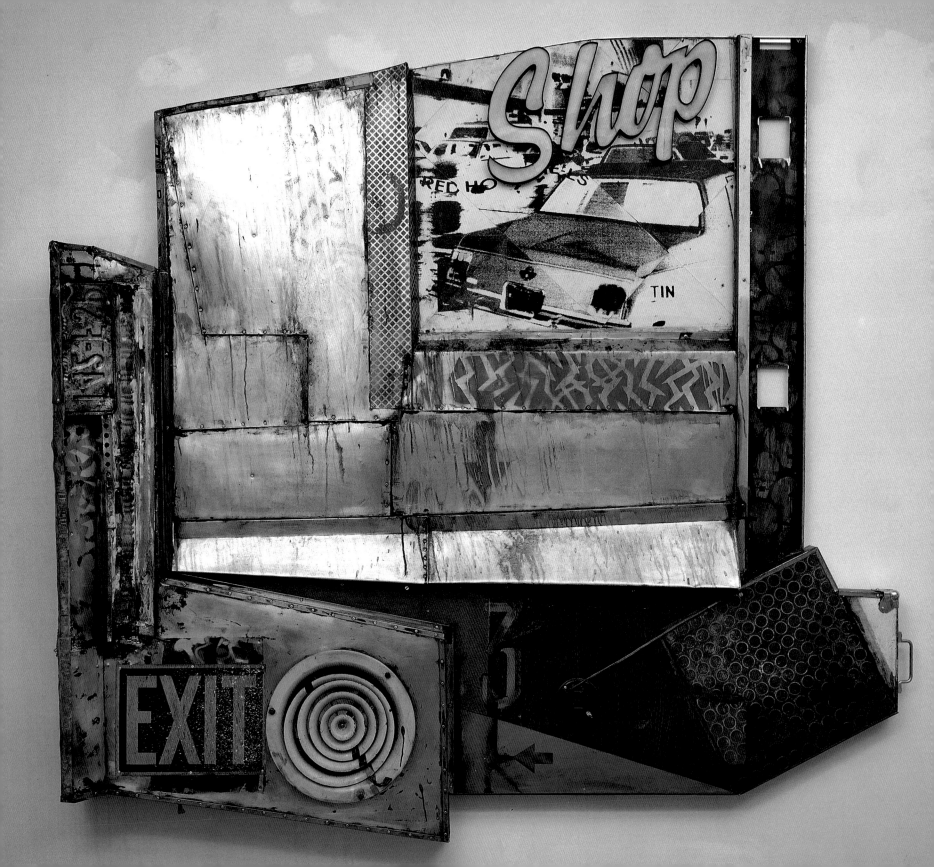

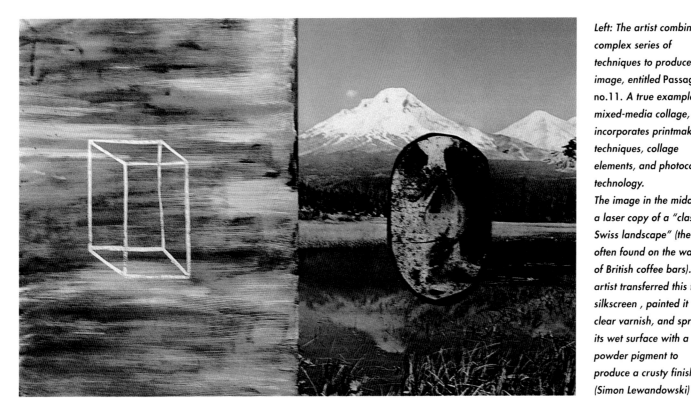

Left: **First Avenue Cruiser** combines many different materials including black and white laser photocopies, riveted metal, air vents, and items salvaged from dumpsters.

Collage is only a small part of the picture-making process for this artist – the action of making the sculpture is more important to him. He views the found materials he employs simply as raw materials to hammer, rivet, photocopy, and paint until they take on a brand-new identity and are transformed into something completely different. (Jake Tilson)

Left: The artist combined a complex series of techniques to produce this image, entitled Passages no.11. A true example of a mixed-media collage, it incorporates printmaking techniques, collage elements, and photocopy technology.
The image in the middle is a laser copy of a "classic Swiss landscape" (the kind often found on the walls of British coffee bars). The artist transferred this to a silkscreen , painted it with a clear varnish, and sprinkled its wet surface with a dry powder pigment to produce a crusty finish. (Simon Lewandowski)

source image. The new image is often mutated into something that, while still resembling its original form, is invested with brand-new connotations and associations.

On page 62 we can see how Terry Dowling subverts the screenprint process designed for the production of duplicate prints in limited editions. Dowling adds collage elements and changes the surface of the paper and inks to produce several versions of the same image. Michael McDonough challenges our notion of color through the screenprint process. Small color-photocopy collages are first scanned and then converted into fine photo-silkscreen stencils. After this, he heightens the colors used to give them an unnatural brilliance, echoing the types of manipulation often seen in picture postcards in which the skies always appear as ultramarine blue!

One particular advantage silkscreening offers over other montage techniques is its unrivaled ability to produce a pure opaque color. This effect is extremely useful when a cut-out montage needs to be placed over a solid-color background. Photographing objects against colored sheets of paper can be the cause of many frustrating problems – any marks or irregularities on the paper's surface will reflect light unevenly, giving rise to a mottled appearance on the resulting print. Using silkscreening techniques allow you to mix colors and print them as unadulterated hues or blend them with a translucent medium in order to permit other colors to "read through." Smooth layers of varnish or heavy mechanical dot screens can then be printed over the surface of virtually any image to provide additional layers on top of your montage.

Computer systems

Computer technology represents a totally new arena for both the manipulation of existing images and the generation of totally new imagery. Since this is such a vast, rapidly developing field, there has not been sufficient space in this book to do justice to the subject. Suffice it to say that the final three images in this book, entitled *Ombra Mai Fu*, could not have been created had it not been for the existence of extremely sophisticated computer systems and software.

Artist David Hiscock had access to such systems and software and used them to produce seamless montages with a sharpness and clarity hitherto

unknown from other computers. Until recently "pixelation"(the visible appearance of the individual dots of light of which a screen image is composed) has always been a visual deterrent to the use of computers. However, it is now possible to employ advanced machines that scan an original and reproduce the image in the form of a 10 x 8-inch transparency in which the pixels appear invisible to the naked eye. Immediately, the potential exists for the photographic representation to become truly a lie.

Interestingly, although the computer blends and merges images in a way that would be impossible to achieve by conventional photographic means, Hiscock still feels the need for the final image to express the manual and physical properties of paint. In his triptych on the right entitled *Ombra Mai Fu,* he utilizes the best of both media: first he produced the images as large-format transparencies directly from the computer system, then he printed them as large Cibachrome photographs, before placing them behind heavy glass overpainted with various paint media, including gold leaf. The depth created by the physical space between the paint on the glass and the image and the depth within the image itself created by the computer combine to produce an extraordinary sense of ambiguity between background and foreground, fact and fiction, lie and reality.

On the down side, the major stumbling block of computer systems today is that they are often difficult to access and their sheer expense inhibits their widespread use by many contemporary montage artists. However, they are currently being introduced to many educational establishments including art schools, and given time – and that time may be soon – their popularity and availability may be comparable to that of the photocopier technology that has dominated the late 1980s and early 1990s.

It is already possible to obtain different electronic color photocopy machines that can successfully interface with computer technologies, as well as linking to video, film, and still-video digital sources. These innovations enable images to be "grabbed" from a variety of different electronic sources, including the moving image, television, and video imagery, freezing them and then drawing them into combination with other media. In a matter of minutes, disparate sources are linked together, saved as digital information, and printed out on the color copier. This material is then ready to be recycled again and again until it takes on a new identity. Perhaps soon television and film imagery will become as appropriated as the printed image. The concepts of authorship and originality become buried and blurred under the weight of technological advances, and everything suddenly holds potential as raw material willing to be mediated and massaged into a new identity.

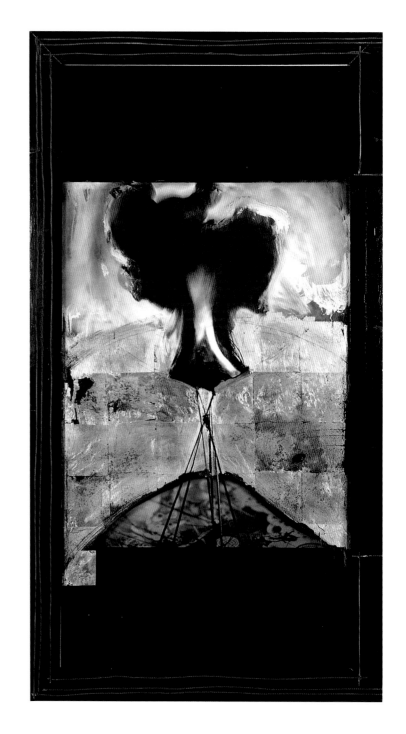

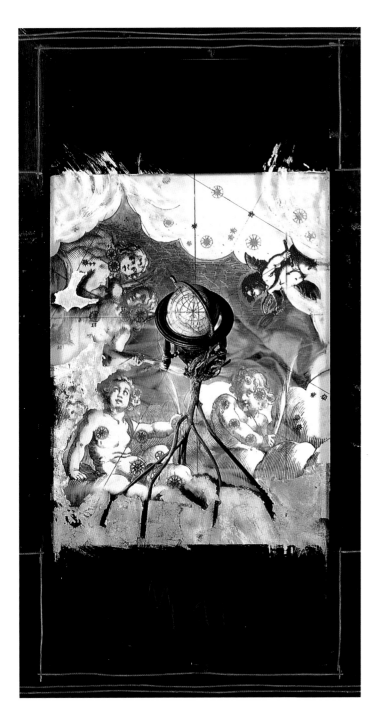

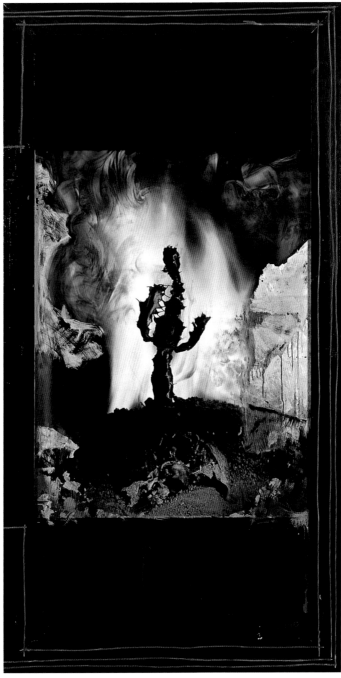

Left: This triptych, entitled Ombra Mai Fu, was the result of a long experimental process. At one point, the artist utilized the sophistication of computer technology to blend the images together. This process would have been impossible to carry out using conventional photographic means. However, the computer image did not constitute the final image – the artist had to manipulate the elements further by hand to give them a painterly finish. First he printed the "computer composites" as large-scale Cibachrome prints, and then he applied various paints, pigments, and gold leaf by hand to produce a unique and powerful triptych. (David Hiscock)

GLOSSARY

Acetic acid: When diluted with water, glacial acetic acid makes an acid stop bath that is used to curtail the development of a photographic image. It reduces the carry-over of developer into the fixing bath, which impairs the performance and life of the fixing solution.

Alternative original: A "one-off" color photocopy created from several separate artworks. This term also applies to a temporary arrangement of images that are placed on the photocopier for the duration of time required to photocopy them.

Aperture: An adjustable hole in the lens shutter which controls the exposure (the amount of light) that enters the camera – the smaller the aperture the greater the depth of field and overall sharpness of the image.

Art paper: High-quality drawing paper, often with a textured surface and available in various weights.

Artwork: An original image from which further permutations are made.

Assemblage: A collection of two- and three-dimensional elements, presented together as one entity.

Backprint film: Translucent film, designed for use with the Canon BJA1 color photocopier.

Bleaching: A method for reducing (lightening) areas of a photographic print.

Cibachrome: The brand name given to the color photographic process that makes positive prints from transparencies.

Collage: A combination of images and materials that are usually glued onto a single surface.

Color balance: The term used to describe the color "composition" of an image. The overall tone of a color image can be shifted by adjusting the color balance.

Compact camera: Often referred to as "aim-and-shoot" models, these small, pocket-sized cameras usually take 35mm or 110 size film. Most compact cameras are autofocus with a built-in flash.

Condenser lens: A large lens which is used to collect or concentrate light in a specific area.

Contact print: A print that is made directly from a photographic negative.

Continuous-tone image: An image that exhibits an infinite range of tones between black and white.

Contrasty: This term is used to describe a lack of middle tones in an image, whereby the image is said to exhibit only shadow and highlight areas. The image is often "punchy" rather than "flat" in appearance.

Crackle glaze: Applied to the surface of a collage, this varnish will simulate the fine cracks that appear on old oil paintings.

Cut and paste: The traditional method for producing collages by cutting out elements from an image or paper and gluing them down onto another surface.

Developer: This chemical agent is employed to produce a visible image from an invisible image such as those produced on sensitized photographic films, papers, and negatives.

Dimensions, variable: The term used to descibe the size of images that exist primarily on transparency or computer disk and can therefore be reproduced to any size. Also used to describe the size of projected images.

Dot screen: A mechanical or digital halftone made up from a series of variable-sized dots based on a fixed grid. Newspaper photographs are a good example of a coarse dot screen.

Dry-paper copy: A conventional photocopy that is made by electrostatically transferring powdered toner onto plain paper and passing it through heated rollers to fuse the toner to the paper.

Duotone: A printing term used to describe the reproduction of two colors over one another to create a tinted effect.

Duplicating film: Special photographic film used to produce duplicate copies (dupes) of images on single sheets of film.

Encaustic: An ancient method of painting with wax which, when applied over another surface, produces a shimmering effect.

Enlarger: A light source used to project a magnified image onto light-sensitive paper to make a print.

Enprint: A standardized photographic print (often 5 x 7 inches in color or black and white usually produced by photolabs from rolls of 35mm film.

Epoxy resin: A powerful chemical glue, made from hardener (catalyst) and glue, used for fixing heavy or bulky objects to a ground. NB: Always follow manufacturer's guidelines when working with epoxy resins. Avoid getting resin on the skin and work in a well-ventilated area.

Film sandwich: The method of combining several frames or sheets of photographic transparencies together to form a single image. Prints are often made from such sandwiches to create an image on a single surface.

Fixing bath: A chemical solution, usually containing Sodium Thiosulphate crystals, which "fixes" photographic prints and prevents them from fading when exposed to daylight.

Frottage: A "rubbing." This term is used to describe an image that is made by placing a sheet of paper or cloth over a relief surface and rubbing over the surface with a crayon or charcoal.

Greek votive: A religious offering that is presented in the form of a small pressed metal plate depicting part of the body.

Highlight: The lightest part of an image.

Icon: A painting of Christ or a saint used as a devotional object in Orthodox Christianity.

Kodalith film: A high contrast line film manufactured by Kodak and used to produce high-contrast images.

Laser copy: A generic term used to describe a photocopy that has been produced using a "digital" laser photocopier.

Laser photocopier: A "digital" photocopier, such as the Canon C.L.C..

Letratone: The brand name for rub-down sheets in shades of gray.

Lightband: A term used to describe the photocopy scanlamp that passes directly underneath the photocopier platen and records the image.

Lightbox: An illuminated box that is used to facilitate the viewing of transparencies and negatives.

Line copy: A single-color copy with no tones – for example, a black and white photocopy.

Liquid emulsion: A liquid, light-sensitive coating that can be applied to most surfaces – even wood – so that photographic images can be printed onto them.

Lith film: High-contrast line film with similar characteristics to Kodalith film.

Lith printing: A photographic technique for making continuous-tone prints from a very dilute lith developer. These prints are characteristically grainy and have a peachy-colored hue.

Litho press: A printing press that produces prints from the four-color set: magenta, cyan, yellow, and black.

Mat board: A thin, stiff, good-quality cardboard used to make mats in framing pictures.

Mechanical reproduction: A generic term used in this book to describe the process of reproducing images with machines – for example, cameras or photocopiers.

Mirror image: The reflection of an image, so that the left side becomes the right side.

Misregistration: The action of misplacing (offsetting) one color over another.

Mixed-media collage: A collage that is made up from a variety of elements and materials.

Monochrome: A single-color image.

Montage: A generic term used to describe the joining of several images or materials to form a single image.

Multi-generation copy: A photocopy that has been recopied several times.

Multiple exposure: A print created from several images that have been exposed onto the same frame or sheet of film.

Multiple print: An image produced from several photographic negatives or transparencies that are exposed onto the same sheet of photographic paper.

Negative print: A print that has had its light and dark areas reversed.

Negative sandwich: A single image produced from several photographic negatives placed together in the enlarger.

Photoetching: A printmaking technique for transferring a photographic image directly onto a metal etching plate.

Photogram: A photographic image made without a lens by placing a semi-translucent object directly onto photographic paper and exposing it to light.

Photomontage: An assembly of several photographic images on a single surface.

Photo-silkscreen printing: A method for transferring photographic images in the form of dot-screen stencils to silkscreens. This method is ideal for printing fine details.

Pixelation: A computer term used to describe the composition of a digital image that is composed of pixels. These appear as a fine mosaic pattern on a monitor or TV screen and serve as a bitmap memory that forms the part of a scanned image.

Platen: The glass screen of a photocopier.

Polaroid film: Brand-name film, sold in a variety of film formats, that produce instantaneous prints in color or black and white.

Poster board: Stiff good-quality cardboard sold in various weights, often used as a base for collage, montage, and assemblage; also called illustration board.

Printing Out Paper: A light-sensitive paper used to expose images in daylight without the need of an enlarger.

Process camera: This camera is used to record images on high-contrast photographic papers and films.

Process color: A color from the four-color printing set – cyan, magenta, yellow, and black. These colors can be mixed to produce an infinite color spectrum.

Rag paper: A high-quality cotton paper with excellent archival properties.

Rostrum camera: A camera mounting system that allows for pin registration and electronically controlled exposures. These are ideal precision tools and used mainly for audiovisual work.

SLR camera: Manufactured in 35mm and roll film formats, single lens reflex cameras are equipped with a top-mounted prism which provides accurate viewing.

Safelight: A photographic light used in the darkroom, often with a red or amber filter.

Sanguine: A term used to describe the red-ocher color of a chalk pencil. When mixed with water, sanguine turns blood-red in color.

Scan lamp: The bright light that passes under the platen and records an image on the photocopier.

Screen print: A print that has been produced on a silkscreen with stencils and inks.

Selenium: A highly poisonous metal-based toner which, when diluted with water, can produce interesting color variations on a black and white photograph.

Sensitized paper: A light-sensitive photographic paper. Also, an electrostatically sensitive photocopy paper that is designed to attract powdered toner to its surface.

Sepia: A chemical commonly used in toning in which the silver salts that make up the black and white photograph are converted into silver sulfide, resulting in a range of brown-toned prints with an antiquated appearance.

Slidemount: A device used for holding a transparency – usually between two sheets of glass.

Solarization: The reversal of image tones caused by massive overexposure.

Source image: A term applied to a found or an original image that serves as the source for further pictorial development.

Split toning: A photographic toning process that produces interesting "splits" in tone in which the shadow areas develop to a noticeable purple/brown but the middle tones remain gray.

Sprocket: Situated on the edges of 35mm film, these notches are designed to guide the film through the camera, keep it flat, and facilitate insertion.

Stop bath: *See acetic acid.*

Sun print: A photographic print made on Printing Out Paper that is exposed using sunlight or a strong ultra-violet light

Toning: The process of adding additional colors (tones) to a black and white photograph.

Triptych: A picture made on three separate panels which may be hinged together.

Tungsten lighting: A high-powered halogen lamp, usually employed when working with special tungsten-balanced film.

Typography: Graphic letterforms.

Vernis à craqueler: *See crackle varnish.*

Vernis à vieillir Aging varnish gives a yellowish, antiqued tint when it is applied to the surface of an image.

Vignette: An image with gradually shaded edges.

DIRECTORY OF CONTRIBUTORS
(all in Britain unless otherwise specified)

Fusako Akimoto
3-14-2 Shinoharhigashi
Kohoku-Ku
Yokohama City
222 Japan

Archer/Quinnell
5 Herne Hill Mansions
Herne Hill
London SE24 9QN

David Blamey
Open Editions
45 Handforth Road
London SW9 0LL

Jon Boatfield
8 Silverdale Avenue
Coton
Cambridge CB3 7PP

Richard Caldicott
11 Myrdle Court
Myrdle Street
London E1 1HP

Christopher Corr
14 Chadwick Road
London SE15 4RA

David Cross
15 Barnwell Road
London SW2 1PN

Muirne Kate Dineen
17 Westbridge House
Westbridge Road
London SW11 3PL

Douglas Brothers
254/258 Goswell Road
London EC1V 7EB

Terry Dowling
12 Jesmond Park East
Newcastle NE7 7BT

Chris Draper
195 Acton Lane
London W4 5DA

Smadar Drefus
c/o Slade School of Fine Art
University College of
London
Gower Street
London WC1 6BT

Dan Fern
58 Muswell Road
London N10 2BE

Nicolas Georghiou
47a Cambridge Road
London W4 3DA

Diana Grandi
Podernovo Di Monticiano
S.R.L.
Localitia Podernovo, 35
53015 Monticiano
Siena, Italy

Diane Gray
8 Picton House
Tilson Gardens
London SW2 4ND

Andrew Hirniak
c/o Peter Marshall
2a Bradbrook House
Studio Place
Kinnerton Street
London SW1

David Hiscock
Purdy Hicks
Jacob Street Studios
Mill Street
London SE1

Jonathan Hitchen
2 Longford Wharf
Stephenson Road
Stretford
Manchester
M32 0SS

Nanette Hoogslag
Egelantiersgracht 390
1015 RR Amsterdam
The Netherlands

Andrzej Klimowski
105 Sutton Court Road
London W4 3EE

Stewart Knight
c/o 8 Fieldend Green
Halton, Leeds LS15 0QJ

Simon Larbalestier
12 Longstone Road
London SW17 9BN

Pui Yee Lau
310 Kings Road
Room 604 Winner House
North Point, Hong Kong

Simon Lewandowski
30a Fonthill Road
London N4 3HU

David Loftus
31 Prothero Road
London SW6 7LY

Mack Manning
Laburnum Cottage
Menthead Road
Alston
Cumbria CA9 3SN

Michael McDonough
83 Maxwellton Road
Paisley PA1 2RB

Russell Mills
Loughrigg Holme
Under Loughrigg
Ambleside
Cumbria LA22 9LN

Shinro Ohtake
U.C.A.
1-4-3F Kojimachi
Chiyodaku, Tokyo
Japan 102

Vaughan Oliver
15 Alma Road
London SW18 1AA

Emma Parker
23 Laburnum Road
London SW19 1BH

Carolyn Quartermaine
72 Philbeach Gardens
London SW5 9EY

Lol Sargent
11a Hildreth Street
London SW12 9RQ

Danusia Schejbal
105 Sutton Court Road
London W4 3EE

Marguerite Suto
c/o 5 Bradenhurst Close
Harestone Hill
Caterham
Surrey CR3 6DS

Jake Tilson
16 Talfourd Road
London
SE15 5NY

Dirk Van Dooren
85 Bushey Hill Road
London
SE5 8QQ

Steve Wallace
59 Barnfield Avenue
Kingston Upon Thames
Surrey KT2 5RD

Holly Warburton
St. Matthias Church House
52 Chilton Street
London E2 6DZ

Lawrence Zeegan
Big Orange
Back Building
150 Curtain Road
London EC2 3AR

Recommended Suppliers

Suppliers of Liquid Light

Rockland Colloid
Corporation
P.O. Box 376
Piermont
New York
NY 10968

Tel. 914 359 5559

Suppliers of art and graphic design materials

Sam Flax
425 Park Avenue
New York
NY 10022

Tel. 212 620 3060

Sam Flax
1460 North Side Drive
Atlanta
GA 30318

Tel. 404 352 7200

Sam Flax
4001 East Colonial Drive
Tampa
FL 32803

Tel. 813 879 4311

Manufacturers of photocopiers and photographic equipment

Canon Inc
1 Canon Plaza
Lake Success
New York
NY 11042

Tel. 516 488 6700

Artwork Dimensions

1: Untitled, 1992, 18 x 18 inches, Chris Draper

2: *Ember Glance* (detail), 1990, dimensions variable, Douglas Brothers/Russell Mills/David Sylvian

3: *Horse in Tantric Circle,* 1990, 11³/₄ x 16¹/₂ inches, Muirne Kate Dineen

4: *Points for a Compass Rose,* 1991/1992, 36 x 24 x ¹/₂ inch, Russell Mills

5: *Red and Book,* 1990, 7¹/₂ x 6⁷/₈ inches, Pui Yee Lau

6: *Les Indes Galantes* 1985, 14 x 20¹/₂ inches, Danusia Schejbal

18/19: *Repetition: Scattered like Mountains* (detail), 1990, dimensions variable, Steve Wallace

20: *Akantchen Series,* 1992, 8¹/₂ x 6 inches, Dan Fern

21: *Brand Names,* 1992, 14¹/₂ x 9¹/₂ x 1 inch, Archer/Quinnell

22: Untitled, 1989, 11⁷/₈ x 5¹/₈ x 5¹/₈ inches, Andrew Hirniak

23 (left): *Voodoo Chilli* 1992, 17³/₈ x 13³/₈ x 2⁷/₈ inches, Archer/Quinnell (right): *Jiff Lemons,* 1991, 18³/₄ x 11³/₄ x ¹/₂ inch, Archer/Quinnell

24: *1986 India Sketchbook,* 13 x 7³/₄ inches, Christopher Corr

25: *Day In, Day In,* 1989-1992, 8⁷/₈ x 6⁷/₈ inches, David Blamey

26: *H.Z.E.* (detail), 1990, 7¹/₈ x 4³/₄ inches, Dan Fern

27: Untitled Postcards, 1990, 4 x 6 inches, Archer/Quinnell

28: *The Pearl,* 1984, 19³/₄ x 20⁵/₈ inches, Russell Mills

29: *Blank Frank,* 1978, 23⁷/₈ x 16⁷/₈ inches, Russell Mills

30: *Chaos and Old Night* (detail), 1986-1992, 216 x 144 inches, Jon Boatfield

31 (right): Untitled, 1991, 7¹/₈ x 3¹/₂ inches, David Lotfus

32/33: *Fratres Series* (detail), 1992, 13¹/₄ x 8 inches, Dan Fern

34: *Animal Experiments,* 1971, 22³/₄ x 16¹/₂ inches, Terry Dowling

35: *Two Chairs and a Car/The Wearing of Smart Suits,* c.1970, 8³/₄ x 7³/₄ inches, Terry Dowling

36: *Genuflection,* 1988, 12⁵/₈ x 12⁵/₈ x ¹/₄ inch, Simon Larbalestier

37: *Dessis,* (detail), 1988, 19³/₄ x 13³/₄ x ¹/₄ inches, Simon Larbalestier

38: *Screen,* 1987, 48 x 72 x 1 inch, Richard Caldicott

39: *Ariadne on Naxos,* 1992, 21¹/₄ x 25¹/₄ inches, Dirk Van Dooren

40: *Drawings,* 1990, 18³/₄ x 26³/₄ inches, Dan Fern

41: *Day In, Day In,* 1989-1992, 8⁷/₈ x 6⁷/₈ inches, David Blamey

42: *V.I. Lenin,* 1984, 6⁷/₈ x 4³/₄ inches, Christopher Corr

43: *Lettres Impériales,* 1989, 28³/₈ x 25⁵/₈ inches, Carolyn Quartermaine

44 (top): Untitled, 1988, 17¹/₂ x 24³/₄ inches, Danusia Schejbal; (bottom): Untitled, 1988, 16¹/₂ x 23¹/₄ inches, Danusia Schejbal

45: *Devils Dance,* 1988, 15 x 2¹/₄ inches, Danusia Schejbal

46: Untitled, 1987, 14¹/₄ x 7¹/₄ x 2³/₈ inches, Richard Caldicott

47: *Nos 8, 12 & 15,* 1987, 6¹/₄ x 5³/₄ inches, Dirk Van Dooren

48 (left): Untitled, 1992, 2 x 2 inches, David Loftus; (right): Untitled, 1991, 4 x 3¹/₂ inches, David Loftus

49: *Screen* (detail), 1987, 48 x 72 x 1 inch, Richard Caldicott

50: *Hotel,* 1986, 17³/₄ x 2³/₄ inches, Richard Caldicott

51: Untitled, 1989, 15³/₄ x 5¹/₄ x 4³/₄ inches, Andrew Hirniak

52: *5 Ball Baby,* 1986, 17¹/₂ x 9³/₄ x 3³/₄ inches, Archer/Quinnell

53: Untitled, 1990, 24 x 16¹/₂ inches, Andrew Hirniak

54/55: *Chaos and Old Night* (detail), 1986-1992, 216 x 144 inches, Jon Boatfield

56/57: Untitled, 1987, 4¹/₈ x 4 x ¹/₄ inch, Richard Caldicott

58/59: *Green Bicycle* (detail), 1990, 11³/₄ x 16¹/₂ inches, Terry Dowling

60: *The Joke,* 1983, 11 x 16⁷/₈ inches, Andrzej Klimowski

61: *Foto Album* (Genève), 1985, 6⁷/₈ x 5⁷/₈ inches, Andrzej Klimowski

62: (top): *Nailing On the Top Piece,* 33¹/₄ x 22⁷/₈ inches, Terry Dowling, *Towards Nailing on the Top Piece,* 25³/₈ x 20¹/₂ inches, 1974-1975, Terry Dowling

63: *Photographs From India,* 1989, 15 x 7⁷/₈ inches, 15 x 7¹/₂ inches, 15 x 4⁷/₈ inches, Muirne Kate Dineen

64: *Night Raid,* 1991, 11¹/₂ x 9¹/₄ inches, Andrzej Klimowski

66: *The Stolen Bacillus,* 1988-1989, 4¹/₈ x 6¹/₂ inches, Jonathan Hitchen

67: Untitled, 1991, 11⁷/₈ x 8¹/₄ inches, Stewart Knight

68: *Souvenir of London,* 1991, 23⁵/₈ x 16³/₄ inches, Lawrence Zeegan

69: *Breakfast Special No.4,* 1987-1989, 7¹/₄ x 5³/₄ inches, Jake Tilson

72: *New Artists Breaking Out,* 1987, 13¹/₄ x 10 inches, Andrzej Klimowski

74: Untitled, 1989, 11³/₄ x 16¹/₂ inches, Richard Caldicott

75: *Green Cow with Mendi,* 1990, 25⁵/₈ x 28³/₈ inches, Muirne Kate Dineen

76: *A Pair of Dancing Shoes,* 1990, 7¹/₈ x 6⁷/₈ inches, Pui Yee Lau

77: *The Enchanted Hunters,* 1991, 10⁵/₈ x 15³/₈ inches, Fusako Akimoto

81: *Temptation of St. Antony,* 1985, 13³/₄ x 13³/₈ inches, Simon Larbalestier

86/87: Untitled, 1990, 10³/₈ x 4³/₄ inches, Mack Manning, credit: VNU Business Publishing

88/89: *Robokoptf,* 1990, 8¹/₄ x 11³/₄ inches, Jonathan Hitchen

90/91: *Tea for Two,* 1991, 8¹/₄ x 11³/₄ inches, Pui Yee Lau

92/93: *The Red Doubles,* 1991, 25 x 10³/₄ inches, Pui Yee Lau

95: *The Qualities of Absence,* 1988, 11³/₄ x 16¹/₂ inches, Simon Larbalestier

96: *Sierra Toulouse,* 1989, 15¹/₄ x 15¹/₄ inches, Lol Sargent

97: *The Love Series,* 1990, 23 x 16 inches, Emma Parker

99: *Both Worlds,* (detail), 1992, 16 x 20 inches, David Cross

100: *Dai Nommi* (Tuenno), 1989, 11³/₄ x 15³/₄ inches, Diana Grandi

101 (left): *Man is Woman,* 1989, 14¹/₄ x 14 inches, Diana Grandi (right): *Boy on Fish,* 1991, 15 x 15 inches, Nicolas Georghiou

102: *Them,* (by Jonathan Green), 1988, dimensions variable, Douglas Brothers, credit: Jonathan Green/Secker & Warburg

105: *Disguise,* 1987, 15³/₄ x 14¹/₄ inches, Andrzej Klimowski

106/107: *A Day,* 1985, 24 x 12 inches, Vaughan Oliver

110: Untitled, 1992, 5 x 4 inches, Marguerite Suto

111: *Two Headed Vulture,* 1992, 16 x 20 inches, Nicholas Georghiou

112: *#8 (Disconnected Series),* 1992, 16 x 12 inches, Simon Larbalestier

115: Untitled, 1992, 6¹/₈ x 4⁷/₈ inches, Diane Gray

116: *The Magician,* 1989, dimensions variable, Steve Wallace

117: (left): *The Smiling Illusions of a Tragic Reality,* 1991, 25¹/₈ x 15³/₄ inches, Emma Parker; (far right): *The Smiling Illusions of a Tragic Reality,* 1991, 60 x 48 inches, Emma Parker

118/119: *From The Air,* 1992, dimensions variable, Steve Wallace

120: *Water,* 1991, 20 x 20 inches, Simon Larbalestier

122: *Screaming Butterflies/Viridus,* 1990, dimensions variable, Holly Warburton

123: *Ein Sof,* 1992, dimensions variable, Smadar Drefus

125: *Spanish Pepsi,* 1989, dimensions variable, Lol Sargent

127: *Portrait of Wouter Kardol,* 1992, dimensions variable, Nanette Hoogslag

128/129: *The World As I Found it* (Wittgenstein), 1987, by Bruce Duffy, dimensions variable, Douglas Brothers, credit: Bruce Duffy/Secker & Warburg

130: *Tegrat,* 1984, 28³/₈ x 22¹/₂ inches, Terry Dowling

131: *12 Denier Man,* 1990, 31¹/₂ x 24 inches, Andrzej Klimowski

132: *Printed Matter* (America/Japan), 1989/1990, 12 x 8¹/₂ inches, Shinro Ohtake

133: (left): *Plane (Art For Officers),* 1991, 11⁷/₈ x 15³/₄ inches, Michael McDonough; (right): *Fish (Art For Officers),* 1991, 11⁷/₈ x 15³/₄ inches, Michael McDonough

134: *First Avenue Cruiser,* 1990, 77 x 83 x 11 inches, Jake Tilson

135: *Passages No. 11,* 1990, 53 x 40 inches, Simon Lewandowski

136/137: *Ombra Mai Fu,* 1990, each panel 36 x 72 inches, David Hiscock

ACKNOWLEDGMENTS

The writing and images for this book would have been impossible without the generous support and help of the following people:

Firstly all the contributors who have kindly donated the rights to publish their work in this book and have provided me with all the necessary material required to explain the nature of montage. I thank them for their patience and openness in describing their work, sometimes at very short notice!

Special thanks are due to Chris Kewbank at the Special Photographers' Company, Terry Dowling, Professor Dan Fern, Andrzej Klimowski, Russell Mills, Richard Caldicott, David Blamey, Jake Tilson, Dirk Van Dooren, Jon Boatfield, John Stezaker, and Mike Eldridge for their advice, ideas, and enthusiasm.

Thanks to Canon (U.K.) and Canon Inc. (Japan) for their support in the Canon Research project held in the department of Illustration at the Royal College of Art. Without their generous sponsorship, much of the color photocopier research material used in this book would have been impossible.

Also thanks to the Bridgeman Art Library and DACS for their helpful advice and provision and licensing of the historical pictures used in the Perspectives chapter and Pentagram/RSC, Pan Books, and Decca for the permission to publish the images on pages 16 and 17.

Also generous thanks to the design and editorial team at Mitchell Beazley Publishers, particularly Catherine Ward, Judith More, Jacqui Small, Larraine Lacey, and Jonathan Hilton for their patience and guidance during the production of this book. Thanks also to Gale Carlill on behalf of Reed Consumer Books.

And finally a sincere thanks to my family for their constant support and encouragement with this book during 1992 and particularly Sue and Jack for their infinite patience and encouragement throughout their entire project.